JOHN F. KENNEDY JR.
A Life in Pictures

John F. Kennedy Jr.
A Life in Pictures

Published in the United States by powerHouse Books,
a division of powerHouse Cultural Entertainment, Inc.
68 Charlton Street, New York, NY 10014-4601
telephone 212 604 9074, fax 212 366 5247
e-mail: jfkjr@powerHouseBooks.com
website: www.powerHouseBooks.com

First edition, 2005

Library of Congress Cataloging-in-Publication Data:

John F. Kennedy Jr. : A Life in Pictures / edited by Yann-Brice Dherbier and Pierre-Henri Verlhac.--
 1st ed.
 p. cm.
 ISBN 1-57687-264-5
 1. Kennedy, John F. (John Fitzgerald), 1960--Pictorial works. 2. Children of
presidents--United States--Pictorial works. 3. Children of presidents--United
States--Biography. 4. Celebrities--United States--Pictorial works. 5. Celebrities--United
States--Biography. I. Dherbier, Yann-Brice. II. Verlhac, Pierre-Henri.

E843.K4J65 2005
070.5'092--dc22
[B]
 2005048732

Hardcover ISBN 1-57687-264-5

A complete catalog of powerHouse Books and Limited Editions is available upon request;
please call, write, or visit our website.

10 9 8 7 6 5 4 3 2 1

Printed and bound in China

JOHN F. KENNEDY JR.

A Life in Pictures By Yann-Brice Dherbier & Pierre-Henri Verlhac

JOHN F. KENNEDY JR.

A Biography by Yann-Brice Dherbier & Pierre-Henri Verlhac

JOHN F. KENNEDY JR.

John Kennedy Jr. was born at Georgetown Hospital on November 25, 1960, barely a month after his father John Fitzgerald Kennedy had been elected president of the United States. Upon seeing his newborn son, the president-elect declared him the most beautiful little boy he'd ever seen. "Maybe I'll call him Abraham Lincoln," he quipped. At forty-three, JFK was the youngest president in American history, and the first Catholic to be elected to the White House. His wife Jackie would become first lady at the tender age of thirty-one. The Kennedy couple embodied a dynamic, determined, and glamorous America, in radical opposition to prevalent perceptions of the political world.

Jackie was eager to move into the White House, and to begin work on a thorough renovation and redecoration. The day after their father's inauguration in late January, 1961, John Jr. and his older sister Caroline, age three, were finally allowed to leave the Kennedy family home in Palm Beach to join their parents at 1600 Pennsylvania Avenue.

Jackie made a point of insisting that her children receive as normal an education as possible. She did not want John and Caroline growing up in the shadow of protocol, raised by bodyguards and nannies. She kept them away from receptions and galas, and had a school set up in the White House. She also had a playground installed right below the windows of the Oval Office, in the discrete shelter of freshly planted hedges. John Jr. and Caroline quickly learned to love their trampoline and their swing sets, and whenever he had a chance, President Kennedy would sneak a little break in-between meetings with eminent guests to come down and join in the fun. John Jr.'s first memories were of the playground. He would later write, "We had a dog called Pushinka, and we trained it to slide down this slide that we had in the back of the White House. Seeing the dog slip down the slide is probably my first memory."

Jackie also had a stable built for John and Caroline's two ponies, Macaroni and Leprechaun. Games extended all the way to the Oval Office, where the President would happily join in playing hide and seek between official visits.

To Jackie's great joy, as the months went by JFK felt an increasing need to spend time with his children. He lunched with them as often as he could and never failed to take them sailing off Hyannis Port, the site of the Kennedy clan's compound, on weekends. The Kennedy family generally traveled to Hyannis aboard the presidential helicopter, Air Marine One.

In infancy, John Jr. was frightened by the sound of helicopter blades. But he quickly grew out of his fear, and soon displayed such a passion for helicopters that he was nicknamed "Helicopter Head." His passion for all things flying never relented, to the great displeasure of his mother, who would later do everything possible to dissuade her son from getting his pilot's license.

In the White House, John Jr. grew up in a protected world. He developed a close bond with his sister Caroline, and, under the aegis of his nanny Miss Maud Shaw, progressively grew into a genuine little gentleman. Jackie was never far off, and she watched over her children like a lioness watches over her young.

Yet the life of the presidential couple also had a hidden, darker side. Much to Jackie's dismay, the president did little to hide his numerous female conquests—which included, among many others, Marilyn Monroe. Despite the acknowledged tension growing between JFK and his wife, the couple made sure to never argue in front of the children. In April, 1963, Jackie announced that she was pregnant again. On August 7, she gave birth to Patrick. Born five weeks premature, Patrick suffered from a severe respiratory problem. Transferred to Boston, the newborn struggled for life in an oxygen tent. Despite the president's influence and the efforts of the greatest specialists, the baby died forty hours after his birth, as his devastated father looked on. This tragic event brought John and Jackie closer together and led them to refocus on their family. To onlookers, it seemed as if they had become closer than ever. Yet their happiness was short-lived.

November 22, 1963, 12:30 PM. Shots ring out from a building overlooking the presidential motorcade in Dallas, Texas, and the president goes down. Half an hour later, a doctor at Parkland Memorial Hospital tells Jackie there is no hope. John Jr. would only learn of his father's fate the next day. "Did Daddy take his plane with him?" John asked his nanny Miss Shaw. "Yes," she answered. "I wonder when he's coming back," said the boy.

The night of the assassination, Lyndon Johnson wrote the following note to young John Kennedy. "It will take you several years to understand how great a man your father was. His death is a great personal tragedy for every one of us, but I want you to know that I share your grief. You can always be proud of him."

Three days later, on November 25, 1963, the entire White House celebrated John Jr.'s birthday. Caroline gave him a toy helicopter and Miss Shaw gave him a book. A few hours later, after the funeral mass for his father, John joined his mother and watched the coffin, draped with the American flag, leave for Arlington National Cemetery. Jackie whispered to him, "John, you can say goodbye to your father now." Recalling a gesture he had made a few minutes earlier, John

executed a perfect military salute. This poignant goodbye moved the entire world and remained fixed in the collective consciousness. Two hundred twenty representatives from one hundred two nations attended President Kennedy's funeral, every detail of which had been overseen by Jackie.

After his father's assassination, John became America's favorite son, the heir to the Kennedy myth. Jackie was dismayed at the idea that her children would grow up in the eye of the press, and she continued to try to give them as normal an upbringing as she possibly could.

In December, 1963, the Kennedy family left the White House. Jackie paid $175,000 for a fourteen-room house on Washington Street. Their new home quickly became a tourist attraction. It grew so bad that soon Jackie couldn't even change in her bedroom, because the tourists looked through the window. Despite the protection of the Secret Service, which Jackie was provided with until 1965, the pressure on the ex–first lady and her children became unbearable. In June, 1964, Jackie decided to leave Washington and its bad memories to move into a five-bedroom, five-bath apartment at 1040 Fifth Avenue in New York. This new home, just a few steps from Jackie's sister Lee's apartment, had a private elevator and an unbeatable view of the Central Park Reservoir. Jackie also rented a house annually in Glen Cove, Long Island, near Bobby and Ethel Kennedy's property.

John's uncle Bobby tried to fill the gap left by his brother by becoming a kind of adoptive father to John and Caroline. Jackie visited his Hickory Hill property with her children on a near-daily basis, in order for John and Caroline to see their uncle and play with their eight cousins (Bobby and Ethel would eventually have eleven children total). During this period, John also drew closer to his bodyguard, Special Agent Bob Foster, whom he sometimes called "Daddy." Concerned by this development, Jackie regretfully asked for Agent Foster to be reassigned.

John easily adapted to New York life, enjoying his tricycle and the swings in Central Park under the watchful gaze of his omnipresent bodyguards. In February, 1965, he was enrolled in the Catholic Saint David's School, on 89th Street. John stood out from the crowd from the first morning by punching a classmate in the nose.

While he led quite a regular little boy's life during the day, John did not shirk the obligations attached to his name. On May 12, 1965, he met the Queen of England at the inauguration of the John F. Kennedy Foundation in London. His nanny Miss Shaw, who was of English stock, chose this opportunity to discretely retire. In order not to alarm her children, Jackie told them that Miss Shaw was staying in London, and that she would join them later. Providencia Paredes, known as Provi, who had been

working for Jackie since 1955, replaced Miss Shaw as the children's nanny.

During the winter of 1966, Jackie traveled extensively to distract herself from the painful anniversary of her husband's death. Accompanied by her children, she visited Antigua, Aspen, Stowe, Gstaad, Rome, and Argentina.

Over that summer, to make up for extensive time spent away from her children while visiting Spain, Jackie made good on a promise JFK had made to his son but had never been able to carry out—to give him a restored plane, an authentic World War II Piper Club, with the motor and fuel reservoir removed.

At school, John hated being called "John John" and frequently used his fists to get that point across. Yet Jackie had more pressing concerns. "I don't want my children to be limited to being privileged kids living on Fifth Avenue and attending fancy schools. There's so much more to the world, outside the sanctuary we live in. Bobby has talked to them about it a little bit—about the children in Harlem, for example. He talked to them about the rats and the terrible living conditions there, even in a rich city, about the broken windows that let the cold in. John was so moved by what he heard that he said he would get a job and use the money he made to fix the windows in those houses. Last Christmas, the children gathered their best toys and gave them away."

In June, 1967, John, Caroline, and their mother spent six weeks in Ireland, where they visited the ancestral Kennedy home in Duganstown. The Irish branch of the Kennedy family was delighted to discover that John could sing *When Irish Eyes Are Smiling* and that he was taking an interest in soccer.

In April, 1968, Jackie was horrified by the assassination of Martin Luther King Jr., and chose to visit his widow. Two months later, on June 6, 1968, Bobby Kennedy was assassinated during his run for the presidency. John and Caroline lost their "second father," and Jackie was left devastated. Profoundly concerned about her children's future, Jackie decided to leave the United States and move to Greece...giving in to the advances of the man with whom she had been having an affair for several months, the Greek billionaire Aristotle Onassis. Onassis offered her security and immense wealth on his private island of Scorpios. In August, 1968, Ted Kennedy and Jackie's advisor André Mayer traveled to Scorpios to negotiate the terms of the marriage contract between he and Jackie. Onassis bestowed three million dollars on Jackie, and one million dollars on each of her two children.

At the age of eight, John was perfectly conscious of what had happened to his uncle, and suddenly saw his Kennedy heritage in a new light. He kept his father's memory alive by playing records of

his most famous speeches for his classmates and friends, including such famous excerpts as "Ich bin ein Berliner," and "Ask not what your country can do for you, ask what you can do for your country."

In September, after Saint David's suggested that John repeat a year, Jackie enrolled him at Collegiate, a school principally attended by children of celebrities. Every morning at 7:55 AM, John was driven to school in a cream-colored Oldsmobile by his governess Marta Sgubin, a fervent Catholic who spoke four languages. They were followed by Secret Service agents who, at Jackie's behest, tried to remain "invisible" once inside the school by staying in the basement and playing cards.

John quickly asserted himself as an energetic, athletic boy. Often the butt of his classmates' jokes as a result of the short pants his mother made him wear, John had no trouble settling his scores with fisticuffs. From his first day at Collegiate, John was getting into fights with other boys, as he had at Saint David's—putting into practice the friendly advice of his Secret Service minders.

On October 25, 1968, the highly controversial wedding of Jackie and Aristotle Onassis took place on the island of Scorpios. Ari's children, Alexander, twenty, and Christina, eighteen, were violently opposed to the marriage. When a journalist asked John if he was happy about it, he turned away in silence. Neither John nor Caroline could be protected from the hysteria generated by the official announcement of the wedding. Americans found it difficult to accept that their most famous first lady was leaving the country. The situation drew Jackie and her children together, but estranged them from the rest of the Kennedy clan. Jackie was conscious of this, and did what she could to ensure that John and Caroline return to Hyannis Port and reconnect with their roots as often as possible.

In 1969, life on Scorpios began to take shape. Jackie was determined to make sure that Ari didn't spoil her children, but she couldn't always fend him off. Ari gave John a mini-Jeep and a red speedboat with his name on the bow. Caroline was given a sailboat, and both children received ponies.

Ari tried to be a surrogate father to John and Caroline. Whenever he was with them, he behaved as if there were nowhere else he'd rather be. His own two children, Alexander and Christina, became friendly with Caroline and John but continued to reject Jackie. In New York, Ari kept a suite at the Hotel Pierre, while Jackie held on to her apartment a few blocks up Fifth Avenue. Here, too, Ari played the part of loving father whenever he had free time, braving his hatred of baseball to take John to Shea Stadium to watch the Mets.

In June, 1969, a few days before Jackie's fortieth birthday, Ted Kennedy drove his car off Dyke Bridge on Chappaquiddick Island. The young woman in the passenger seat, Mary Jo Kopechne, was drowned. The frenzy of media attention that resulted from the accident dashed Ted's presidential ambitions for that year. Jackie and her children joined the rest of the Kennedys in a united front to preserve the family's image. On November 15 of the same year, Jackie told her children that their grandfather was ailing and would probably soon pass away. Joseph P. Kennedy died soon thereafter. Five days later, at his grandfather's funeral, John recited a psalm before the entire Kennedy family, which had gathered to pay a final tribute to its patriarch.

John was a happy nine-year-old. He lived in a comfortable world, shuttling between New York and Scorpios, surrounded by caretakers and Secret Service agents. Whether he was playing soccer in Central Park, spending the weekend in Hyannis, or sailing off Scorpios, John took full advantage of his golden childhood. Ari introduced him to the ways of billionaires, which allowed John, who was already very comfortable among the powerful, to mix seamlessly with the richest people on earth.

Halfway through 1970, disastrous rumors began to circulate about the Onassis household. Ari was photographed with opera singer Maria Callas, with whom he had had a long affair before he met Jackie. Paparazzi were everywhere, ceaselessly nagging Jackie and reviving feelings she thought she had left behind.

In February, 1971, Jackie accepted an invitation from the Nixons to visit the White House. Though she had dreaded returning to the scene of a bygone era, she got through her visit without trouble. During the dinner, John, who was something of a klutz, spilled the contents of his glass over the president's lap. President Nixon wiped himself off without flinching. At his mother's request, John wrote a thank you note to the Nixons, written in his childish scrawl and personally dropped in the mail. The letter read, "I can never thank you more for showing us the White House. I don't think I could rember much about the White House but it was really nice seeing it all again. When I sat on Lincolns bed and wished for something my wish really came true. I wished that I have good luck at school. I really really loved the dogs they were so funny as soon as I came home my dogs kept on sniffing me. Maybe they rember the White House..." [sic]

John spent the next summer on Scorpios where he played with photographer Peter Beard, who had become an intimate friend of Jackie's and was undoubtedly her favorite photographer. When he wasn't shooting for top luxury brands, Beard was an activist for the protection of wildlife. An athlete and a sailing enthusiast, he reminded John of Bobby Kennedy.

With the beginning of a new school year in New York, John enthusiastically got involved in drama classes. He made his stage debut in December at the end-of-the-year school show,

playing one of Fagan's thieves in *Oliver*. He enjoyed the thespian experience immensely.

In the spring of 1972, Peter Beard took John and Caroline snake hunting in the Florida Everglades. Jackie's marriage was more fragile than ever. Ari was annoyed by his wife's independence, and by the capricious way she played off the press but constantly kept it at arm's length. Jackie criticized Onassis for his long absences and the ambiguous nature of his relationship with Maria Callas.

In December, Ari asked his lawyer to break the marriage contract, but the procedure came to an abrupt halt with the death of his only son, Alexander. A plane crash on January 22, 1973 left Alexander with irreversible brain damage, and Ari found himself forced to pull the plug on his twenty-four-year-old son.

Alexander's death plunged Ari into an emotional wilderness from which he was never able to return. John's stepfather became a broken-down old man who no longer made the slightest effort to hide his contempt for Jackie. The extravagant gifts and baseball games were things of the past. Nevertheless, John, who at twelve had lived through more tragedies than a vast majority of his peers, did what he could to try and lift Ari's spirits.

John spent all of 1973 in New York, far from his mother, who was constantly traveling with Ari in an effort to cheer him up. He was also far from his sister, who was now enrolled at the Concord Academy in Boston. During the period that Jackie was trying to save her second marriage, John found himself alone for the first time. He discovered and occasionally abused substances like alcohol, tobacco, and marijuana, but Jackie soon found out and threatened to forbid his going out if he continued smoking and drinking.

At fourteen, John was a turbulent teenager whose concentration in school left much to be desired. He had also developed an interest in a profession that his family had always been wary of, but to which both his parents had been drawn long ago: journalism. "'What do you want to be when you grow up? President?' 'Everybody wants me to be a lawyer, but I want to be a journalist'" (from *The Day John Died* by Christopher Anderson). Unhappy with her son's grades, Jackie sent him to a psychiatrist to deter any problems that might interfere with his academic career.

Meanwhile, Ari's state was getting worse. The shocks and stress he had undergone quickly developed into a severe pathology. In December, 1973, he was hospitalized for myasthenia—a rare, incurable muscular disease. By the next year, Ari and Jackie had grown so far apart that she did not bother to visit his sickbed, which was a few steps from her New York apartment. The situation continued to get worse. Beginning in February, 1975, Ari had severe difficulty seeing and speaking. On March 15, 1975, Jackie received a

telephone call informing her that her husband had died at the American Hospital in Neuilly, near Paris. Ari's daughter Christina had been at his bedside through the last days of his life. When Jackie's secretary Nancy Tuckerman was asked why Jackie hadn't gone to visit her dying husband, she answered that "the arrangement with Ari called for Jackie to spend part of her time with her children, and Jackie felt she needed to be with John and Caroline."

Like his mother, John did not show much outward emotion in response to the death of the man who had become so distant following his son Alexander's death. But Christina Onassis, who had lost her aunt, her brother, and both her parents in a span of a few years, attempted to kill herself the day of her father's death, blaming Jackie for "spreading bad luck to those who surround her." John, who had already lived through his father and his uncle's assassinations, Ted's severe accident, and now the death of his stepfather, still managed to react with strength as his mother had taught him to.

During Ari's funeral on Scorpios, Jackie was physically excluded from the cortege by the Onassis family, and had to resign herself to walking behind the procession. The conflict between Jackie and Christina would last another eight months, until their relations finally resumed a certain civility. Christina eventually made the decision to give her father's widow twenty-six million dollars, which had not been required by the wedding contract. In return, Jackie agreed to renounce any further claim to the billion-dollar Onassis fortune.

Ari's death did not curtail the Kennedy family's social agenda. Immediately after his death, Caroline and John represented their mother at an official dinner with President Valéry Giscard d'Estaing at the Palais de l'Elysée. The French president told the Kennedy children that "you have the smile and bearing of your father, and I am delighted to host his children."

A few days later, John visited the Soviet Union with his uncle Sargent Shriver and his cousins Maria, Timothy, and Robby Shriver. This trip was highly unusual for in general, Jackie did not want her children to be influenced by their cousins. She considered their mother Ethel unable to provide them with a stable upbringing due to her fragile psychological state, and was highly aware that the cousins seemed to cause trouble wherever they went. Jackie wanted her children to take their place in the Kennedy dynasty, but she wanted them to have a degree of self-control that she found lacking in most of their cousins. In order to provide an appropriate upbringing for John and Caroline, she raised them in New York but allowed them to join the Kennedy clan for the large family reunions in Hyannis Port. Naturally, her attitude was little appreciated by the rowdiest of the Kennedys. While Jackie regularly criticized Ethel for being a Kennedy to a fault, Ethel's children accused John of being far too Bouvier.

All these concerns flew out the window in October, 1975 when Caroline, interning at Sotheby's in London following her graduation from Concord Academy, narrowly missed being killed by a car bomb. It was later discovered that the bomb was actually aimed at her host, Member of Parliament Hugh Fraser, an outspoken opponent of the IRA.

In 1976, John and his cousin Timothy Shriver volunteered for the Peace Corps. They spent that summer reconstructing homes in Guatemala, which had just recently been stricken by a devastating earthquake. The tragedy left more than thirty thousand dead. Determined to avoid any preferential treatment, the cousins slept on the waterlogged ground and subsisted on the local black bean–based diet.

In September, John left the family nest on Fifth Avenue to enroll as a junior at the Phillips Academy in Andover, near Boston. Andover was the oldest and one of the most prestigious private schools in the country, with such notable figures as George H. W. Bush among its alumni. From his dorm room, John could look out at the pond into which Humphrey Bogart had once pushed a professor before being expelled. With his long curly hair, worn jeans, boating shoes, and wrinkled shirts, John fit right in with his classmates. It was here at Phillips Academy that John began a lasting friendship with Alexandra Chermayev, the daughter of the famous architect Serge Chermayev. John would later be godfather to her children.

With her children away from home and a strong new relationship with diamond merchant Maurice Tempelsman forming, Jackie decided to return to work in publishing. She accepted a position as an editor at the Viking Press. Two years later, following a disagreement with her boss, who was publishing a novel detrimental to the Kennedys' reputation, Jackie left the Viking Press to become an editor at Doubleday.

During the 1977 school year at Andover, John spent a lot of time in the gym, and developing his talents as an actor. The success he met with on stage was far from matched with his academic accomplishments. John had difficulty with self-discipline and working hard. Andover's administrators allowed him to stay at the school so long as he agreed to repeat his junior year.

That summer, in order to toughen him up, Jackie sent John to an Outward Bound program in Maine for the month of June. The next year, also in June, she sent John to work on her friend John Perry Barlow's farm in Wyoming, where he built fences and milked cows. The farm's employees were duly impressed by his physical strength and by his total lack of pretension. Back at Andover, John volunteered with a tutoring program, and started teaching English to immigrants' children from poor neighborhoods.

On November 26, 1978, Jackie organized a joint party for John's eighteenth birthday and Caroline's twenty-first, inviting one hundred fifty guests to join the family at Le Club, an exclusive New York City nightclub. Towards four in the morning, in front of Le Club's entrance, John and a few of his friends got into a fight with a group of paparazzi who had been hounding him. The photos of the ensuing chaos made the next day's front pages.

As the summer of 1979 drew closer, Jackie wanted her son to take another trip out of the comforts of the New York microcosm—to open his mind to other perspectives and different cultures. Having finished his schooling at Andover, John left for a ten-week journey through Kenya. At nineteen, John had grown into an unquestionably handsome six-foot athlete. Though he had become one of the most eligible bachelors in the country, he remained down-to-earth and straightforward.

Convinced that his recent acceptance to Harvard was only due to his name, John chose instead to enroll at Brown University, a less prestigious school, but one that would not bury him in the Kennedy myth. At the time, Brown was the most popular school among young people who wanted a quality education but did not want to be subjected to the academic rigor of Harvard, Princeton, and other schools of that caliber.

John made his first public speaking appearance at the inauguration of the JFK Library near Brown by reciting a Stephen Spender poem, "I Think Continually of Those Who Were Truly Great." At Brown, John tried to gain a better understanding of his father through history courses and seminars on the Vietnam War. He also continued to develop his talent for acting, much to Jackie's chagrin, for she wanted him to finish his studies before he even considered getting involved with the theater. "Even on the scale of our modest requirements regarding scholastic achievement, you are skating on very thin ice, which could shatter at any moment...." the dean of Brown wrote John.

During his time at Brown, John dated a literature student, Sally Munro, who bore a strange resemblance to his sister Caroline and was, like her, a graduate of Concord Academy. For her part, Jackie had settled into a steady and fulfilling relationship with Maurice Tempelsman. The couple had been living together since August, 1975. One of Jackie's friends, Vivian Crespi, once said, "Jackie's husbands didn't always treat her the way she deserved to be treated, but Maurice worshiped the ground she walked on. He didn't dominate her, and she didn't dominate him. They were equals." Jackie's children felt the same way.

In 1980, Maurice discretely arranged for John to spend the summer in South Africa learning the finer points of the diamond trade. But

John seemed to learn more about social justice in South Africa—he returned to Brown determined to fight Apartheid. To do so, he set up a series of conferences intended to expose the political situation in South Africa.

Yet a feeling that JFK's only son was stagnating had become increasingly prevalent over the previous few years. The press pulled no punches, regularly reporting uncomplimentary anecdotes and mediocre academic results, and publishing unflattering photographs, including a series of shots of John on stage as Bonario in *Volpone*. But 1981 was a turning point. Ted Kennedy obtained Jackie's permission to allow John to give a press conference at the Center for Democratic Policy, where he was a summer intern. The conference was a success, thanks to John's clever and gentle way of disarming the press.

As he reached the end of his time at Brown, John was increasingly convinced that his future was in acting. Jackie had to fight hard to dissuade him from enrolling at the Yale School of Drama. On June 6, 1983, John received his diploma from Brown University. During the graduation ceremony, John, who was wearing jeans and cowboy boots under the traditional robe, looked up in the sky to see the inscription "Good Gluck John," a deliberately misspelled send-off from his mother in reference to a bungled birthday cake inscription that had greatly amused him. Ted Kennedy framed JFK's original handwritten notes from the Cuban Missile Crisis and offered them to his nephew as a graduation present.

That summer, John took off on another adventure, joining his old diving friend Barry Clifford, who was trying to raise the wreck of the *Whydah*, a legendary pirate ship. The ship had sunk off Cape Cod in 1717, and was rumored to be holding a treasure worth two hundred million dollars. John joined the team and actively participated in the search, but was unable to share the elation of discovering the wreck—it was not found until two years later, a feat due only to Barry's unyielding persistence.

In October, as the twentieth anniversary of his father's death drew near, John left to spend nine months in India studying public health at the University of New Delhi. Following his return from India in June, 1984, John moved into a small apartment on 86th Street and began work for the non-profit 42nd Street Development Corporation. John had not given up on his acting dreams, but his career was dealt a hard blow when the actor Peter Lawford died on Christmas Eve. Lawford's passing robbed John not only of an uncle, but also of a precious ally in defending his desire to be in the movies. Only Rudolf Nureyev now remained among Jackie's friends to plead John's case. Following Jackie's lead, all the other Kennedys now believed that John should study law. Yet John, who in 1985 was not quite twenty-five, would not give up so easily. He insisted on making a real attempt at being a professional actor in order to

evaluate his talent. In March, he played the lead part in *Winners* by the Irish playwright Brian Friel, costarring with Christina Haag, an ex-roommate from Brown. John and Christina became lovers during the production of *Winners*, and remained together for six years. Jackie refused to attend the August premiere.

In the spring of 1985, Jackie lost her thirty-nine-year-old half-sister Janet, the mother of three children, to lung cancer. Devastated by this new tragedy, Jackie left to recover in India, where John joined her in the fall.

On July 19, 1986, exactly seventeen years after the events at Chappaquiddick, Caroline married the artist Edwin Schlossberg on Cape Cod. John, who served as his sister's witness, was delighted by the match.

In the fall, John made Jackie's dreams come true by enrolling at New York University School of Law. "Now I can die happy," she joked. In February, 1988, John gave in to his second passion, and got to work on getting his pilot's license. He secretly began taking flying lessons at the Martha's Vineyard airport, but his mother quickly caught on. Highly aware of the dangers of John's hobby, particularly since Alexander Onassis and Ted Kennedy's accidents, Jackie had regular nightmares about it and demanded that John quit his lessons. Out of respect for his mother, and in order to relieve her fears, John agreed to withdraw from the pilot's license program.

In June of the same year, John introduced his uncle Ted at the Democratic National Convention in Atlanta. At the time, John was twenty-seven and spending the summer interning for the Manatt, Phelps & Phillips law firm in Los Angeles. In the fall, John returned to NYU Law for his final year. Everything seemed to be going according to Jackie's plans when suddenly, in September, *People* magazine proclaimed John the "Sexiest Man Alive," immediately ruining his credibility as a candidate to public office. Around the same time, Madonna resurfaced in John's private life to resume the secret affair they had been having since the failure of her marriage to actor Sean Penn.

In September, John met the actress Daryl Hannah at his aunt Lee Radziwill's wedding to successful Hollywood director Herb Ross. John and Daryl had briefly met when they were eighteen, while vacationing with their families on Saint Martin. Though Daryl was currently living with musician Jackson Browne, John assiduously courted her, eventually taking her on a few dates. In July, 1989, Daryl spurned John, and chose to stay with Browne. John was no stranger to failure this year—a few weeks after begin rejected by Hannah, he failed the New York bar exam shortly after graduating from NYU Law. Soon after, however, John was offered a job as the assistant prosecutor for New York district attorney Robert Morgenthau. He decided to take it.

In February, 1990, John failed the bar exam for a second time, much to the media's delight. The *New York Post* headline read "Pretty Boy Flunks." John now ran the risk of being perceived as intellectually mediocre and having to resign from the district attorney's office if he failed the exam a third time. He hired a tutor to help him prepare.

Over the course of the year, John won all three cases he was assigned to. That summer, John and Daryl secretly began seeing each other again. When Daryl was hospitalized while filming in an Amazon forest, John had one thousand roses delivered to her room.

In 1990, John lent his support to the Kennedy Fellows Program, an annual financial award given to seventy-five social workers to put towards their own education or that of their children, in recognition of the exemplary nature of their work and commitment. A year later, John again displayed his philanthropy by joining the board of the Robin Hood Foundation, an organization dedicated to raising funds for various projects in poor New York neighborhoods. As part of his commitment to Robin Hood, John regularly took the subway to Harlem and the Bronx to make sure that its funds were being well used.

In March, 1991, William Kennedy Smith, the cousin John was closest to in age, was accused of raping a twenty-nine-year-old woman. Once again, Kennedy loyalty was put to the test, but John actively supported his cousin, who was eventually acquitted.

In September, 1992, Daryl Hannah told Jackson Browne she was leaving him for John. A fight ensued, and Daryl had to be taken to the hospital. John immediately rushed to her side, and took her back to New York to nurse her. The couple soon moved into Daryl's apartment and began an idyllic relationship that would last until August, 1994. Yet Jackie always refused to meet Daryl, for she was convinced John deserved better than an actress, and was terrified that Hollywood might lure him into ending his career in law.

After four years of distinguished service, John left the district attorney's office in 1993. Jackie became particularly insistent that John end his relationship with Daryl, going so far as to cancel her attendance at Ted Kennedy Jr.'s wedding when she learned that John was planning to bring Daryl.

Over the Christmas holidays, while she was vacationing with Maurice Tempelsman in the Antilles, Jackie fell ill. It was quickly discovered that she was suffering from a particularly virulent cancer. In early 1994, Jackie told her devastated children the bad news. The family was able to keep Jackie's condition secret for only a few weeks.

It was during this difficult time that John met Carolyn Bessette, an ex-schoolteacher and former model who was now a publicist for Calvin Klein. The tall, slender beauty impressed John with her poise and elegance. At the time John met her, Carolyn was in a serious relationship with Michael Bergin, a Calvin Klein model.

In the spring, John moved to a hotel close to 1040 Fifth Avenue in order to be closer to his mother, and to be able to take her for walks in Central Park every day. He told her about Carolyn Bessette, and Jackie began to dream of a serious, durable relationship for the two young people.

In March, 1994, John confirmed rumors that he was attempting to launch an offbeat monthly magazine about politics that would cover political figures in the way other publications covered any other celebrity. Despite Jackie and Maurice's advice, and their insistent reminders that 90 percent of new magazines go bankrupt in the first year, John pursued the project. He even told his ailing mother that he and his partner Michael Berman had found a name for the magazine—*George*, in honor of George Washington.

On April 14, Jackie's health suddenly took a turn for the worse and she returned to the hospital. Later, back in her apartment on Fifth Avenue and knowing that her days were numbered, Jackie wrote a final letter to her son.

"I am aware of the pressures you will always have to endure as a Kennedy, despite the fact that you came into this world an innocent. You, among all others, have a place in history. Whatever path you choose, I can only ask you and Caroline to continue to make me proud, to make the Kennedy family proud and, especially, to continue to be proud of yourselves. Remain faithful to those who love you, particularly Maurice. He is a good man, and he is full of solid common sense. Do not hesitate to seek his advice."

On May 19, 1994, Jackie slipped into a coma while surrounded by her loved ones: John, Caroline, and Maurice. At 10:15 PM, her heart stopped beating. The next day's *Daily News* headline read, "We Miss Her." A few days later, Hillary Clinton and Lady Bird Johnson were among the large and varied crowd of notable figures who gathered for Jackie's funeral mass at Saint Ignatius of Loyola in New York.

Over the following two months, John was overwhelmed by preparations for the launch of *George* and the complexity of Jackie's estate. He decided to put some order in his life, beginning by ending his four-year relationship with Daryl Hannah, who returned to Jackson Browne in Los Angeles. Shortly thereafter, John sold the Fifth Avenue apartment to oil king David Koch for nine million dollars, and bought himself a magnificent loft on North Moore Street in Tribeca. Most importantly, he tirelessly courted Carolyn Bessette, who soon accepted his advances...and moved in with him on North Moore.

In January, 1995, an entire Kennedy era came to an end with the death of Rose Kennedy, the eldest daughter of the legendary Boston mayor John Francis Fitzgerald, and the mother of one of the most famous American presidents, John Fitzgerald Kennedy. She was one hundred four. John attended the funeral mass with Carolyn and twenty-four of his cousins.

In March, the American branch of the Hachette Filipacchi group entered into partnership with the Kennedy-Berman duo to launch *George*. Hachette, which was banking on John's personality to sustain sales, committed to investing twenty million dollars over a period of five years. John's incursion into the world of the press echoed his father's journalistic coverage of the founding of the United Nations in 1945 and, especially, his mother's work as a photojournalist for the *Washington Times-Herald* before her marriage to JFK. "In my view, the wedding of politics and publishing is merely a combination of the two family traditions," John stated.

The magazine's official launch took place before one hundred sixty journalists on September 8. It was a smashing success, largely due to John's seductive combination of energy and devastating humor. Stepping up to the podium to address the gathered journalists, he began by saying, "I don't think I've seen so many of you gathered together since the first time I failed the New York bar." He finished off winning over his audience when he answered an inappropriate question regarding one of his acquaintances by saying, "Yes. No. We're just friends. It's none of your business. I swear she's my cousin from Rhode Island." John insisted upon the fact that *George* be resolutely irreverent, leading his Uncle Ted to tell him, "If I'm still speaking to you at Thanksgiving, you won't have done your job." On September 26, *George* appeared on the newsstands with an initial print run of 500,000 copies and an impressive 175 pages of advertising.

John approached his new profession with a hands-on, in-the-field approach. He took *George* very seriously and fully dedicated himself to its success, personally interviewing an ever-expanding and varied roster of public figures including Muhammad Ali, George Wallace, Billy Graham, Louis Farrakhan, Madeleine Albright,and even Fidel Castro.

As early as the following year, *George* had quickly and easily become a stunning success. John's private life, however, was proving a little more difficult. Carolyn was having more and more trouble accepting his numerous trips and the constant attention of the media. In February, a stranger in Central Park photographed one of their fights and the pictures were immediately sold around the world.

In the spring, a large auction of objects that had belonged to Jackie Kennedy was organized in New York. Despite the auction's success

and Maurice Tempelsman's approval, the American public's reaction to the sale was divided—many people criticized John and Caroline for opening their mother's intimate world to the American public.

John Kennedy and Carolyn Bessette were married in absolute secrecy on September 21, 1996, before about forty guests drawn almost exclusively from the couple's families. The wedding took place on Cumberland Island, off the coast of Georgia—home to only twenty-one people. John's witnesses were his sister Caroline and his favorite cousin, Tony Radziwill. When the press caught on and announced their wedding, John and Carolyn had already been married two days and were honeymooning in Turkey. They continued their honeymoon with a cruise aboard a two-mast schooner on the Aegean Sea.

Though his late mother had done everything possible to keep him away from it, John eventually returned to one of his oldest passions, flying. He bought a ULM, an aircraft that can be piloted without a license, and took his first flight in August, 1996.

Carolyn was still having trouble dealing with the constant pressure media brought to bear on her relationship. She could not get used to being photographed wherever she went, and could not understand how John had resigned himself to it. Beginning in 1997, it became difficult for the couple to lead a normal life because of constant gossip column rumors that both spouses were engaging in extra-marital affairs (Carolyn with Michael Bergin, John with Daryl Hannah). Additionally, tensions began to appear on a professional level—John and his partner Michael Berman argued vehemently about *George*'s content and Carolyn's influence on their decisions.

In June, John and Carolyn went on a second honeymoon. The trip improved their situation for a few months, but new tensions soon darkened the skies. Carolyn was deeply disturbed by the murder of her friend Gianni Versace, and John felt tarnished by the scandals surrounding his cousins Joe and Michael Kennedy. In September, 1997, he published a scathing editorial attack on that branch of the Kennedy family, from which his mother had successfully shielded him.

That fall, John tried to mend his problems with Carolyn, while receiving severe criticism for his editorial. Undeterred, he planned and executed a historic and unprecedented interview with Fidel Castro in Havana, over a five-hour lunch. John was stunned when the *Lider Maximo* told him he was an admirer of his father's, and that he had always regretted denying Lee Harvey Oswald a Cuban visa in October, 1963, for the visa could have stopped him from being in Dallas to commit murder in November of that year.

Though Carolyn had always disapproved of John's flying lessons, her concern was magnified by Michael Kennedy's death in a skiing accident in Aspen on December 31. "With all the bad things that happen to this family, John is the last person in the world who should be flying his own plane," she told a friend.

1998 brought the couple a newfound calm, with both John and Carolyn inarguably faring much better. They were frequently seen holding each other and kissing at dinners and benefits. In February, John and Carolyn attended a White House dinner in honor of British Prime Minister Tony Blair, giving Bill Clinton the opportunity to host the son of the man who had shaken his hand in the White House gardens in July, 1963.

In April, John got his pilot's license. Despite his constant invitations, none of his family members flew with him. His sister Caroline regularly reminded John that flying his own plane was a contradiction of his mother's final wishes. But John's passion for flying held the upper hand, and Caroline eventually gave up nagging him about it.

George occupied an increasing amount of John's time, largely due to the repercussions of the Lewinsky scandal and the release of several politically themed movies, such as Primary Colors and Thirteen Days. Revenue from the sale of advertising pages reached a record high of one million dollars for the April issue. By October, however, the trend had reversed and advertising sales collapsed, keeping John at the office late into the evenings and over the weekends. John eventually decided to take a trip to Italy to personally recruit advertisers, starting with the Milan designers.

In March, 1999, with rumors about their respective love lives circulating widely, John and Carolyn met with a marriage counselor. Their passionate, tumultuous relationship was naturally inclined to periods of extreme tension. John was also suffering emotionally as a result of his favorite cousin Anthony Radziwill's battle with cancer, which had been prolonged over ten years.

Every weekend, John and Carolyn returned separately to the family seat on Martha's Vineyard—John flying his plane to the island and Carolyn taking the ferry. While waiting for John at the island's small airport, Carolyn became friendly with Melissa Mathison, Harrison Ford's wife, who shared Carolyn's anxieties whenever Ford flew one of the three planes he kept in Hyannis Port. The two decided to take emergency landing courses in case their husbands should lose control of a plane while they were flying with them.

Rory Kennedy, one of John's cousins, was set to be married on July 17, 1999. At the time, Rory was a thirty-year-old documentary filmmaker who, like all the Kennedys, had had more than her fair share of personal tragedy—her father had been assassinated the year of her birth, her brother David had died of an overdose when she was only fifteen, and, most recently, her brother Michael had died at twenty-eight in a skiing accident on the slopes of Aspen.

John and Carolyn had planned to fly to Hyannis Port the night before the wedding. Lauren, one of Carolyn's sisters, was flying with the couple, but was not attending the wedding. John's plan was to drop Lauren in Martha's Vineyard on a "touch and go," and take off again for Hyannis Port, which was straight across the water.

Shortly after 8:00 PM, Carolyn and her sister Lauren joined John eighteen miles outside of Manhattan at Essex airport in New Jersey, where New York's wealthy inhabitants kept their private jets. Essex was where John kept his latest toy, a Piper Saratoga II HP, which he had acquired a few months earlier for $350,000.

John was just finishing going over his plane's checklist when his wife and sister-in-law arrived on the tarmac. At 8:38 PM, more than two hours after its scheduled departure, the plane took off and began to follow its course along the coast of Long Island, then northeast to Martha's Vineyard. With only about a hundred hours of flying experience, John was not a highly experienced pilot. Moreover, he had recently had a cast removed from his left leg. Contrary to what the weather forecast reported, visibility was low. A night landing in thick fog lay ahead, and John, who was not instrument qualified, was not yet ready to fly in those conditions. At 9:39 PM, the plane began its descent towards its first destination. It was at this point that the Federal Aviation Administration's air traffic controllers lost radio contact with the Piper Saratoga.

Lisa Ann, Lauren Bessette's twin sister, was the first to worry that the plane was late. Towards 10:00 PM, the Kennedy family called the control tower at the Hyannis Port airport, but the controllers there did not have any information for them. Minutes turned to hours. At 2:00 AM, Senator Ted Kennedy personally called the FAA. The officer on watch confirmed that the plane had indeed left New Jersey, but that it had dropped off the radar screens a few miles off the coast of Martha's Vineyard. Ted then contacted the U.S. Air Force, which is responsible for coordinating the search for lost aircraft.

At 2:15 AM, the FAA received a signal from a distress beacon, and immediately dispatched several aircraft and coast guard frigates to the area. A massive search effort followed.

Shortly before 7:00 AM, White House Chief of Staff John Podesta came to Bill Clinton's bedroom at Camp David, where the president was spending the weekend, to tell him that the "Kennedy heir" and his wife were missing. The president, who had always been close with the Kennedy family, was stunned. JFK had long been his role model, and upon taking office he had even requested to use Kennedy's desk. Bill Clinton asked to be kept informed of the

progress of the search efforts in real time, and requested that the Army help as well. He then called Ted Kennedy and John's sister Caroline, who had been tracked down while rafting in Colorado.

Though the Civil Air Patrol and the Coast Guard had dispatched most of their crafts to the area in question, the search remained fruitless. In Hyannis Port, concern was replaced with distress, and Rory's wedding was postponed. In the late morning while walking on Philbin beach, the McCarthys, a Boston couple, spotted a piece of luggage floating on the water. The bag's label clearly read Lauren Bessette. Around the same time, the rescue teams discovered the first wreckage from the plane, a landing wheel and a headrest. The terrible truth now had to be faced—the Piper Saratoga had gone down with its occupants. That Saturday morning, America was in a state of shock. In New York, hundreds of strangers came to lay flowers, tokens, and notes in front of John and Carolyn's apartment.

The distraught family did not give up hope until Monday night. Bill Clinton made a public statement. "For more than forty years now, the Kennedy family has inspired Americans families to public service, strengthened our faith in the future, and moved our nation forward. Through it all, they have suffered much and given more." On Wednesday afternoon, seven miles off the coast of Martha's Vineyard, an exhausted and very pale Ted Kennedy witnessed the recovery of the three bodies. Only John's body was autopsied, a procedure which confirmed that the cause of death was indeed the aircraft's impact with the water surface at a speed of nearly sixty miles per hour.

The Kennedy and Bessette families agreed to bury the crash's victims at sea, dispersing their ashes over the Atlantic. One significant reason for this choice was to maintain a level of intimacy, and to keep the ceremony out of sight of the hundreds of journalists who flocked to the area.

On Thursday morning, the destroyer *Briscoe* was requisitioned to carry the seventeen members of the immediate family to the crash site, where the contents of the three urns were dispersed into the waves. The next morning, in New York, three hundred fifteen handpicked guests, including Muhammad Ali, John Kenneth Galbraith, Arthur M. Schlesinger Jr., and the Clinton family attended the funeral mass at the Church of Saint Thomas More on 89th Street. The entire country was united in mourning its favorite son, the heir to the Kennedy myth, a young man who had always been expected to see a glorious destiny fulfilled, a son worthy of his father's legacy.

In his funeral oration, Senator Ted Kennedy said, "We dared to think that this John Kennedy would live to comb gray hair, with his beloved Carolyn by his side. But like his father, he had every gift but length of years."

"Now my wife and I prepare for a new Administration, and for a new baby."

JFK, November 9, 1960, at his first press conference, given in Hyannis Port, after being elected president

December 8, 1960 / Washington, DC / Jackie Kennedy poses with her son John F. Kennedy Jr. after his baptism.

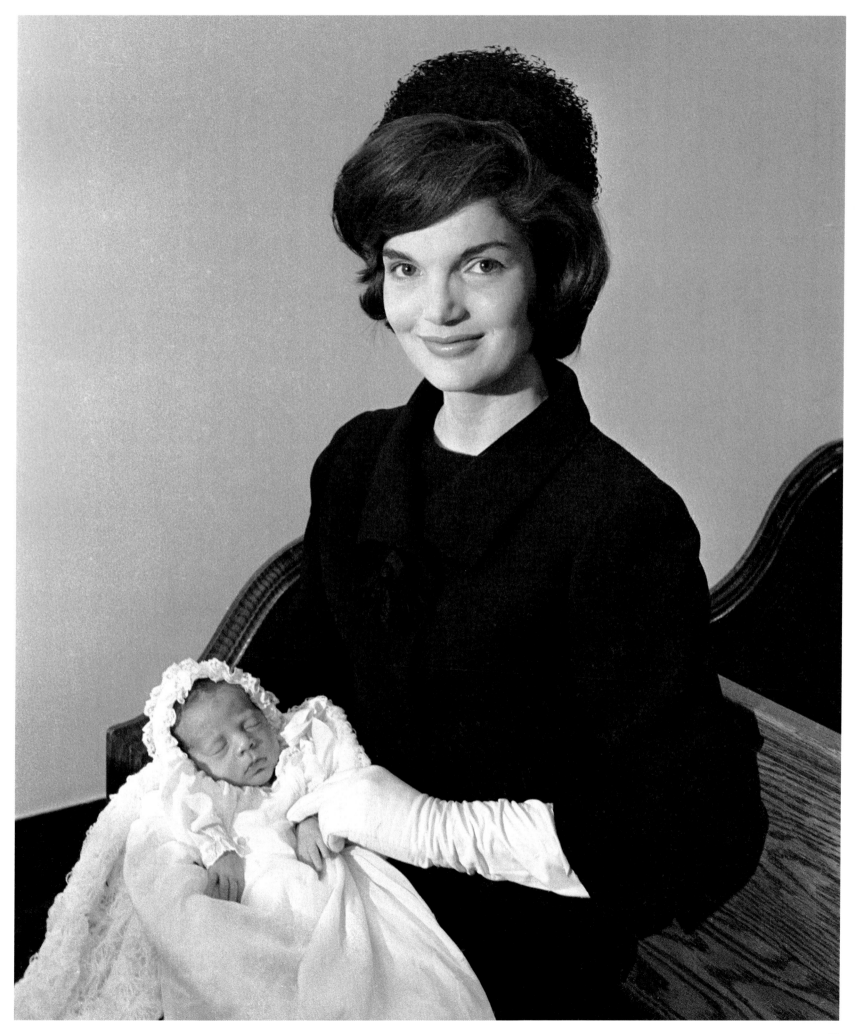

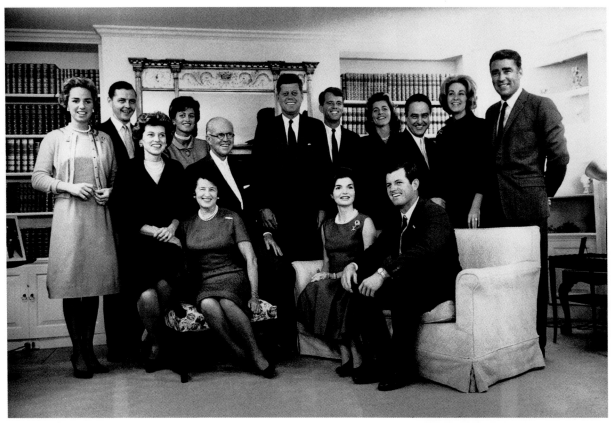

November 9, 1960 / Hyannis Port, MA / Portrait of the Kennedy clan in Hyannis Port the day after John F. Kennedy's victory in the presidential election. Seated, left to right: Eunice Shriver, Rose Kennedy, Joseph Kennedy, Jacqueline Kennedy, and Ted Kennedy. Back row, left to right: Ethel Kennedy, Stephen Smith, Jean Smith, John F. Kennedy, Robert F. Kennedy, Pat Lawford, Sargent Shriver, Joan Kennedy, and Peter Lawford.

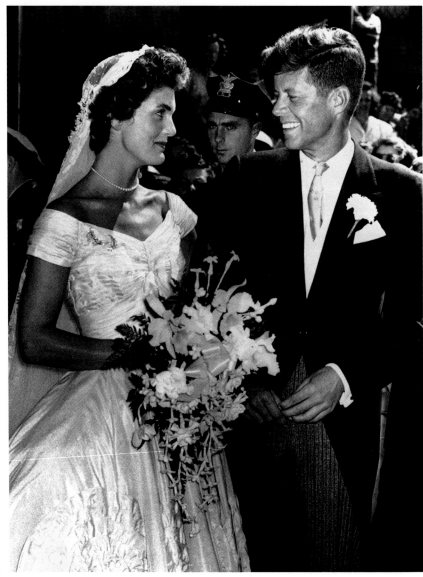

September 12, 1953 / Newport, RI / Wedding of John and Jackie Kennedy.

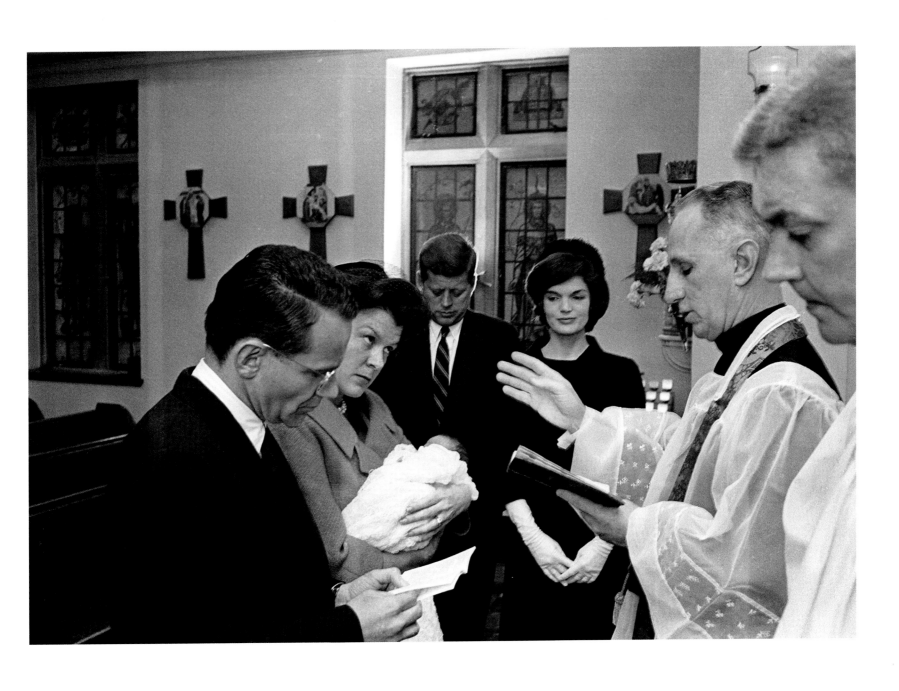

December 8, 1960 / Washington, DC / John F. Kennedy, who has just been elected president, and his wife Jackie baptizing their son John Jr. in the chapel of Georgetown Hospital. The godfather and godmother, standing near the child, are Mr. and Mrs. Charles L. Bartlett.

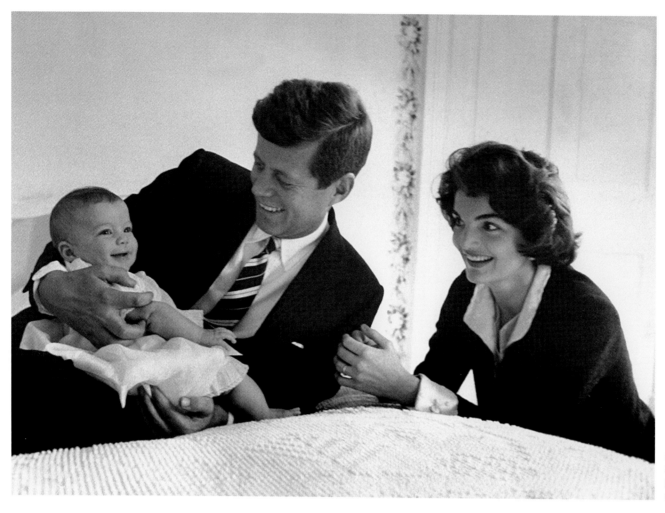

March 25, 1958 / Georgetown, DC / Senator John Kennedy and his wife Jackie pose in their bedroom with their daughter Caroline, age four months.

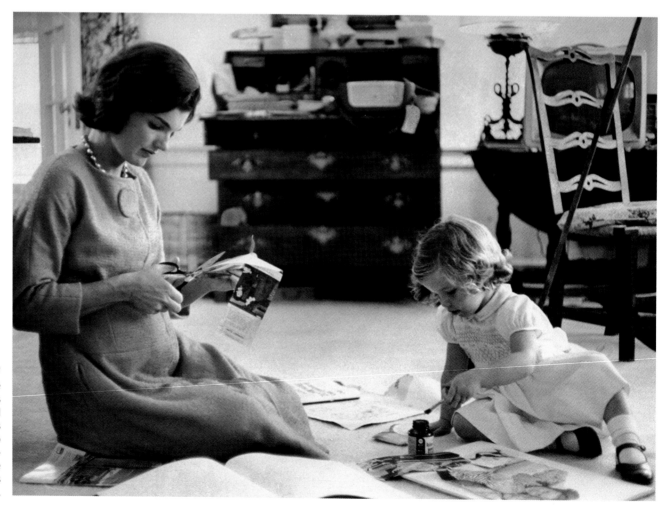

September 13, 1960 / Hyannis Port, MA / Sitting on the living room rug, Jackie Kennedy cuts out press about her husband Senator John F. Kennedy, and pastes them in an album. Seated next to her is her daughter Caroline, two-and-a-half, playing with the glue pot. Jackie is seven months pregnant with John Kennedy Jr.

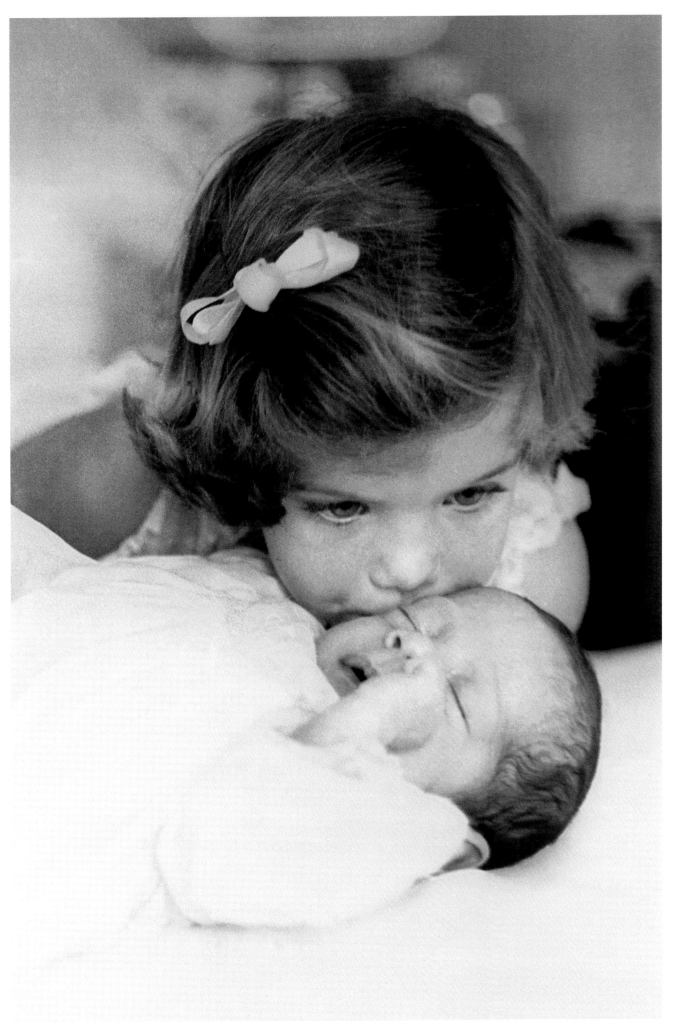

February 13, 1961 / Palm Beach, FL /
Caroline kisses her baby brother
John Jr. This photo was taken in Palm
Beach, where the family was living
in the period leading up to John F.
Kennedy's inauguration, at the age of
forty-three, as thirty-fifth president of
the United States .

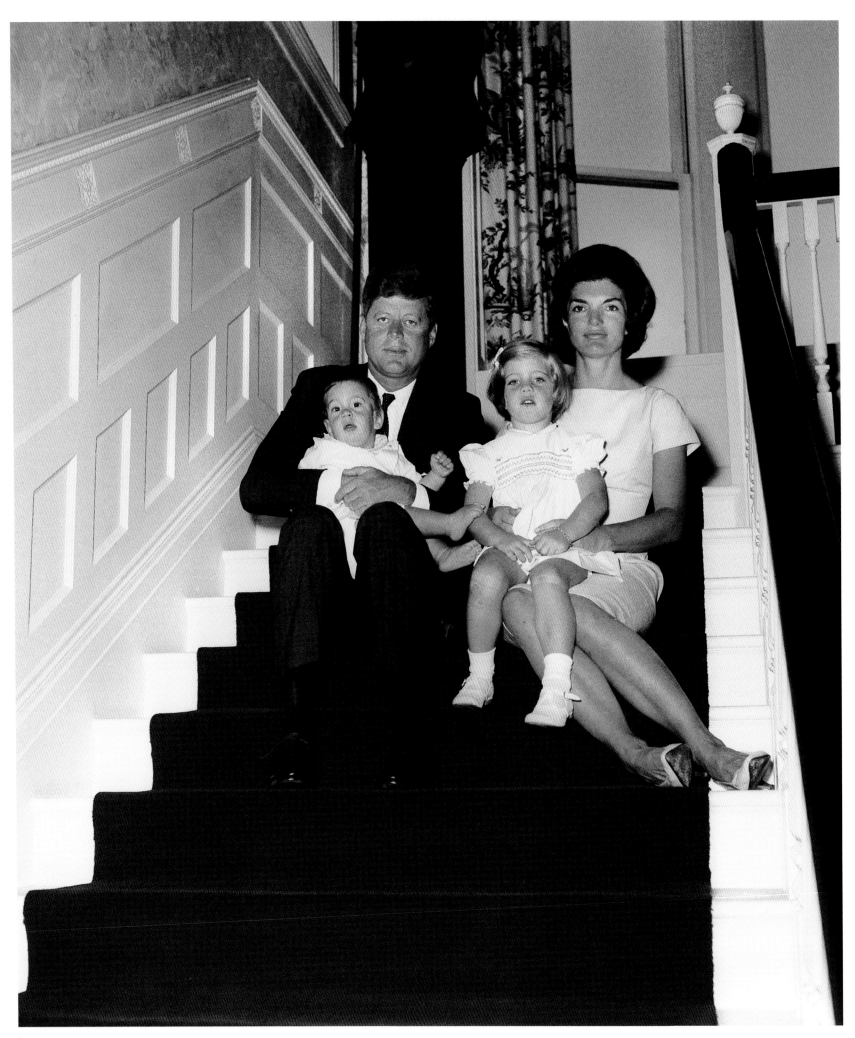

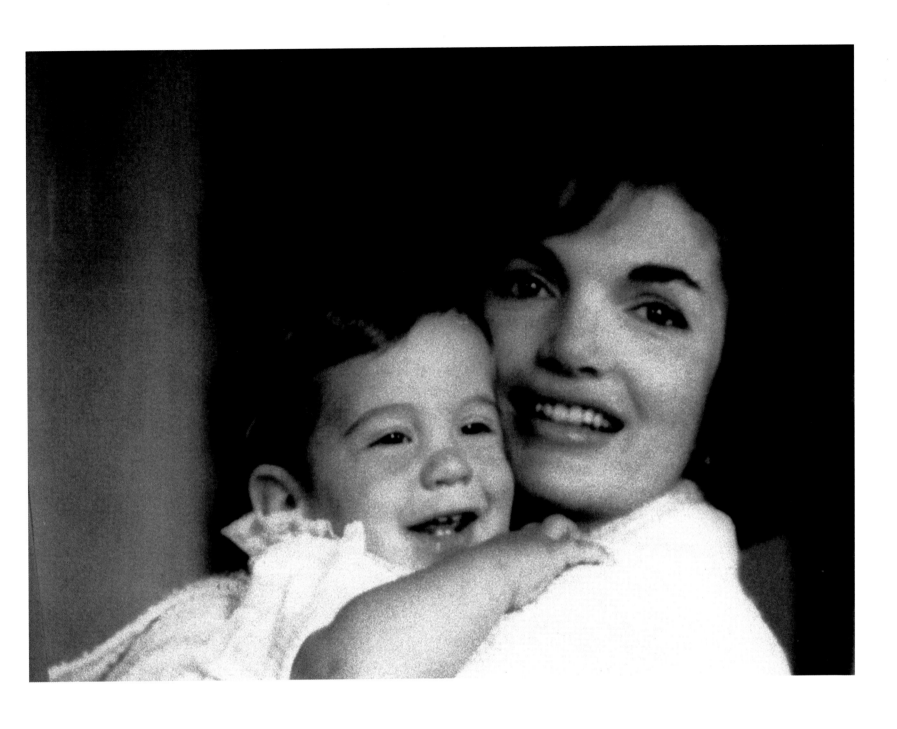

September 28, 1961 / Newport, RI / The Kennedys pose with their children, John Jr. and Caroline.

October, 1961 / Washington, DC / Portrait of Jackie Kennedy and her son John Kennedy Jr., age eleven months.

November 16, 1961 / Washington, DC /
Portrait of one-year-old John
Kennedy Jr., posing in his room.

May 17, 1962 / Washington, DC /
Portrait of John Jr. in his stroller,
age seventeen months.

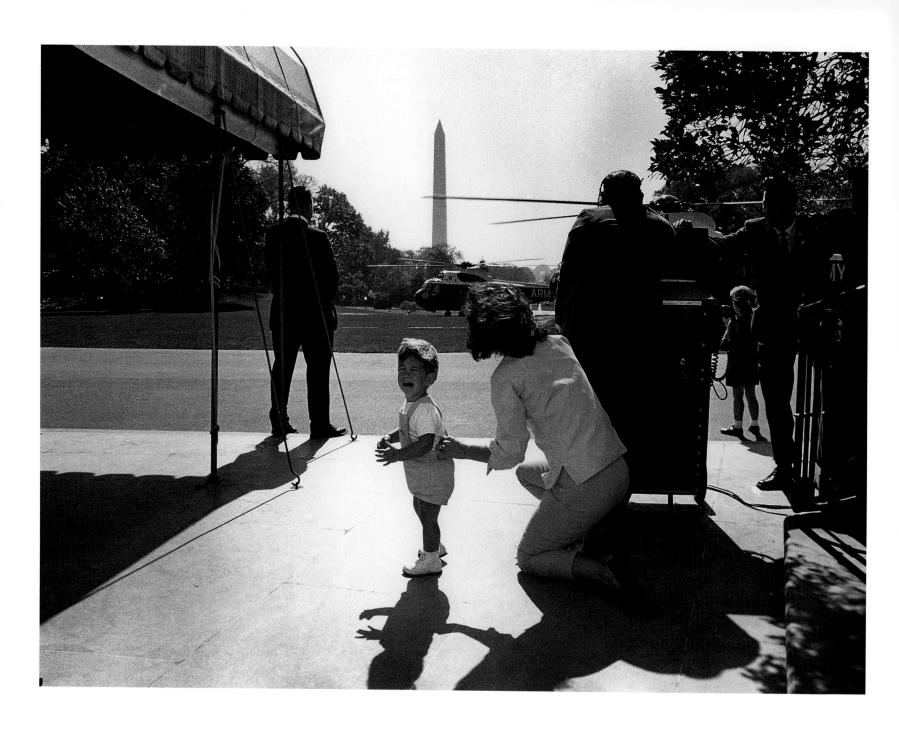

October 11, 1962 / Washington, DC / John Jr. cries after his father leaves on the presidential helicopter. Though he loved to play in the helicopter, John Jr. was generally terrified by the sound of its blades, and burst into tears every time it took off from the White House.

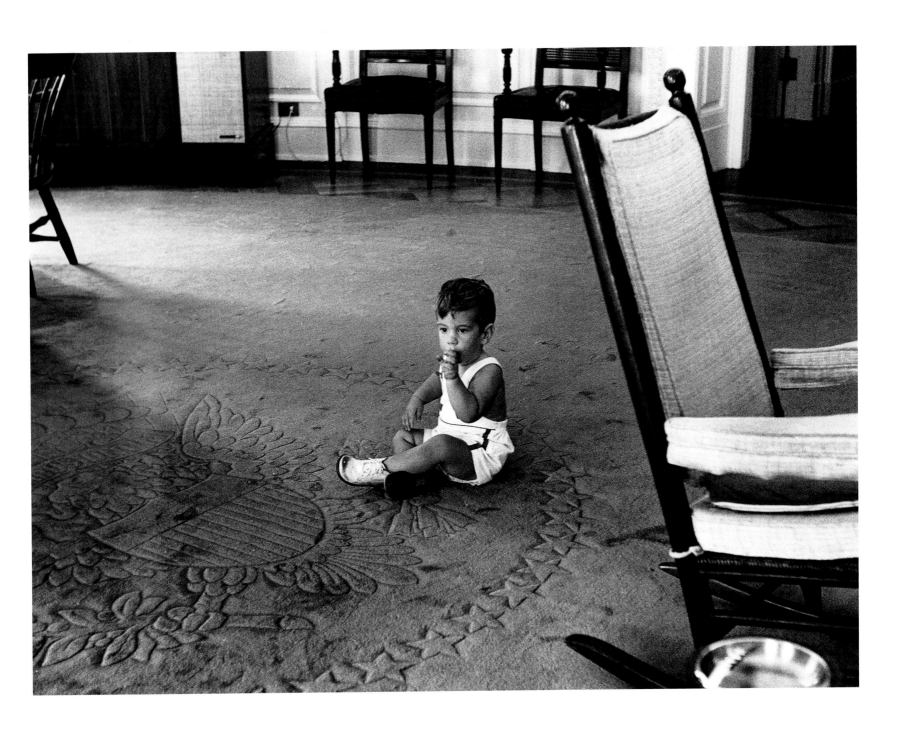

May 22, 1962 / Washington, DC / John Jr. sucks his thumb as he sits on the Oval Office carpet that bears the presidential seal.

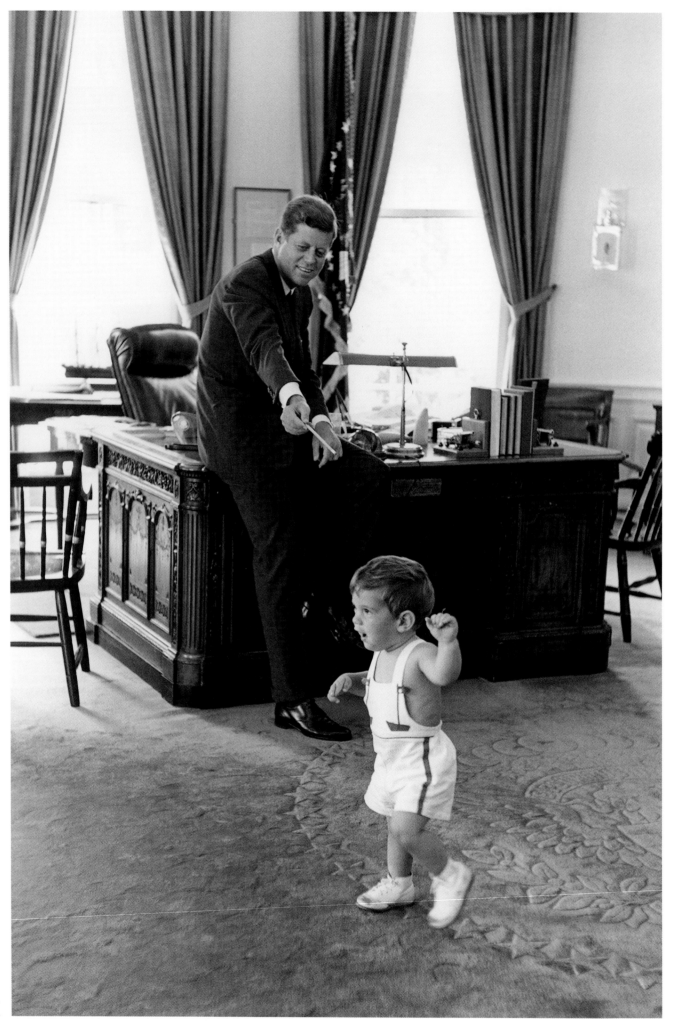

May 25, 1962 / Washington, DC /
President Kennedy plays with his son
John Jr. in the Oval Office.

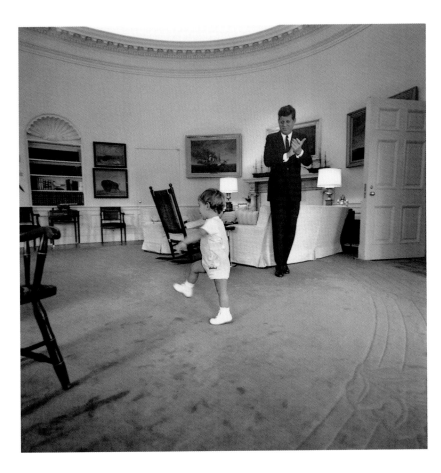
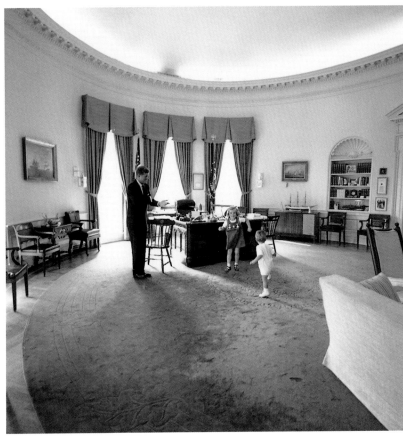
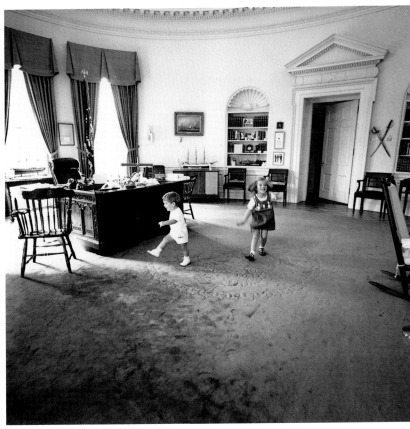
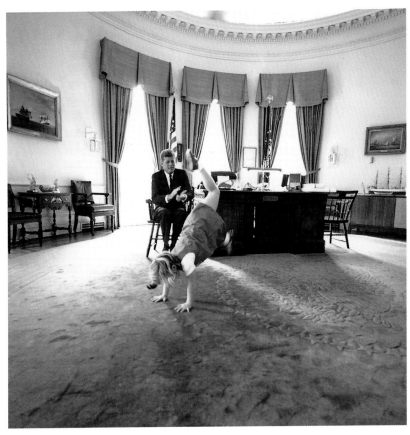

October 10, 1962 / Washington, DC / President Kennedy claps his hands as his children play in the Oval Office.

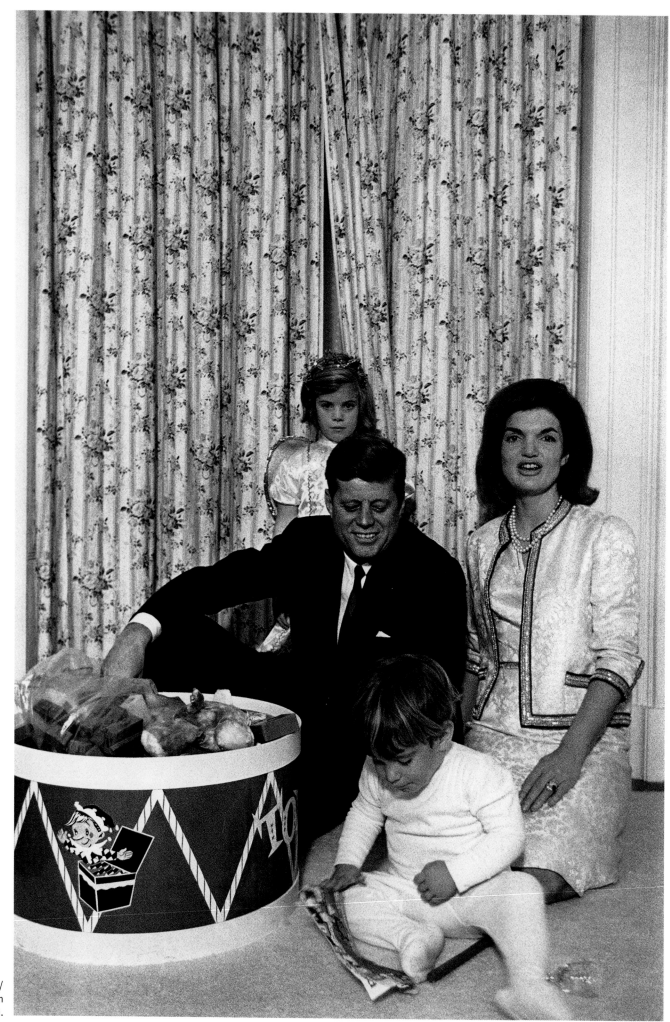

November 25, 1962 / Washington, DC /
Family photo taken
in John Jr.'s room.

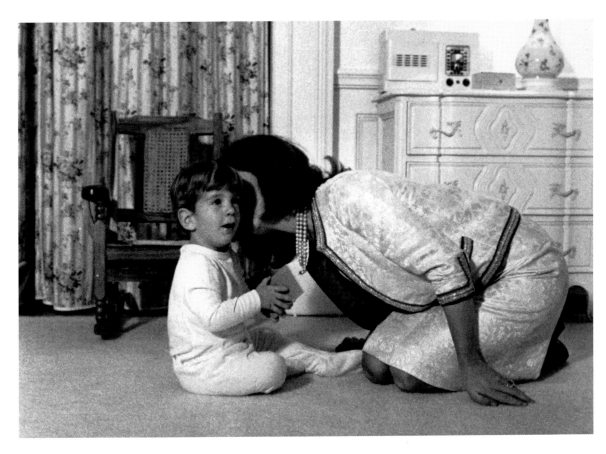

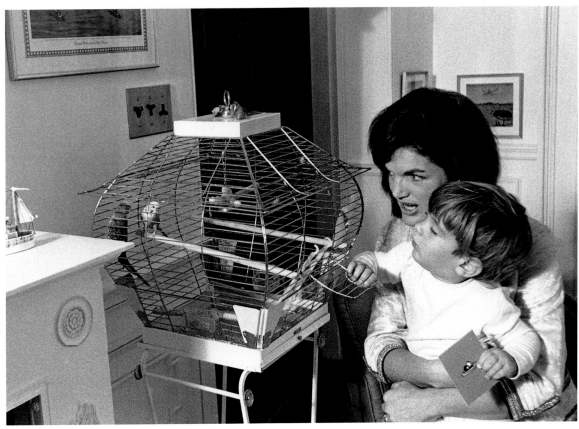

August, 1962 / Washington, DC / John Jr. and Jackie Kennedy in the nursery she had installed in the White House.

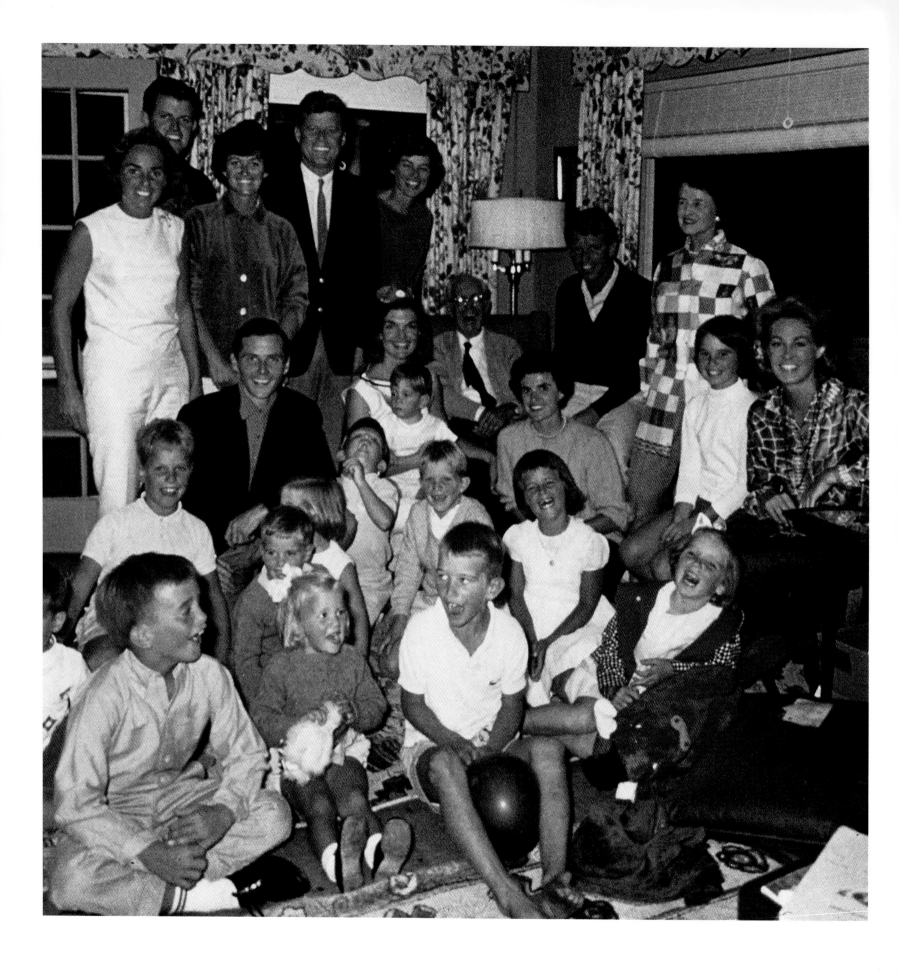

September 8, 1962 / Hyannis Port, MA / Kennedy clan reunion for the birthday of patriarch Joseph P. Kennedy. Standing, from left to right: Ethel Skakel Kennedy, Edward Kennedy, Jean Kennedy Smith, President John F. Kennedy, and Eunice Kennedy Shriver. Kneeling and sitting in the center from left to right: Stephen Smith, Jacqueline Kennedy (holding John Jr.), Joseph P. Kennedy, Anne Gargan, Robert Kennedy, Rose Kennedy, Kathleen Hartington Kennedy, and Joan Bennett Kennedy. In the foreground: the Kennedy, Shriver and Smith children.

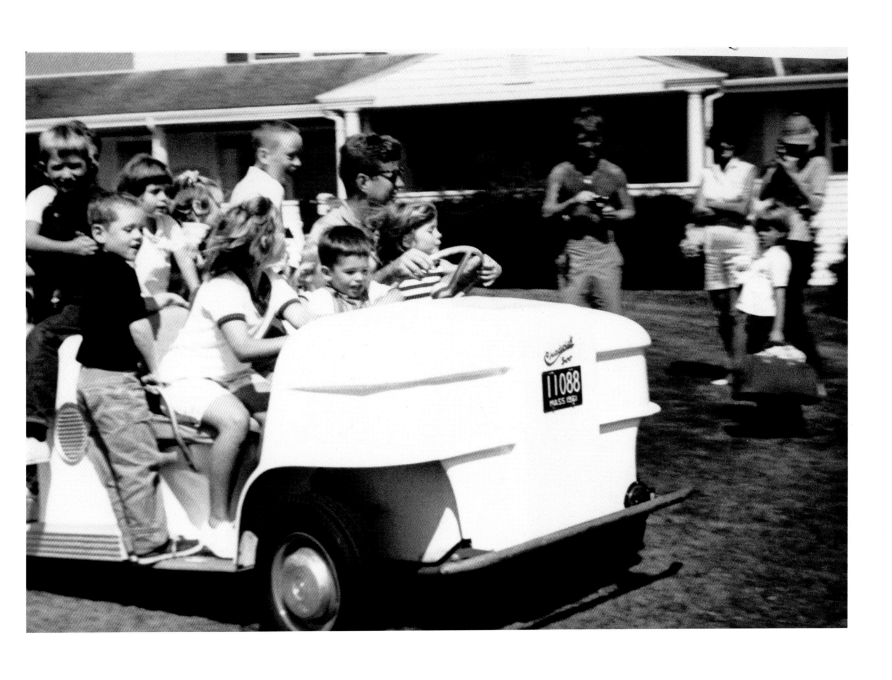

September 3, 1962 / Hyannis Port, MA / President Kennedy takes his gleeful children, and his nephews and nieces, on a golf cart ride.

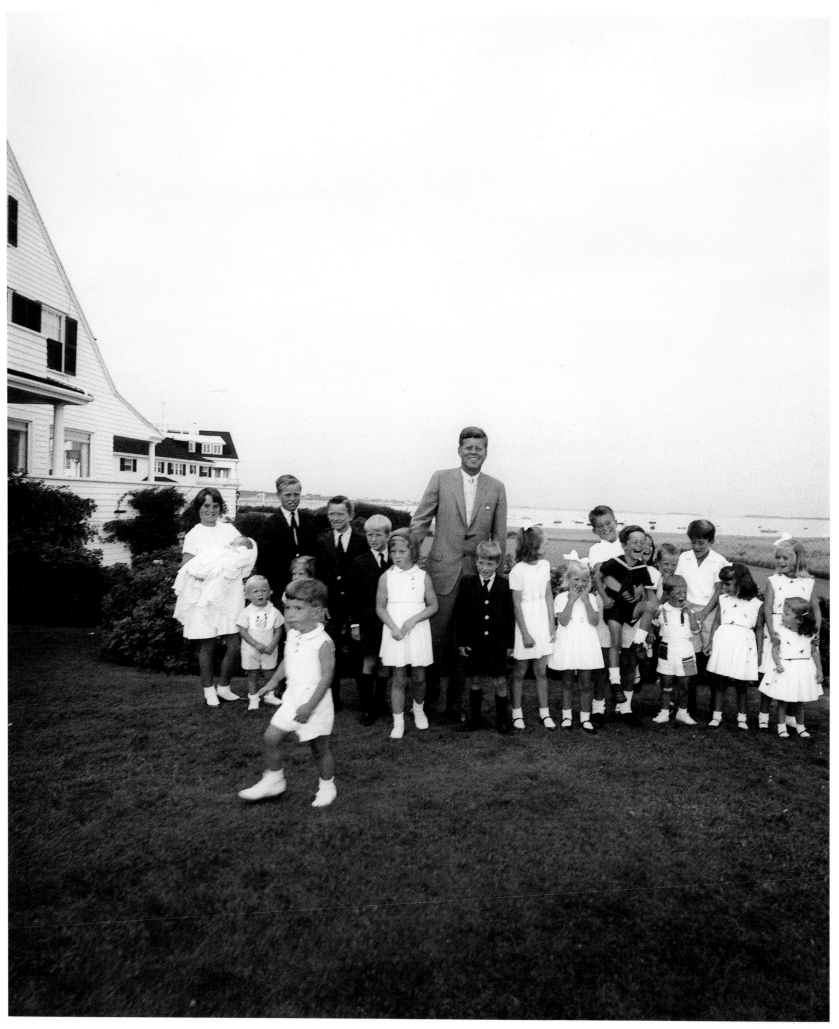

August 3, 1963 / Hyannis Port, MA / President Kennedy poses with the Kennedy clan children during a family reunion. From left to right: Kathleen Kennedy, holding Christopher Kennedy, Joseph Kennedy. In front of Kathleen and Joseph: Ted Kennedy Jr. and Kara Kennedy (partially hidden). To her right: Robert Kennedy Jr., David Kennedy, Caroline Kennedy, President Kennedy, Michael Kennedy, Courtney Kennedy, Kerry Kennedy, Bobby Shriver, holding Tim Shriver (wearing a sailor suit), Maria Shriver (partially hidden), Steve Smith Jr. In front of Steve Smith Jr.: William Smith (crying), Chris Lawford, Victoria Lawford, Sydney Lawford. In front of Sydney Lawford: Robin Lawford. In the foreground, moving away from the group: John Kennedy Jr.

August 26, 1962 / Newport, RI / President Kennedy, in the pool, tries to teach his son to dive. John Jr.'s nanny Maud Shaw is standing to his right, wearing a white dress and holding a towel.

March 31, 1963 / Camp David, MD / John Jr. takes the controls of the presidential helicopter.

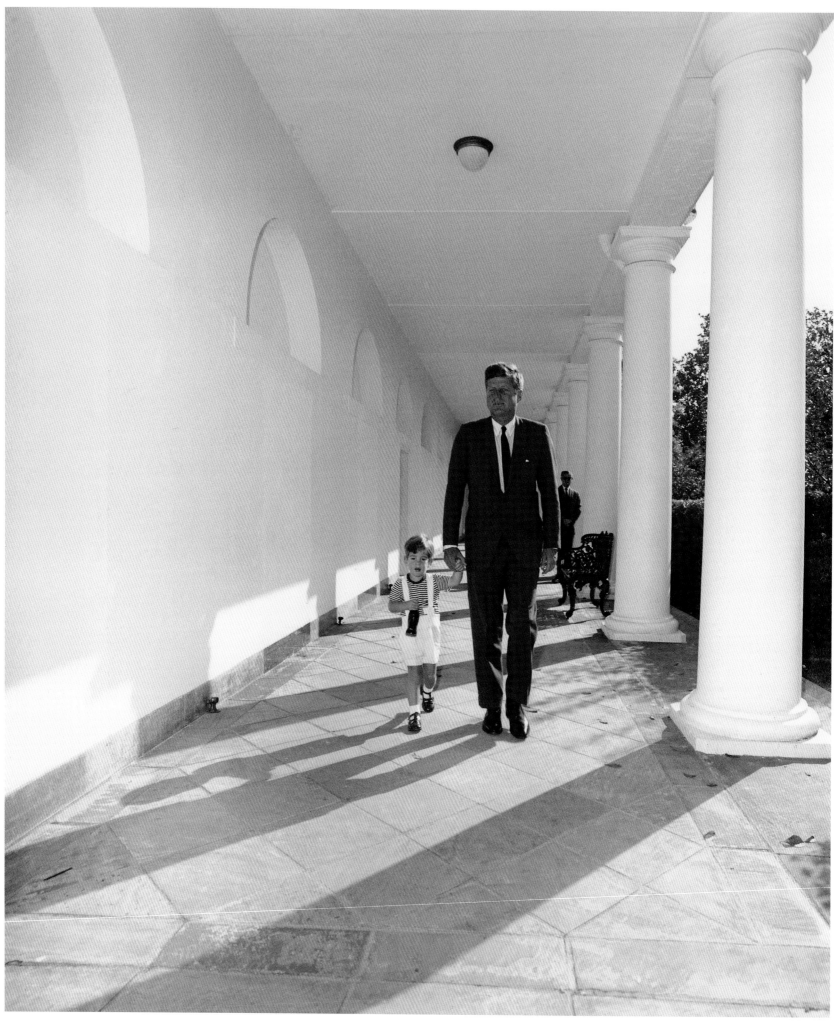

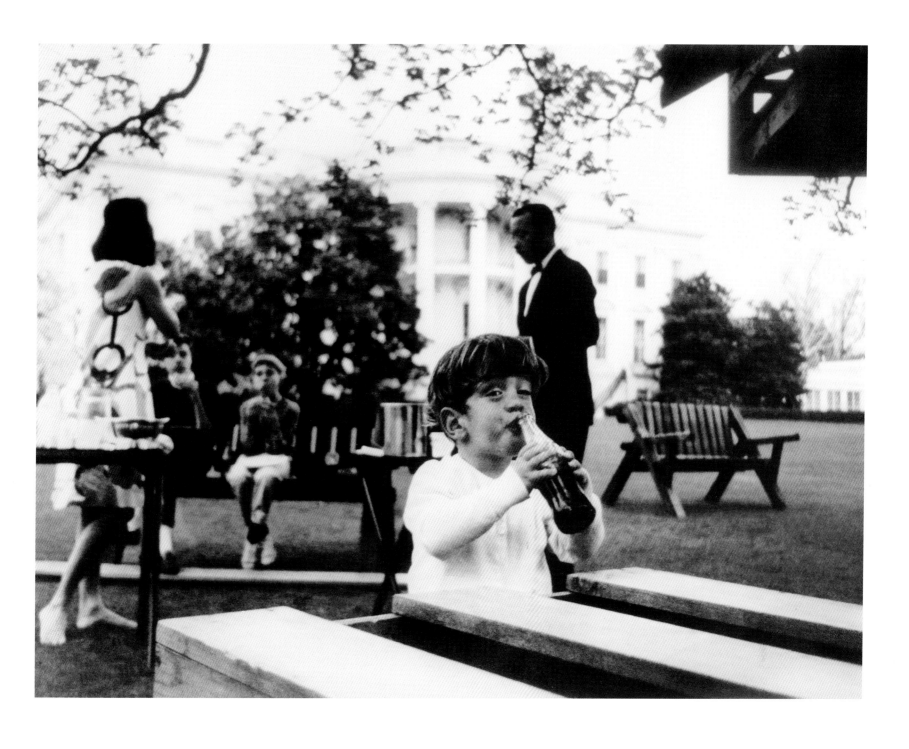

October 7, 1963 / Washington, DC / President Kennedy and his son John Jr. under the columns of the White House's West Wing.

April 4, 1963 / Washington, DC / John Jr. enjoys a Coca-Cola during a children's party on the White House's South Lawn.

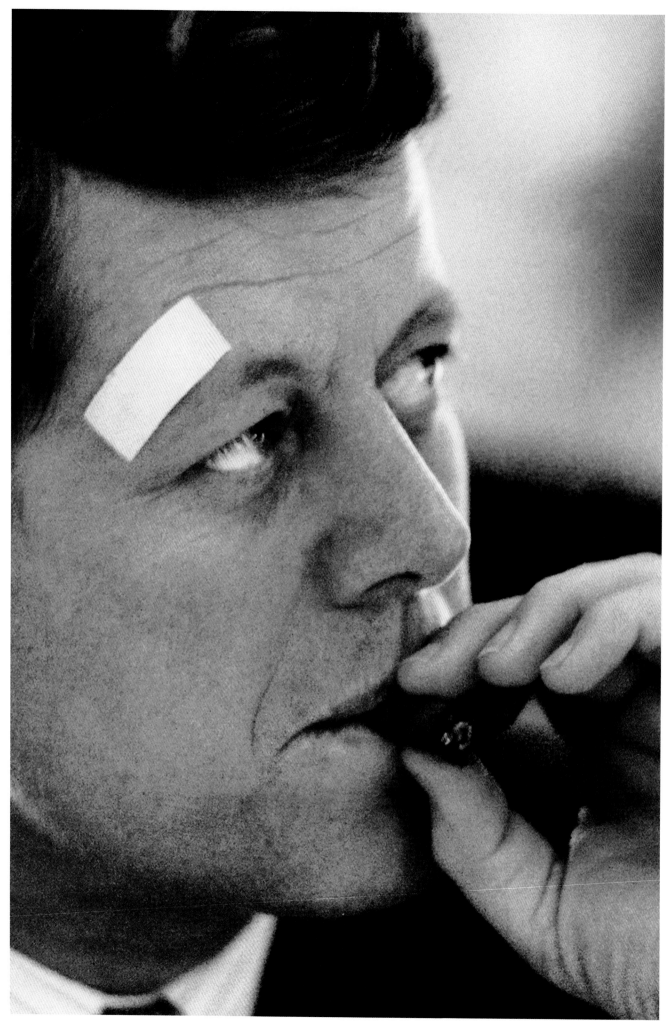

1961 / Washington, DC / President John F. Kennedy cut his forehead by bumping it against his desk while picking up a toy for his daughter Caroline.

February, 1963 / Palm Beach, FL / John Jr. plays with a plastic gun at snack time.

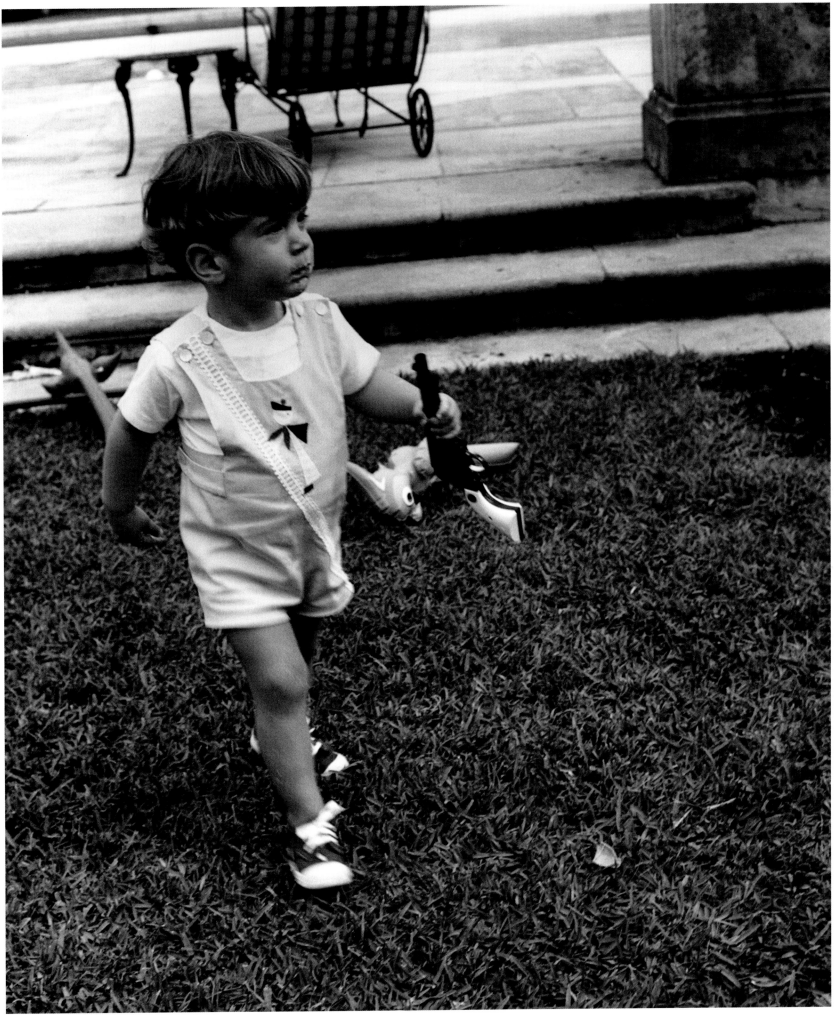

"He comes spitting in my room, jabbing left and right,

Shouting, OK, Caroline, ready for a fight?

He is trying to blow us up with his chemistry set,

He has killed all the plants but we've escaped as yet.

He loves my mother's linen sheets and hates his own percale.

He can imitate the sounds of a humpback whale.

I love him not just because I oughter.

But also because blood runs thicker than water."

In 1971, Caroline wrote this poem about her brother John as a Christmas gift to her grandmother Rose Kennedy

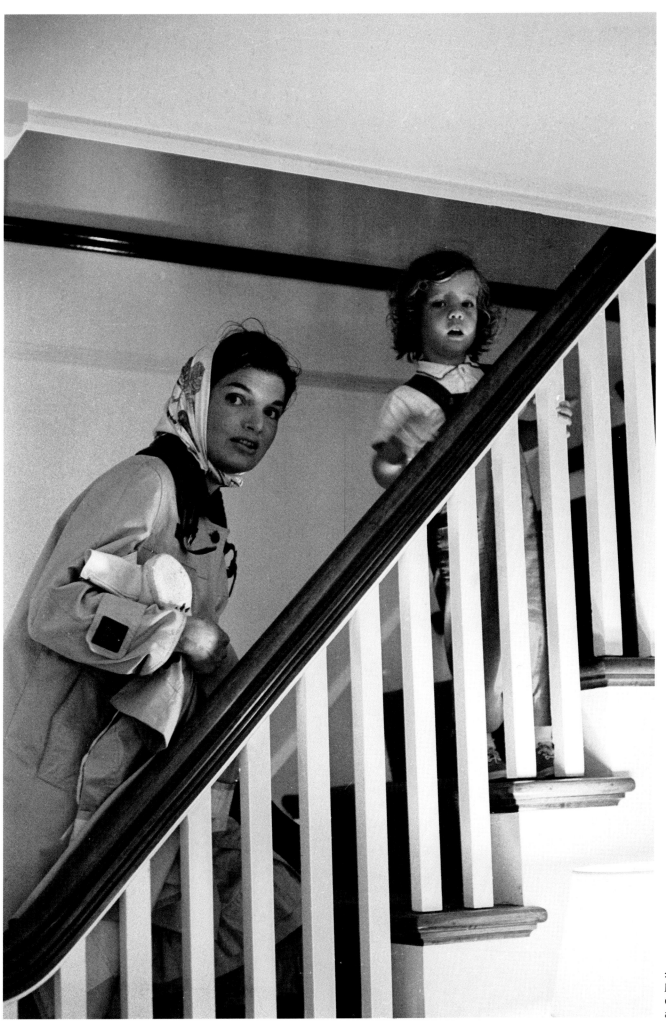

1962 / Hyannis Port, MA /
Jackie and her daughter Caroline
climb the staircase to the bedrooms
after a walk on the beach.

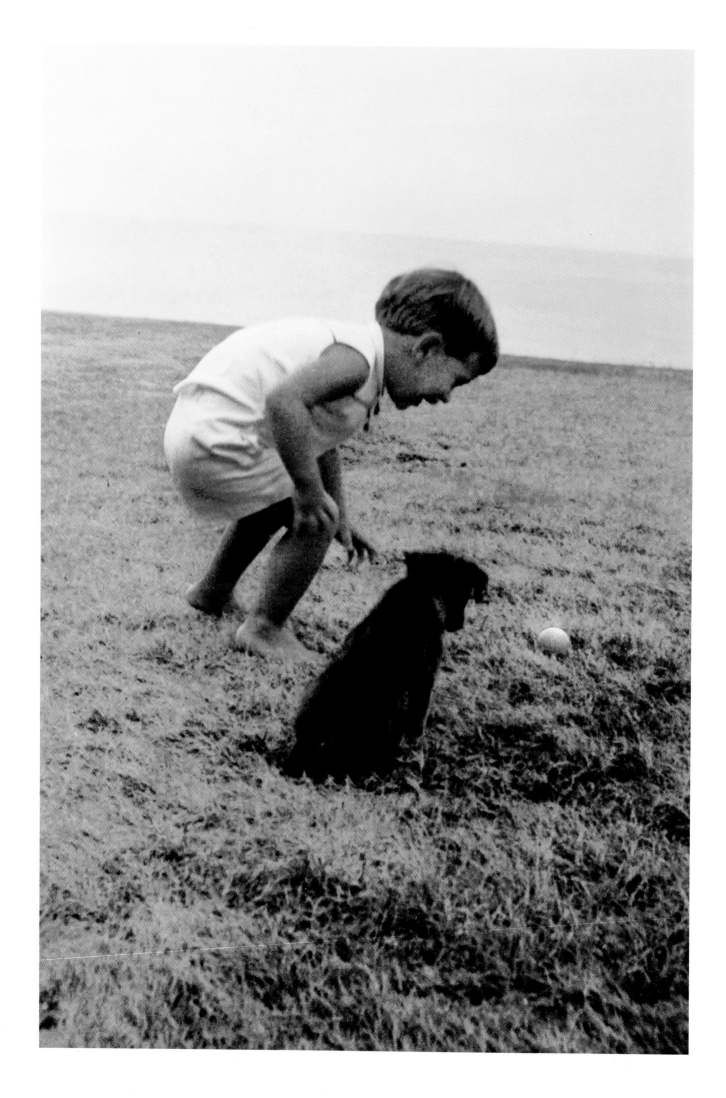

August 3, 1963 / Hyannis Port, MA / John Jr. and Caroline play with their dogs on the lawn of the family home, where the Kennedy clan gathered on weekends.

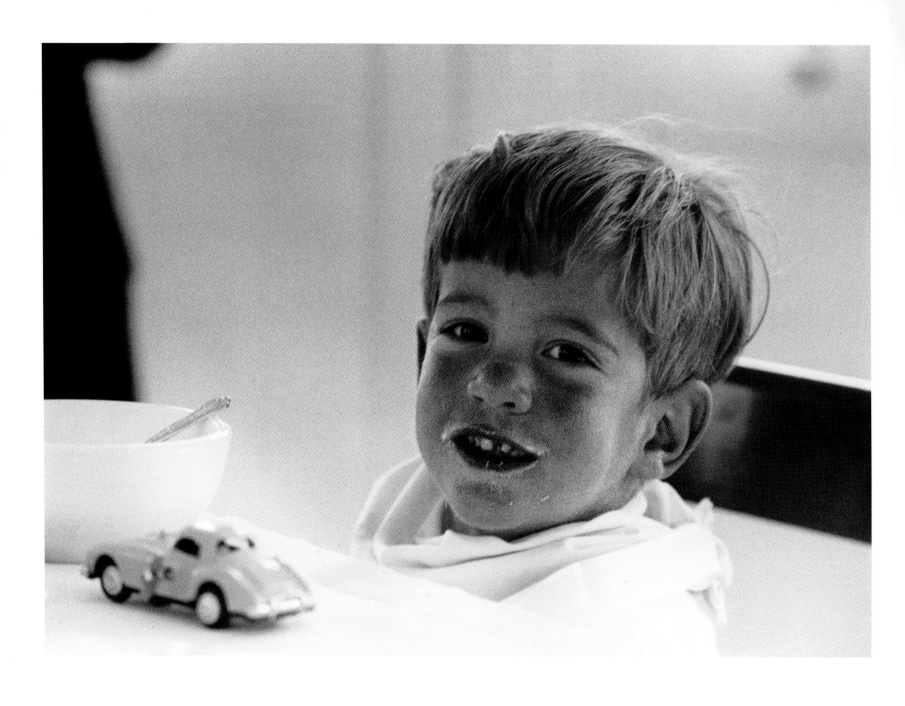

August 31, 1963 / Hyannis Port, MA / Portrait of John Jr., age two-and-a-half.

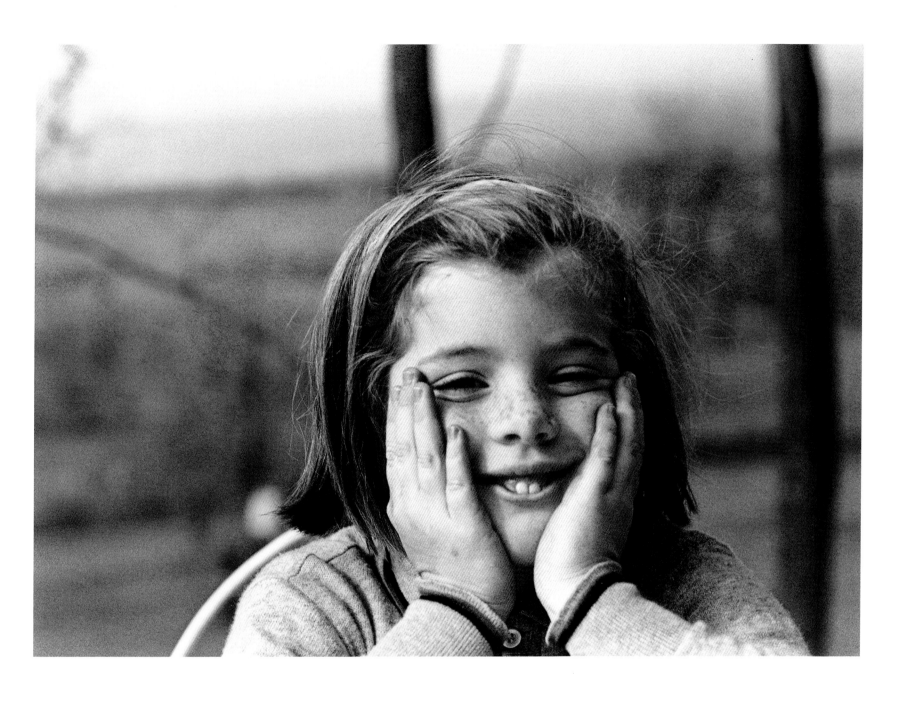

November 10, 1963 / Hyannis Port, MA / Portrait of Caroline Kennedy, age six.

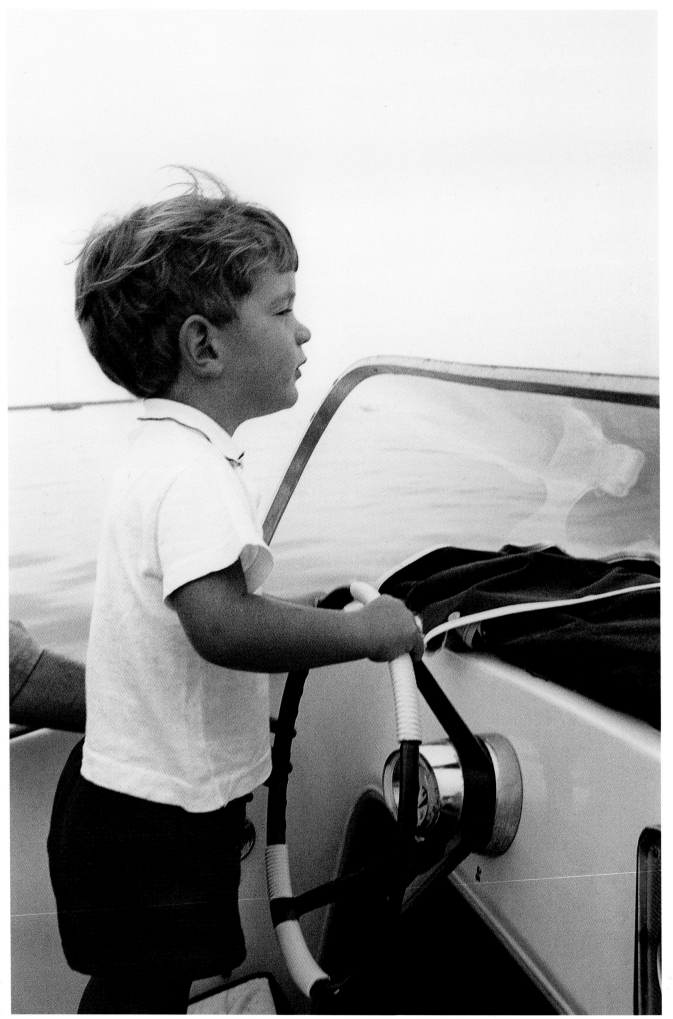

August 31, 1963 / Hyannis Port, MA / John Jr. takes the controls of a motor boat during a family weekend in Hyannis Port.

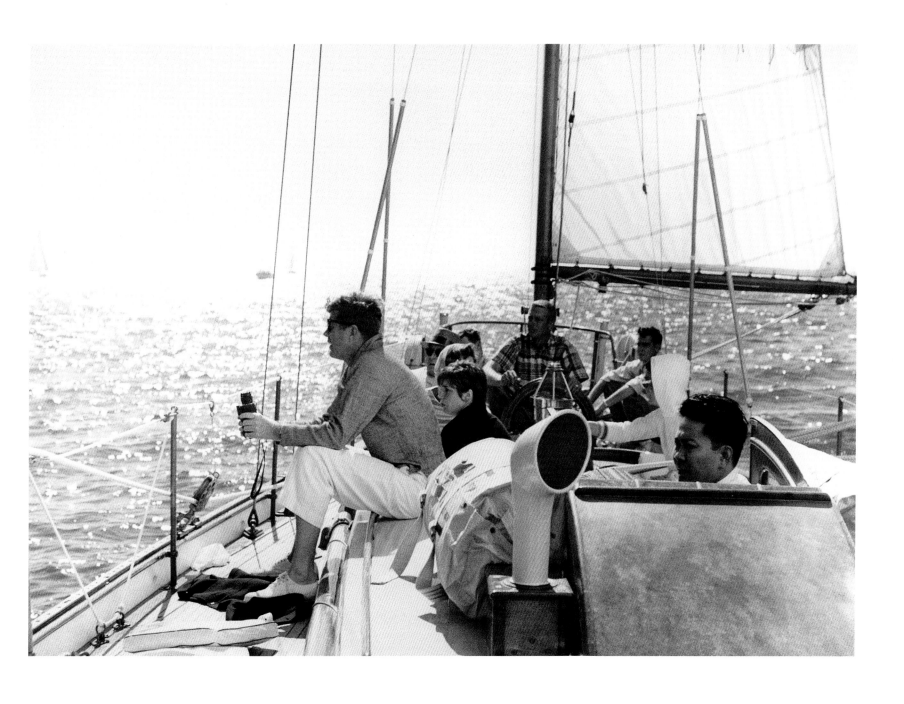

September 9, 1962 / Hyannis Port, MA / President Kennedy takes advantage of a weekend off to do some sailing on the bay at Hyannis Port.

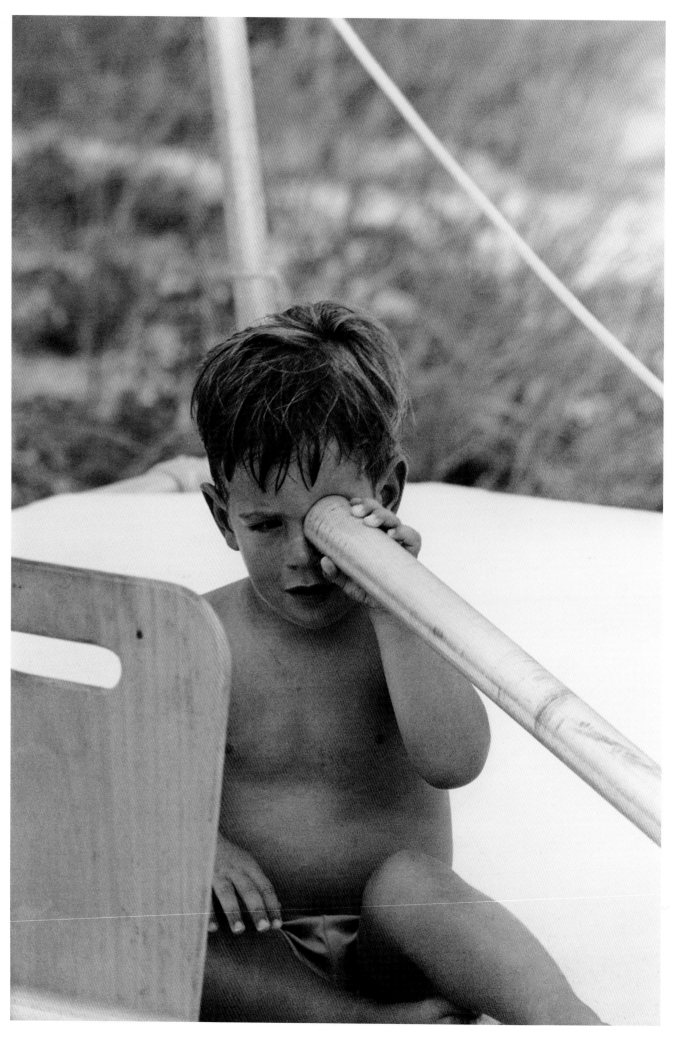

August 31, 1963 / Hyannis Port, MA/
John Jr. having fun on Labor Day
weekend.

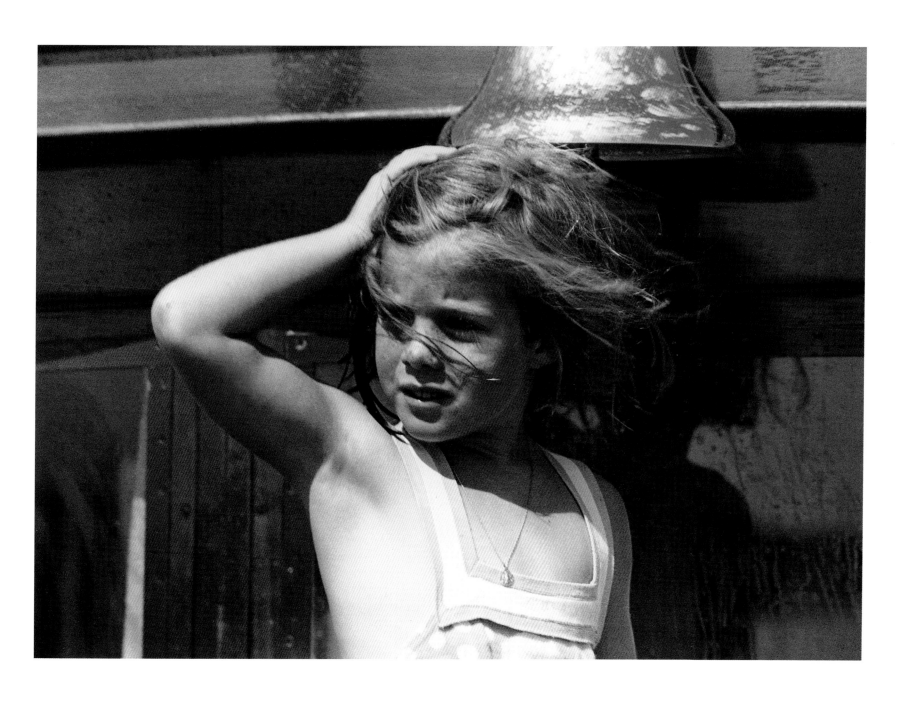

August 31, 1963 / Hyannis Port, MA / Portrait of Caroline Kennedy on the deck of their boat, *Honey Fitz*, on Labor Day weekend.

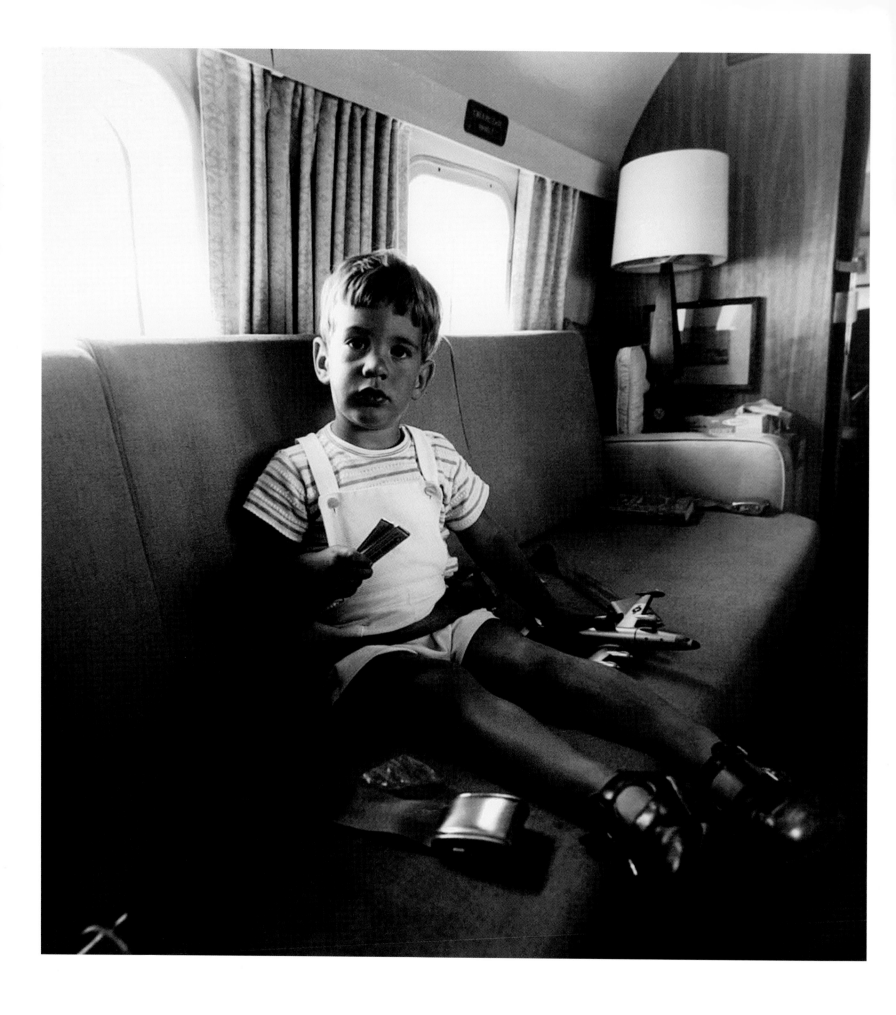

August 13, 1963 / Camp David, MD / John Jr. aboard the helicopter bringing the Kennedy family back to the White House.

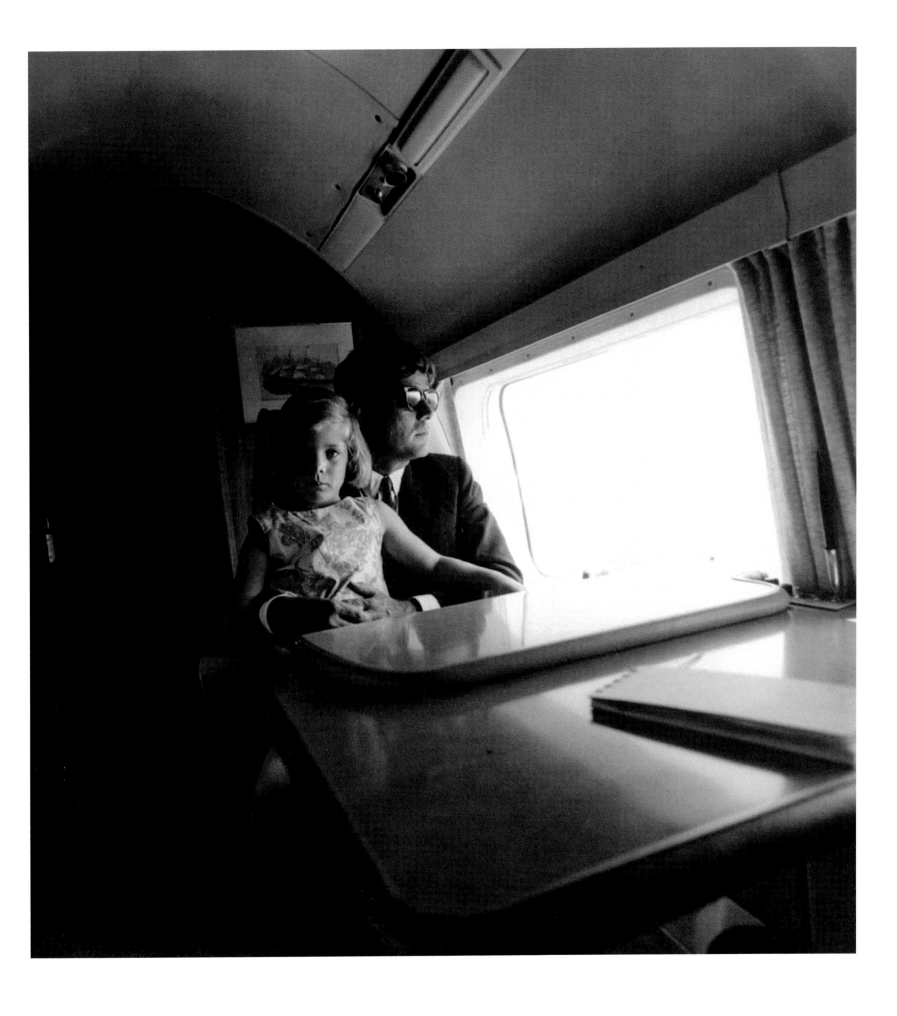

August 13, 1963 / Camp David, MD / Caroline Kennedy on her father's lap, aboard Air Marine One.

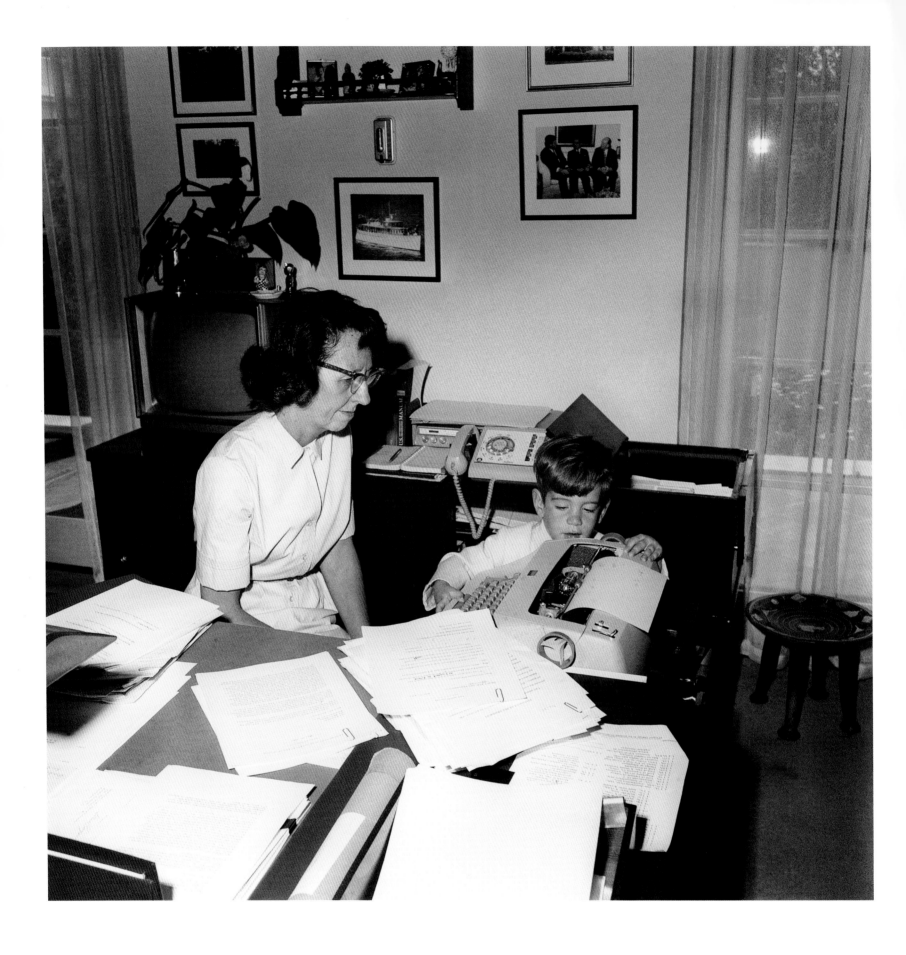

May 30, 1963 / Washington, DC / John is intrigued by the typewriter used by Evelyn Lincoln, President Kennedy's personal secretary.

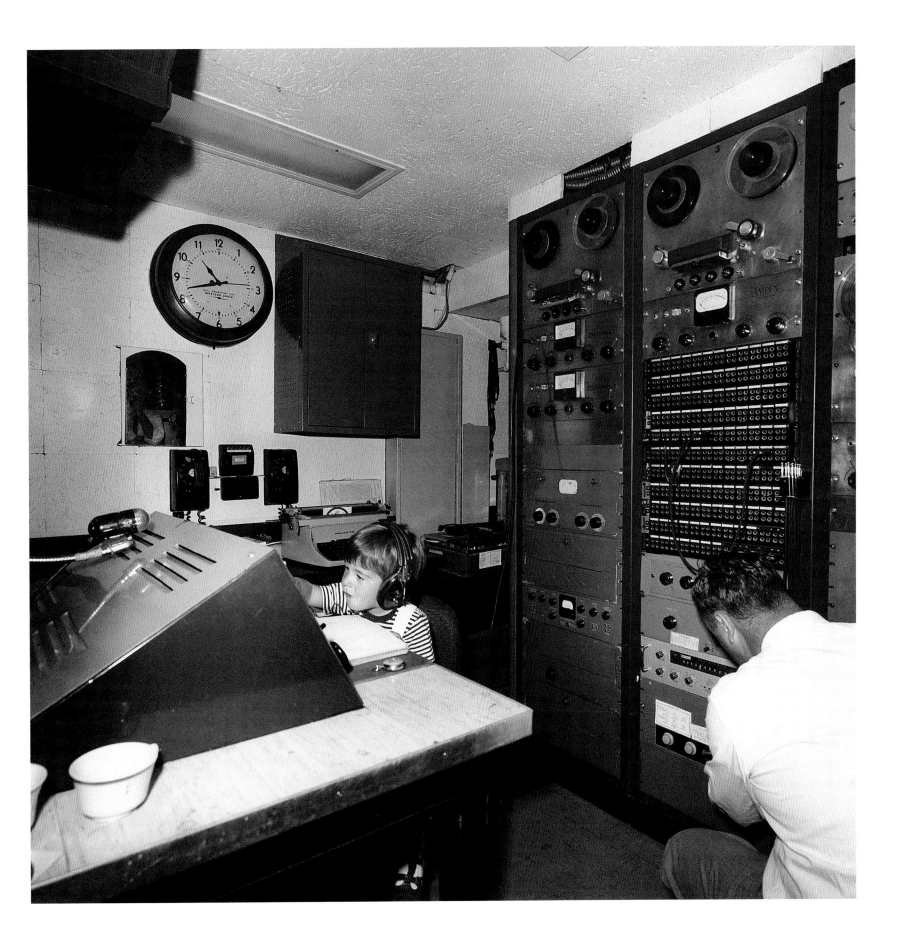

October 9, 1963 / Washington, DC / John Jr. plays with the computer buttons in the White House's video room.

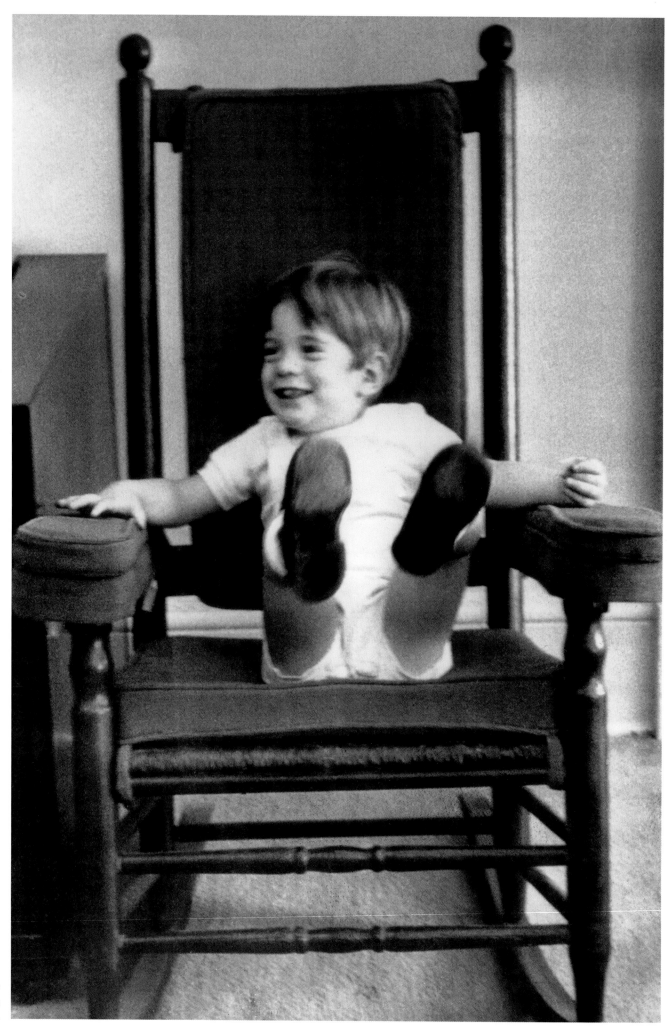

October 14, 1963 / Washington, DC /
John Jr. plays with his father's
rocking chair.

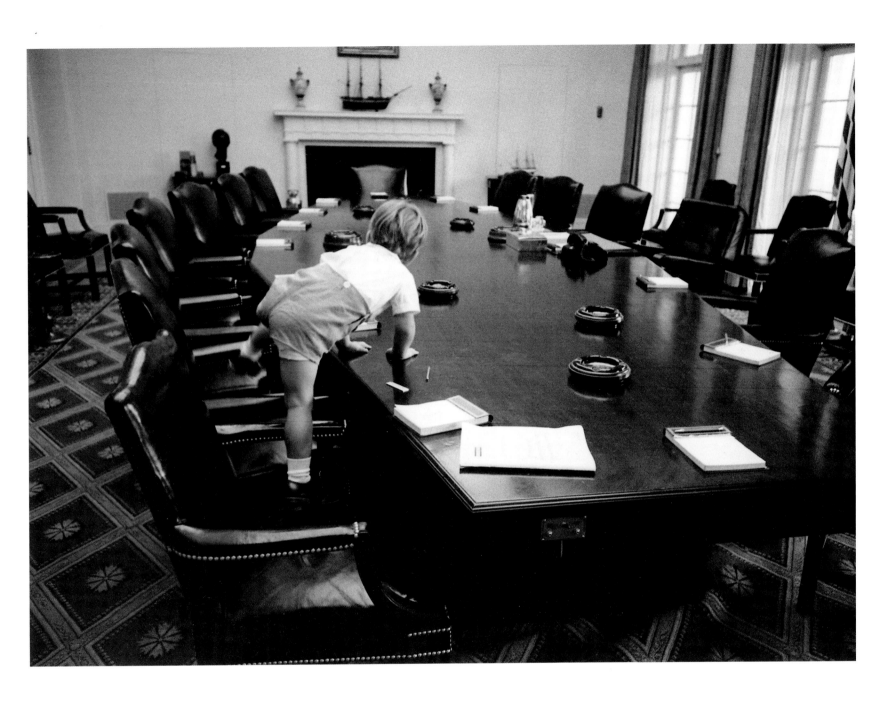

October 14, 1963 / Washington, DC / John Jr. climbs onto the table in the White House conference room. During the Cuban Missile Crisis a year earlier, President Kennedy had gathered the Executive Committee around this very table.

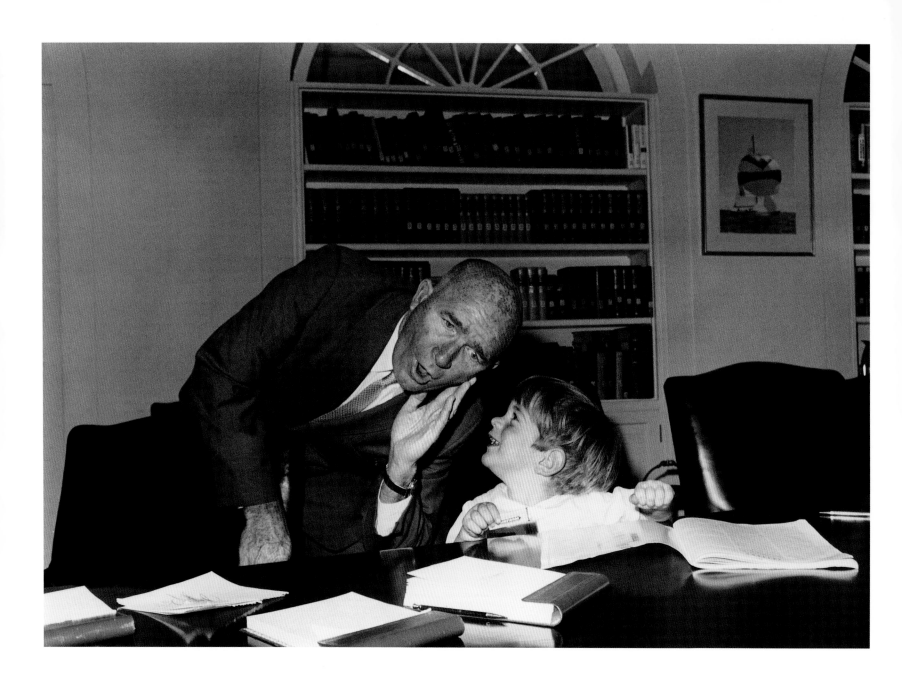

October 10, 1963 / Washington, DC / John Jr. playing with David F. Powers, President Kennedy's personal adviser, in the White House. David Powers joined John F. Kennedy's electoral campaign in 1946, when JFK was running for Congress, and the two men had formed a solid friendship. Powers resigned his post at the White House in 1965, and, at the request of Senator Robert Kennedy, became the first curator of the John F. Kennedy Presidential Library, where he remained until his retirement in 1994.

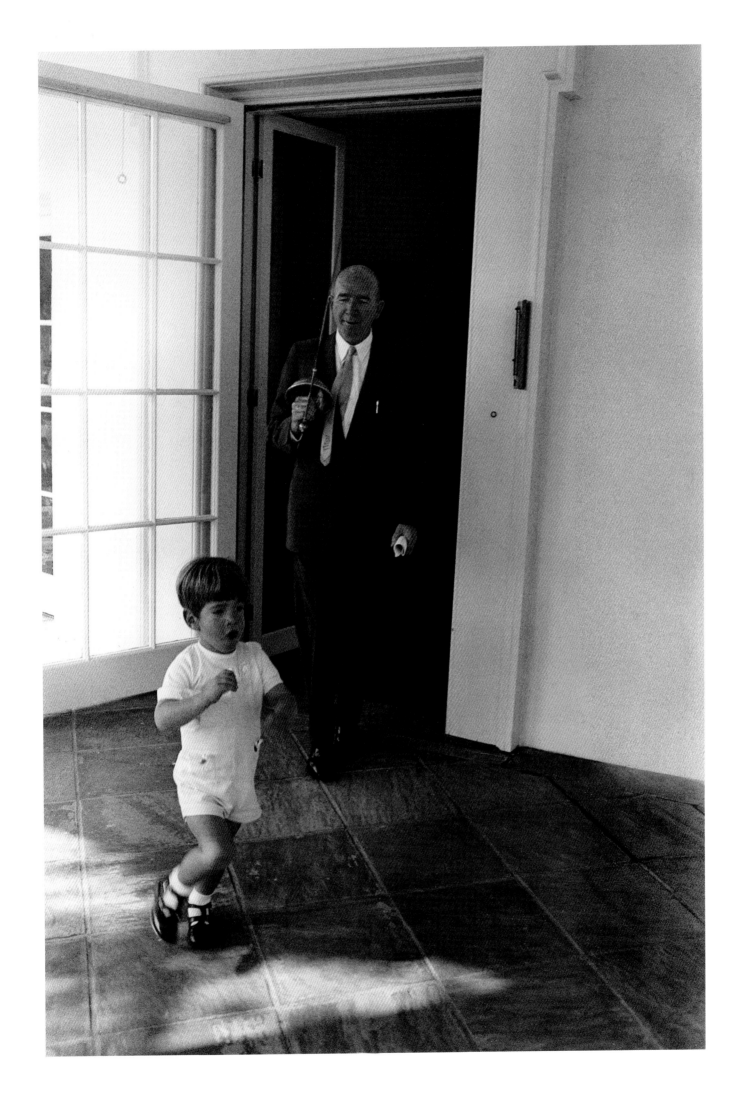

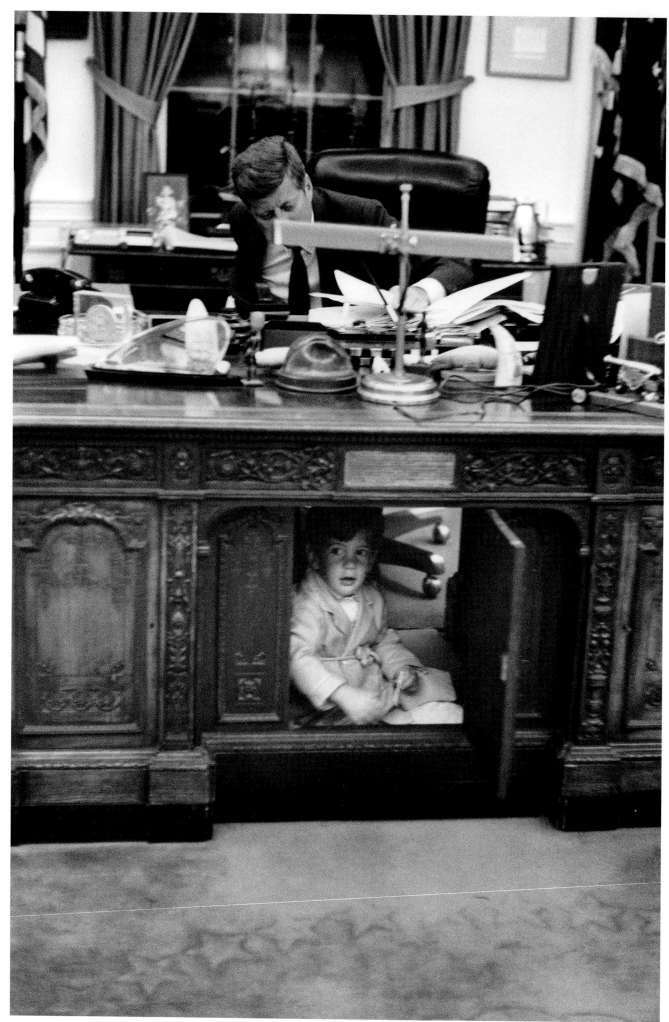

October 14, 1963 / Washington, DC /
John Jr. plays under President John F.
Kennedy's desk while the president
looks at his files.

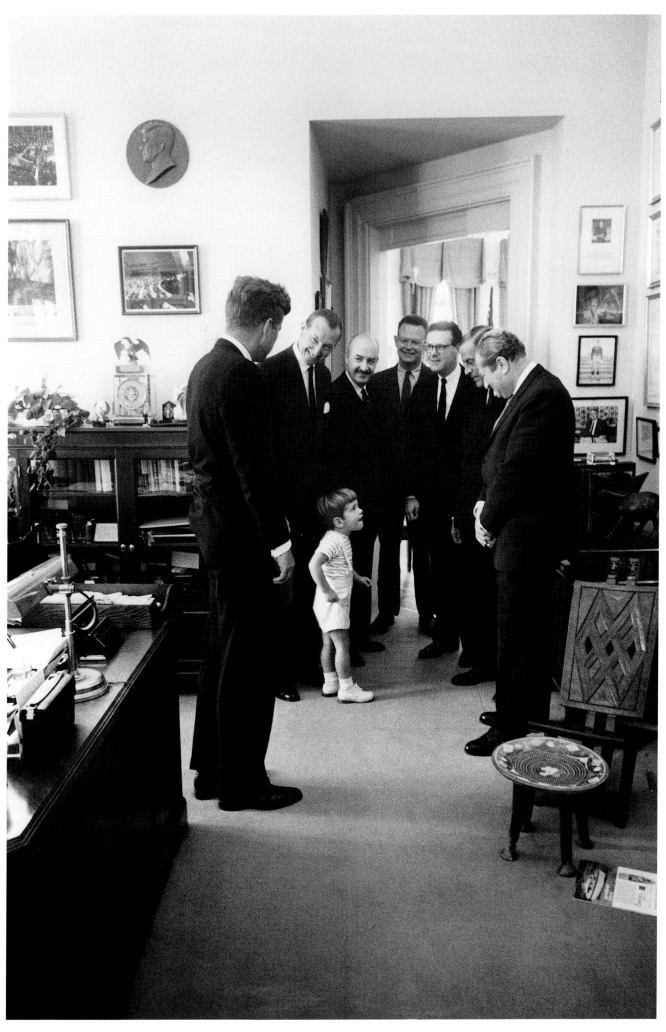

October 14, 1963 / Washington, DC /
John Jr. in the Oval Office, surrounded
by his father and his advisers.

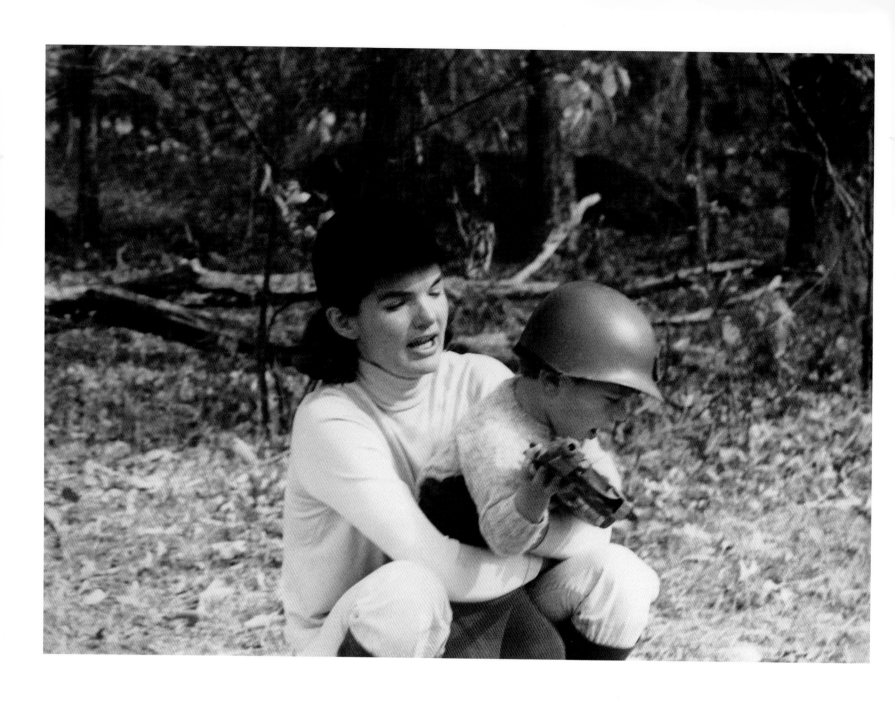

November 10, 1963 / Camp David, MD / John Jr. dresses up as a G.I. during a family weekend in the country. It would be the last weekend that John, Caroline, and their parents spent together.

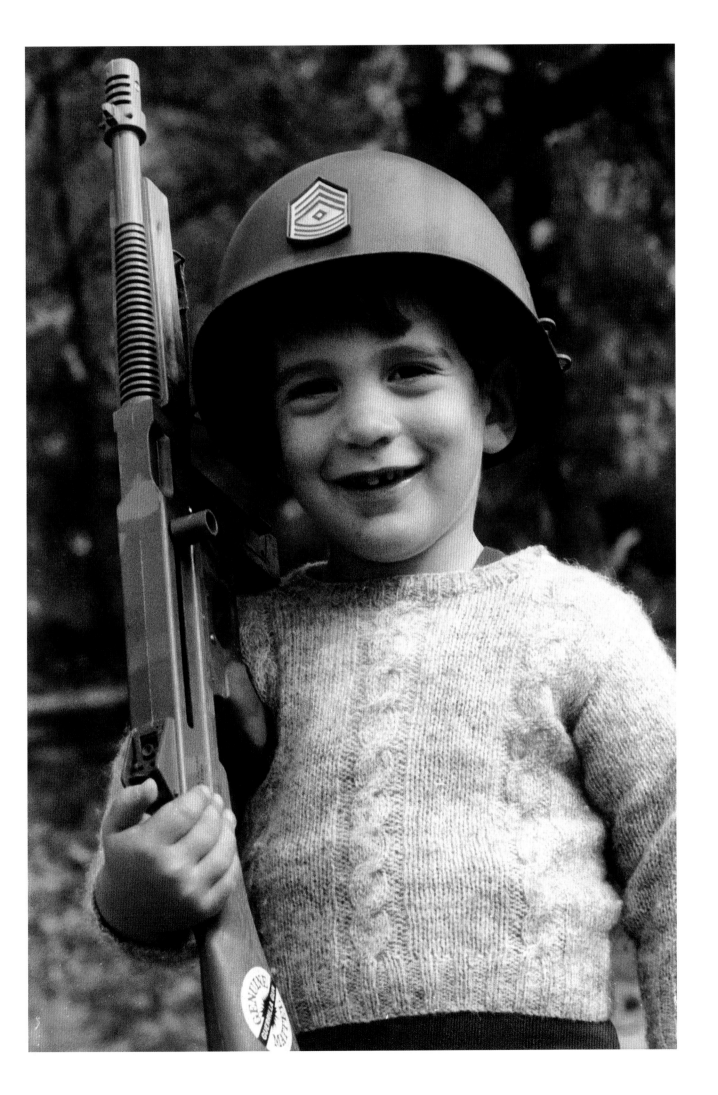

"He had a legacy, and learned to treasure it. He was part of a legend, and he learned to live with it."

Senator Edward Kennedy, July 23, 1999, from his eulogy for John Jr.

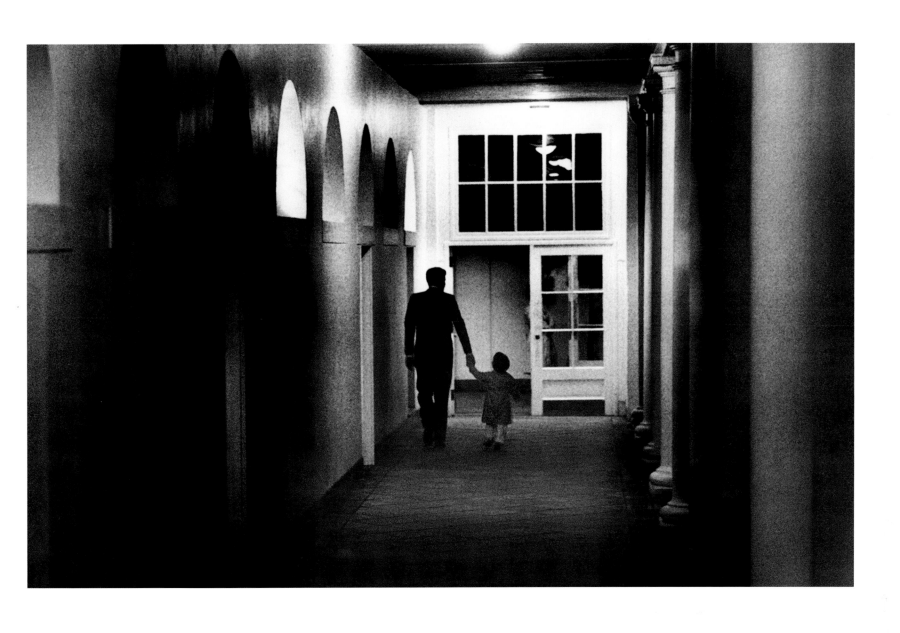

October 14, 1963 / Washington, DC / President Kennedy and his son John Jr. in the halls of the White House.

November 22, 1963

Dallas, Texas: Assassination of President John Kennedy

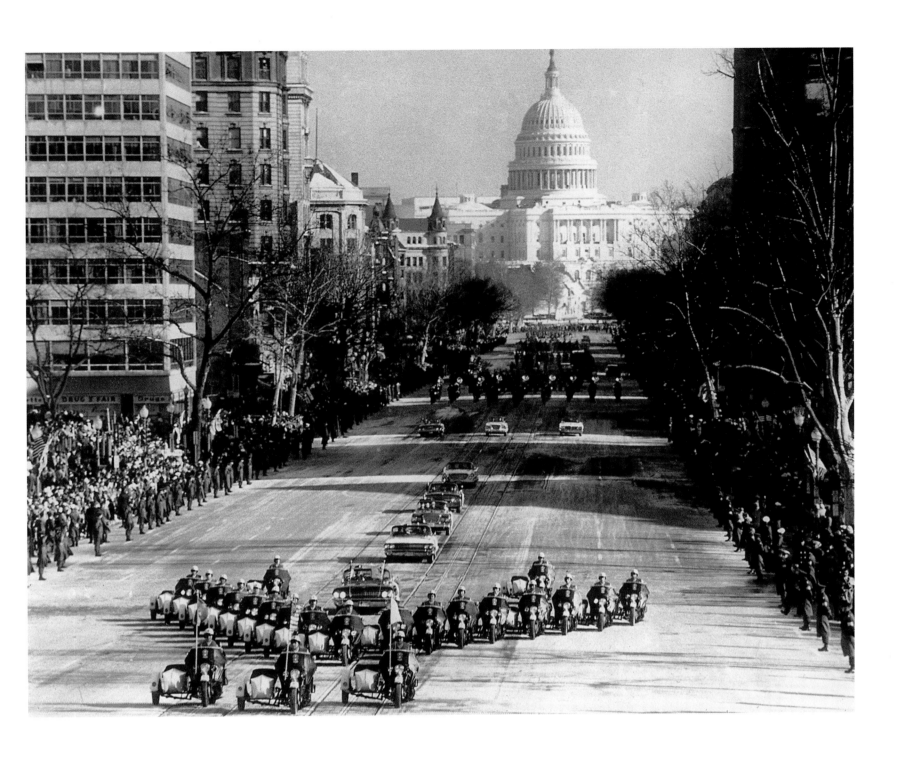

November 25, 1963 / Washington, DC / Every detail of President John F. Kennedy's funeral was overseen by Jackie, who drew her inspiration from Abraham Lincoln's funeral. The horse-drawn carriage transporting the coffin initially stopped at Saint Matthew's Cathedral, then traveled to Arlington Cemetery. More than ninety foreign heads of state were present, and the ceremony was broadcast live on television throughout the entire world. More than a million people came to Washington to pay a final tribute to the assassinated President.

pp. 68-69:
November 25, 1963 / Washington, DC / On the day of his third birthday, John Jr. attends the funeral of his father, President John F. Kennedy, assassinated in Dallas three days earlier. He salutes his father's coffin as it is transported from Saint Matthew's Cathedral to Arlington Cemetery.

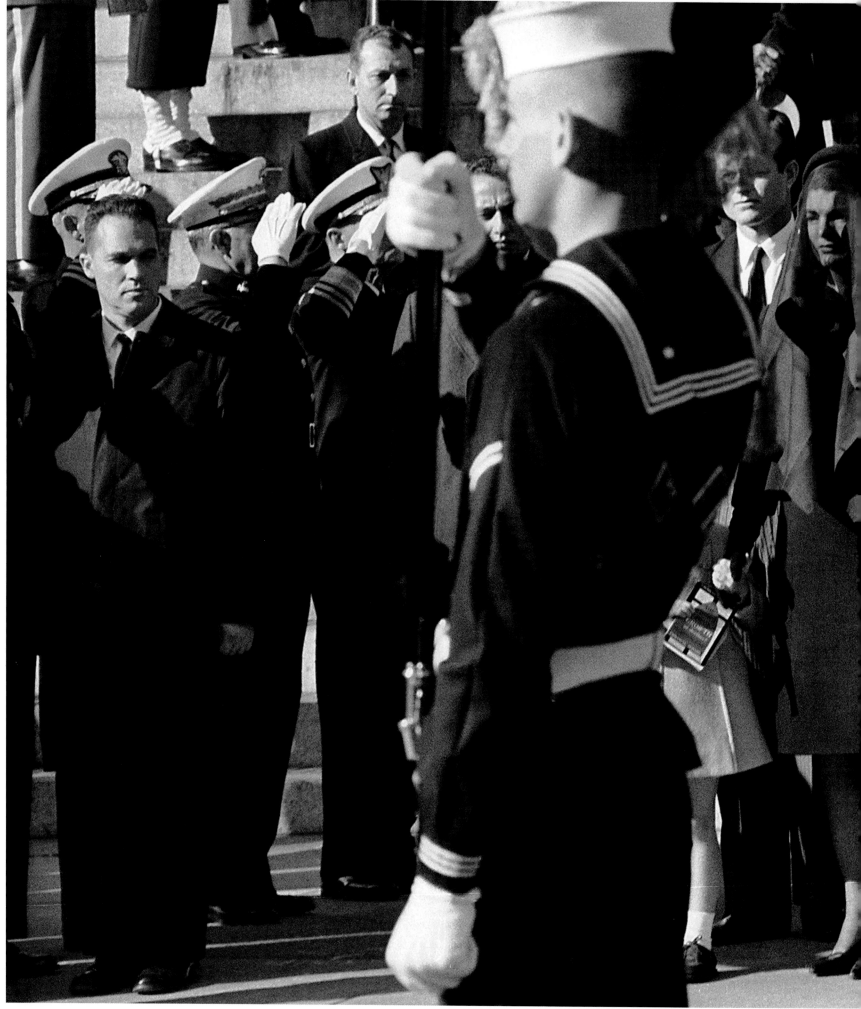

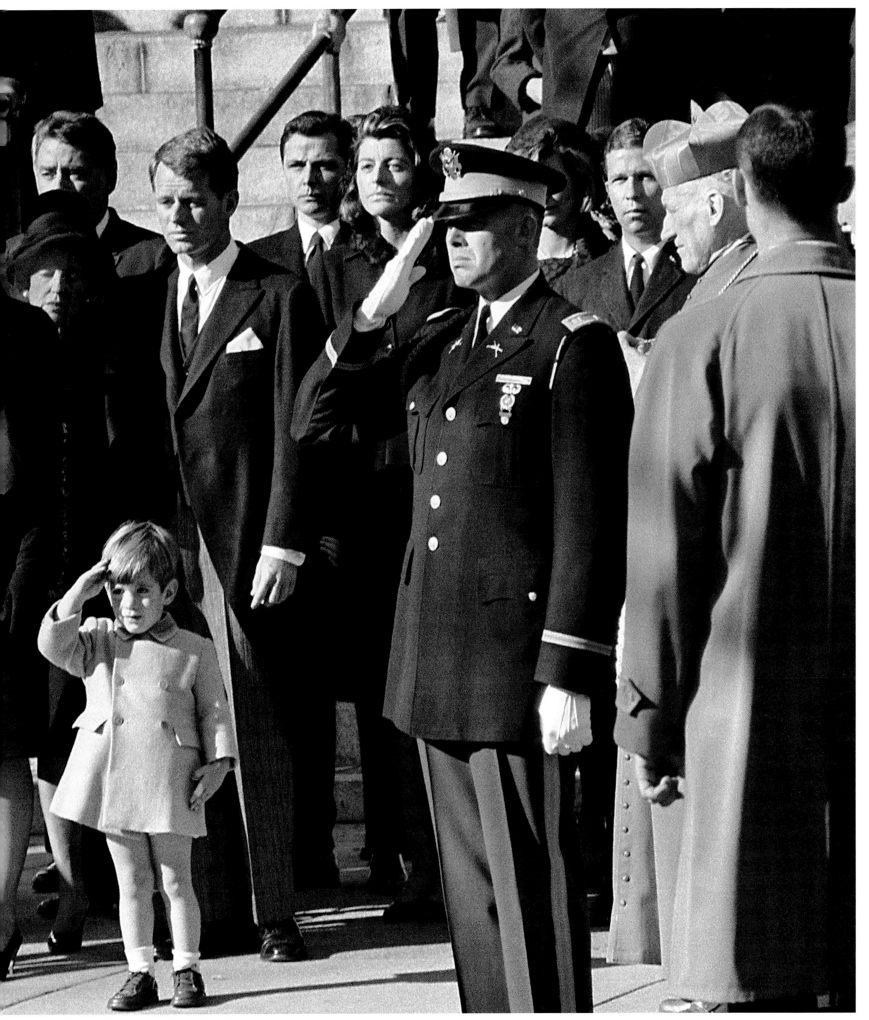

"Jack made John the mischievous, independent boy he is. Bobby is keeping that alive." Jackie

July 3, 1964 / Hickory Hill, CT / Cover of *Life* magazine. Senator Robert "Bobby" Kennedy poses with his children, and Caroline and John Jr. He took Jackie's children under his wing after JFK's assassination seven months earlier. Caroline is seated on Bobby's lap, with Bobby's daughter Courtney to her left. Kerry and Michael stand behind Bobby, while Bobby's son David stands in front of him, hugging his cousin John Jr.

70

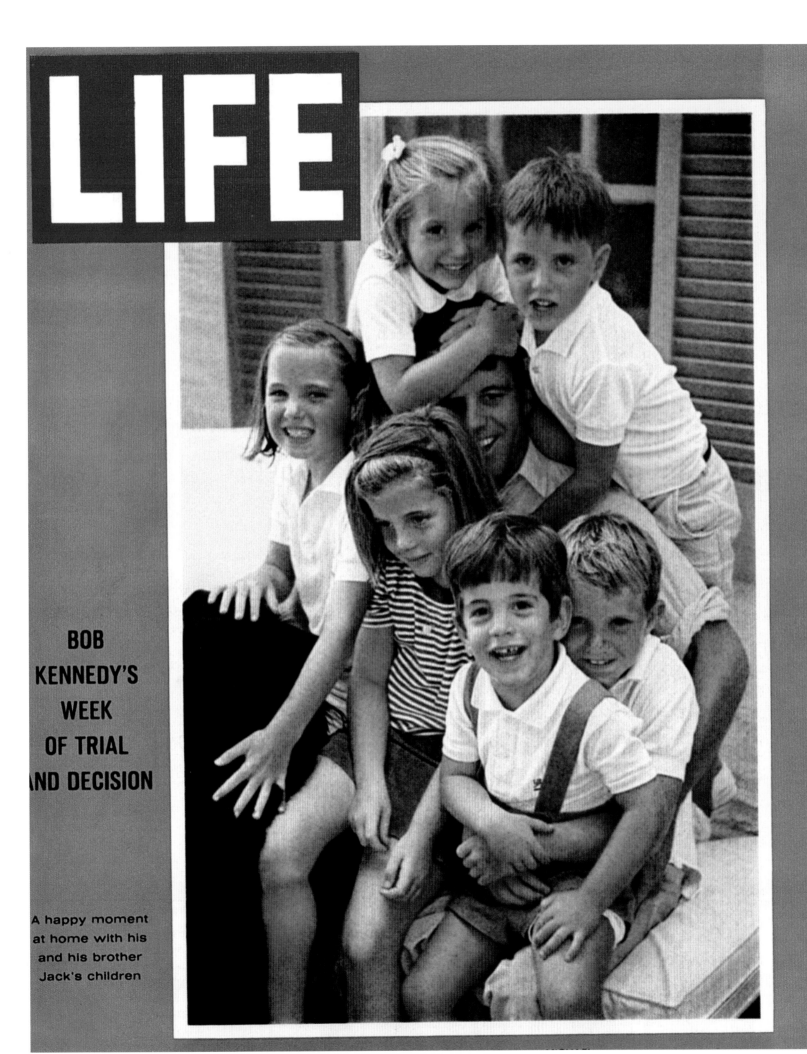

LIFE

BOB KENNEDY'S WEEK OF TRIAL AND DECISION

A happy moment at home with his and his brother Jack's children

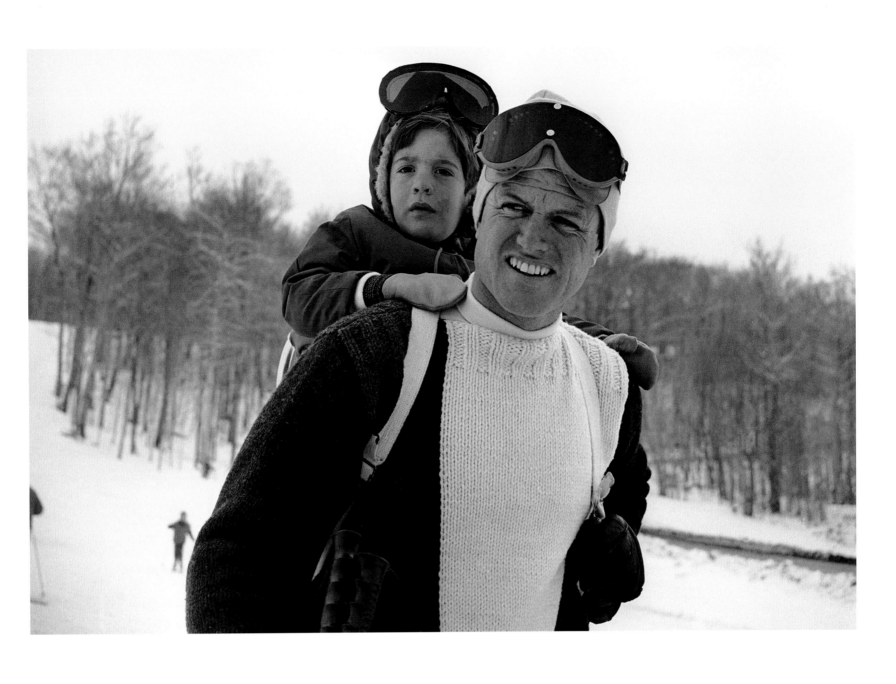

March 31, 1964 / Spruce Mountain, Stowe, Vermont / Ted Kennedy, senator from Massachusetts, skis with his nephew John Jr. during a stay in Stowe, where the entire Kennedy clan had gathered for Easter weekend.

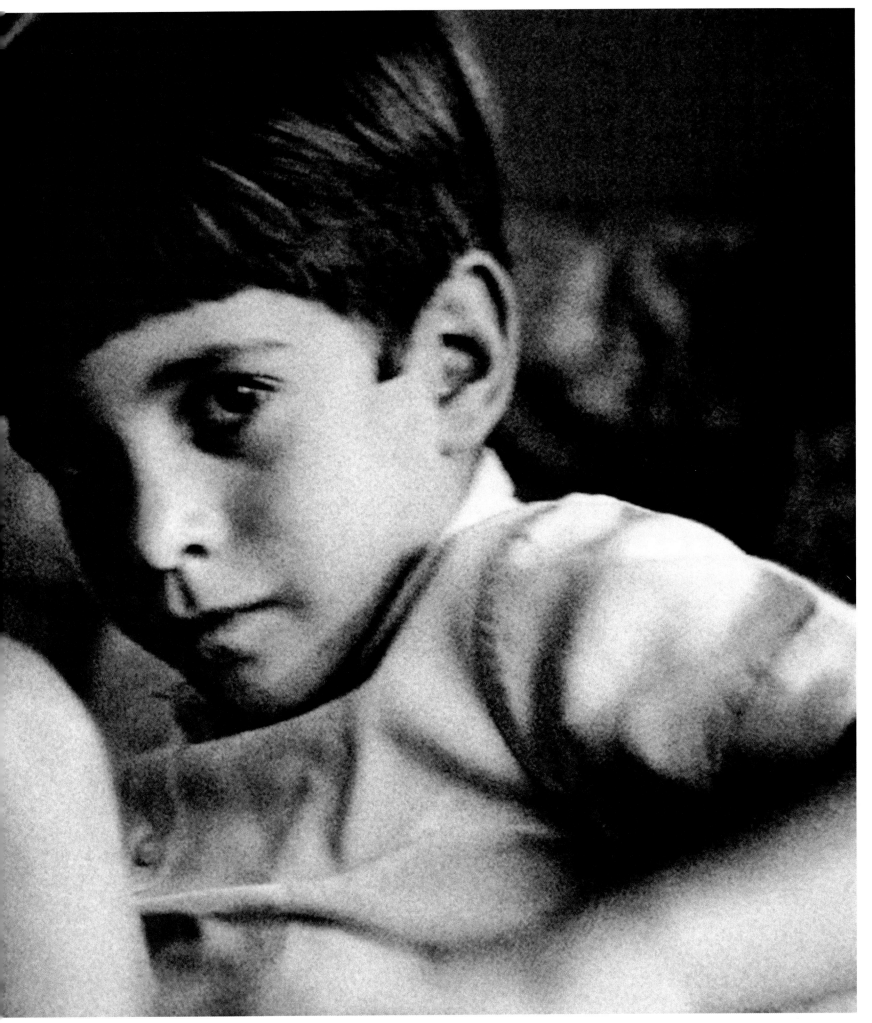

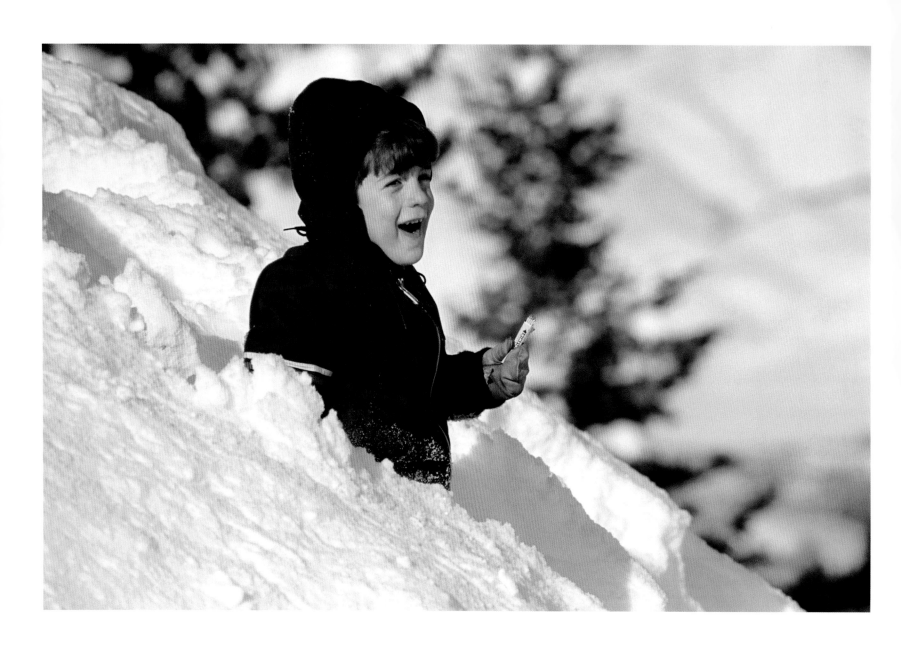

pp. 74-75:
1965 / New York, NY / Portrait of John Kennedy Jr., age five.

July 1, 1966 / Sun Valley, ID / John Jr. spends Christmas in the mountains, with his mother and his sister Caroline.

76

December 30, 1965 / Sun Valley, ID / John Jr. snuggles with a husky puppy. Jackie had taken John and his sister Caroline to spend the Christmas holidays with Senator Robert Kennedy and his family.

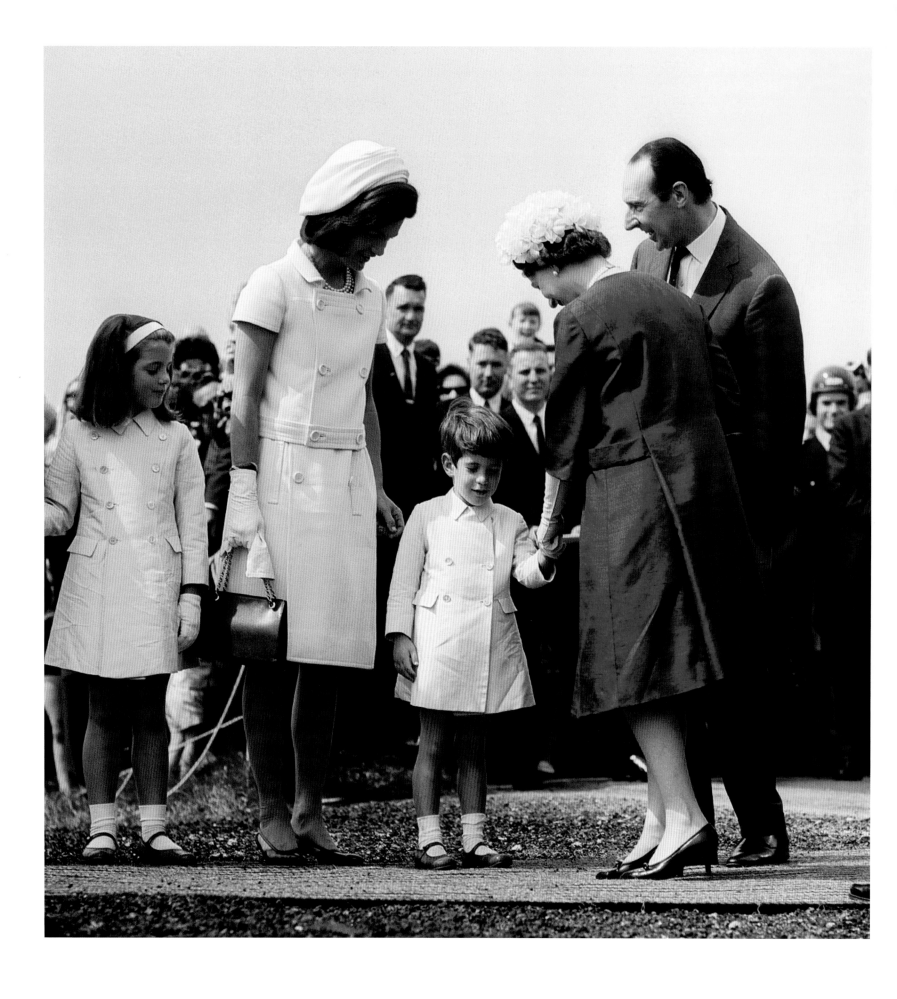

May 14, 1965 / Runnymede, England / John Jr., age four, shyly bows his head before Queen Elizabeth II as she prepares to inaugurate the John F. Kennedy Memorial. The man on the queen's right is Lord Harlech, a close friend of Jackie Kennedy's and the British ambassador to the United States.

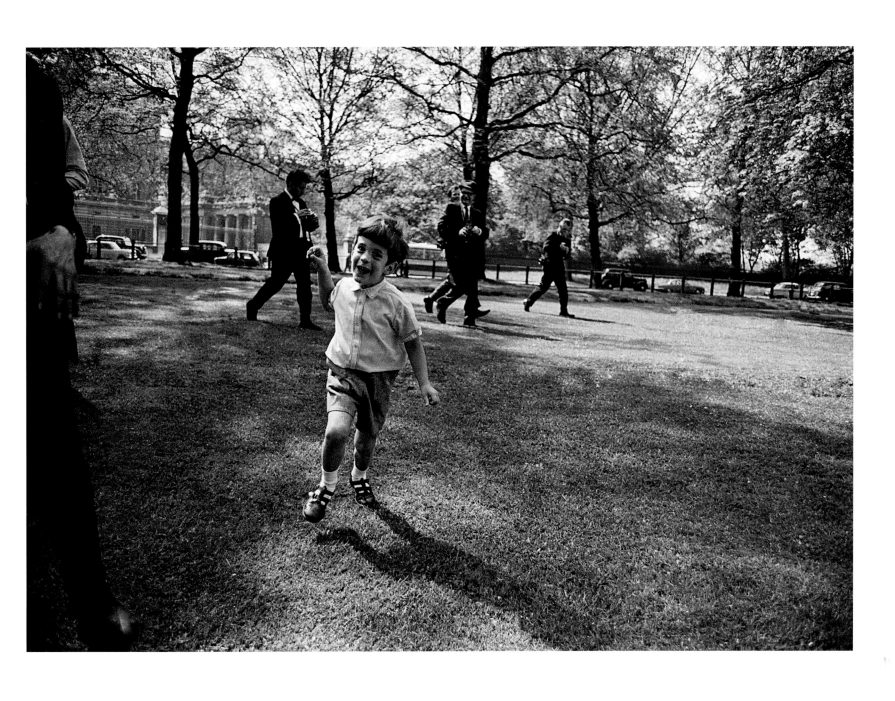

May 14, 1965 / London, England / To the great satisfaction of the numerous English photographers and journalists gathered to see the Kennedys, John Jr. appears to be having a wonderful time on a family outing in Green Park.

June 6, 1968

Los Angeles, California: Assassination of Senator Robert Kennedy

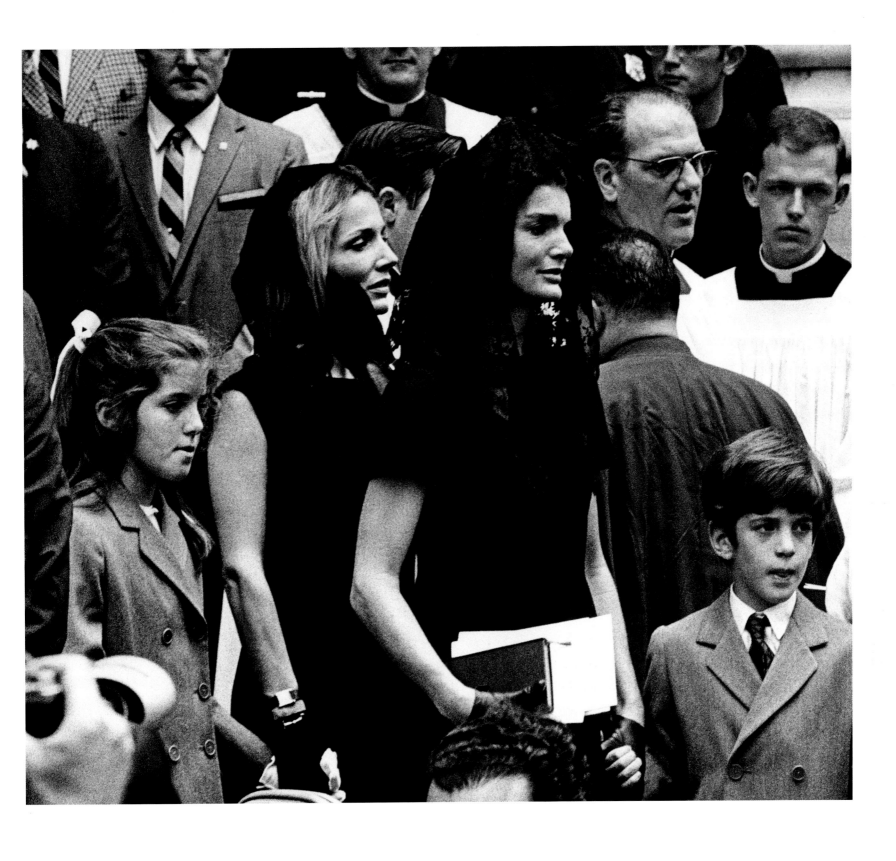

June 8, 1968 / New York, NY / Jackie Kennedy, her children, and her sister Lee Radziwill wait in front of Saint Patrick's Cathedral after attending the funeral services for Senator Robert F. Kennedy. Bobby Kennedy was assassinated four-and-a-half years after his brother President Kennedy. He had just announced his intention to run for the Democratic candidacy in the upcoming presidential election.

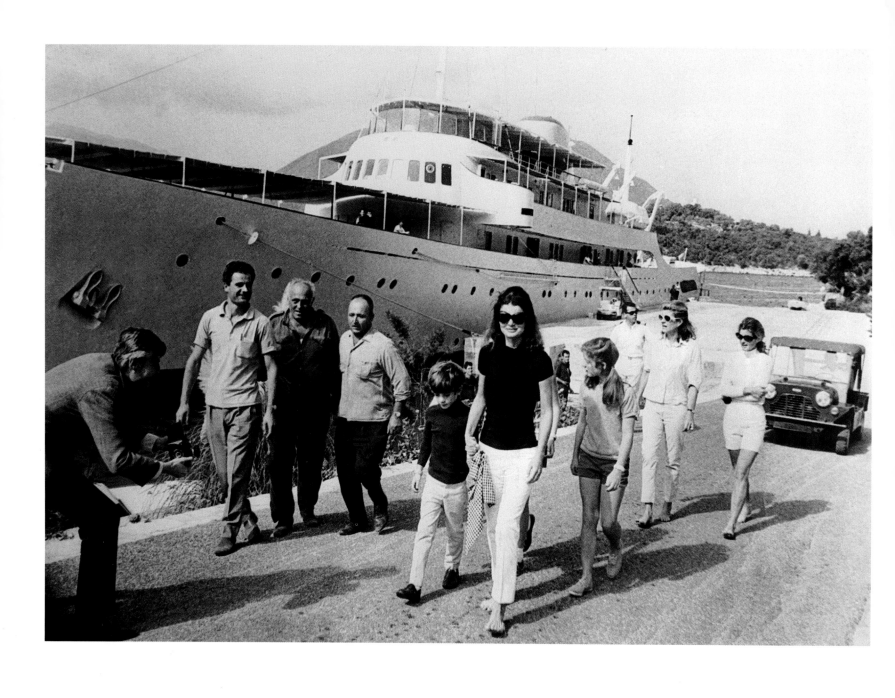

October 19, 1968 / Scorpios, Greece / Jackie and her children leaving the *Christina*, Aristotle Onassis's yacht. This photo was taken the day before the wedding between Jackie and the Greek billionaire took place on his private island.

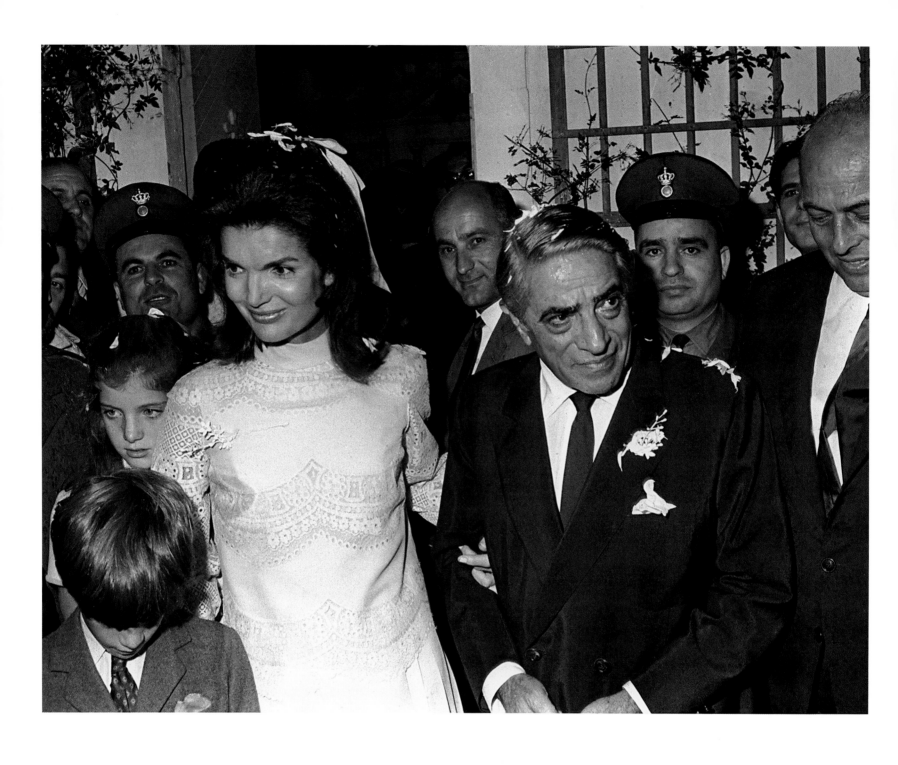

October 20, 1968 / Scorpios, Greece / John Kennedy Jr. was seven years old when Jackie was remarried to the Greek billionaire Aristotle Onassis. The ceremony took place on Onassis's private island of Scorpios.

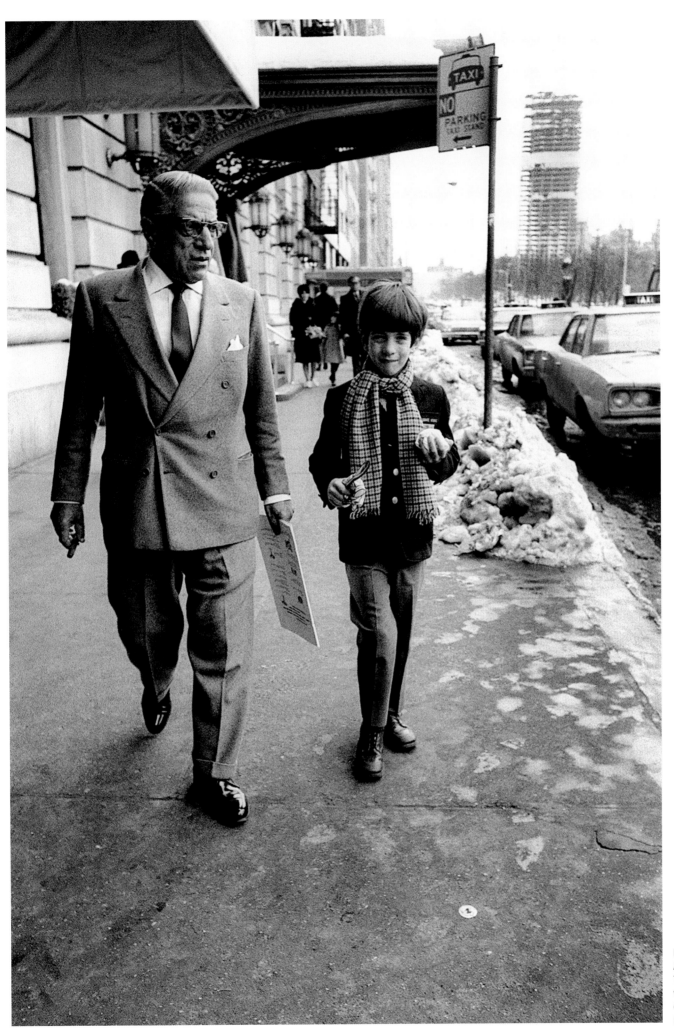

February 16, 1969 / New York, NY / Aristotle Onassis and John Jr. leaving Trader Vic restaurant. John proudly wears a scarf and carries a miniature canoe given to him by one of the restaurant's hostesses.

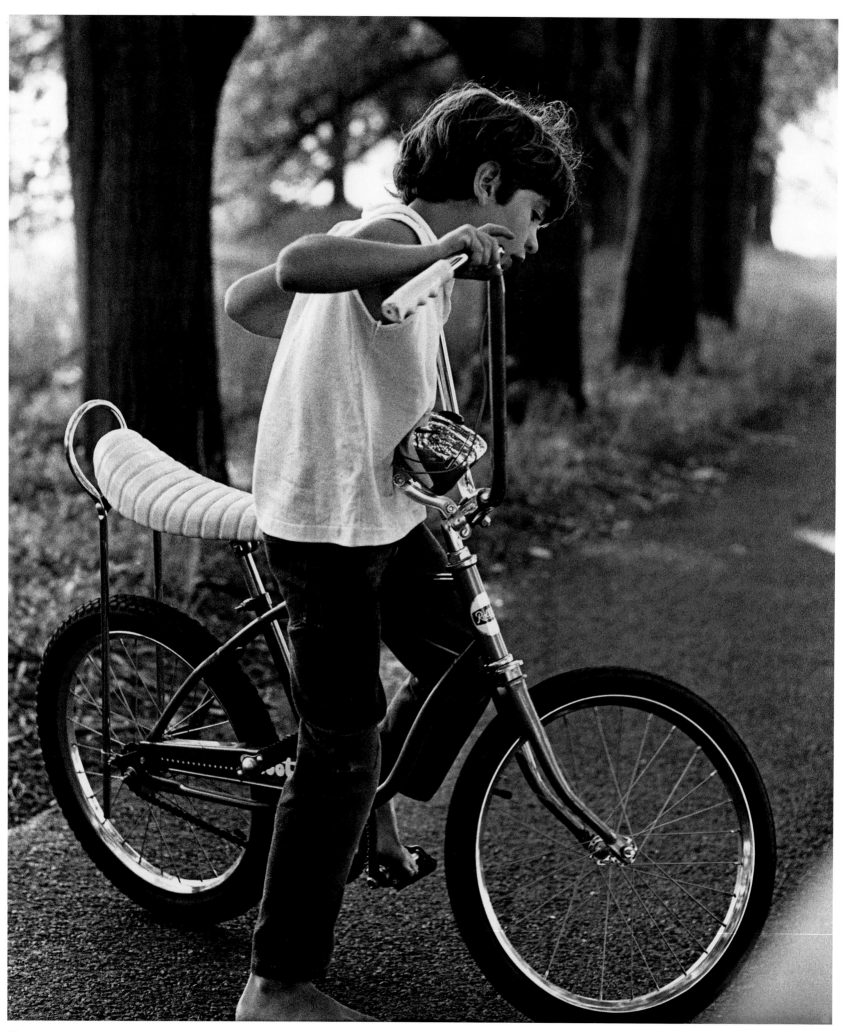

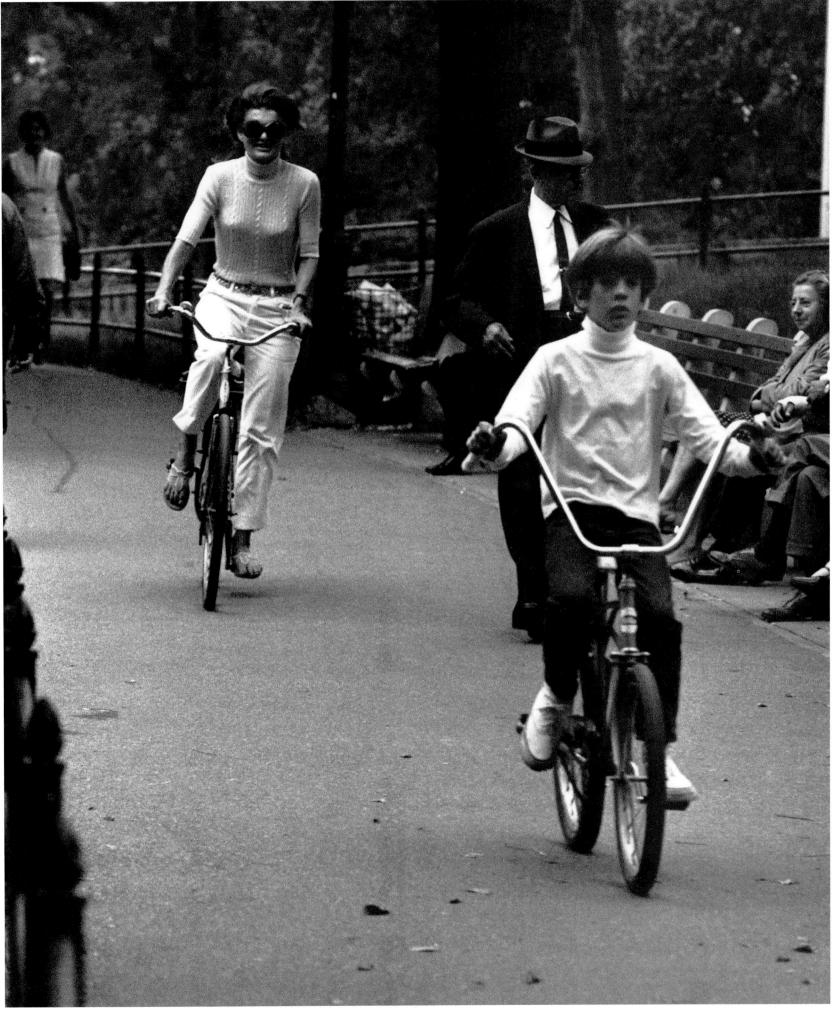

"You, especially, have a place in history." Jackie, in her final note to John Jr.

pp. 86-87:
May 6, 1969 / Peapack, NJ / A nine-year-old John Jr. enjoys some barefoot weekend biking.
September 24, 1969 / New York, NY / Jackie Kennedy and her son John Jr., eight years old, on a bicycle outing in Central Park.

July 7, 1969 / Athens, Greece / John enthusiastically greets his mother, who has come to welcome him at Athens International Airport.

88

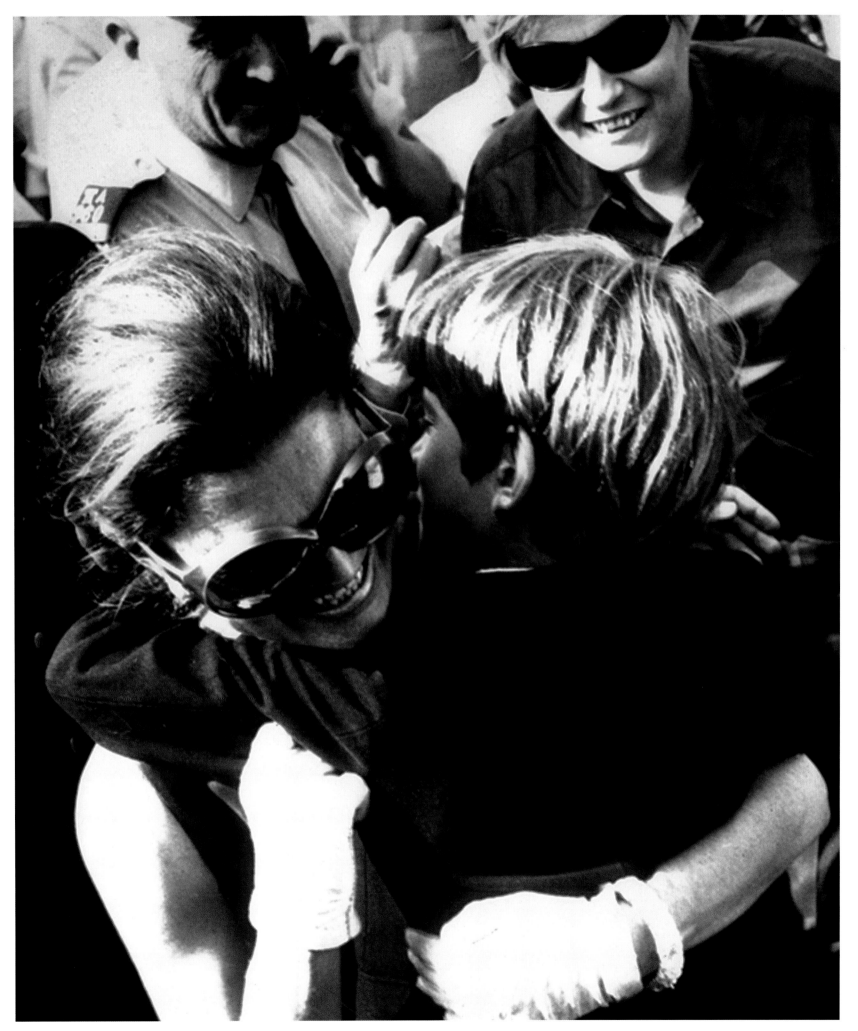

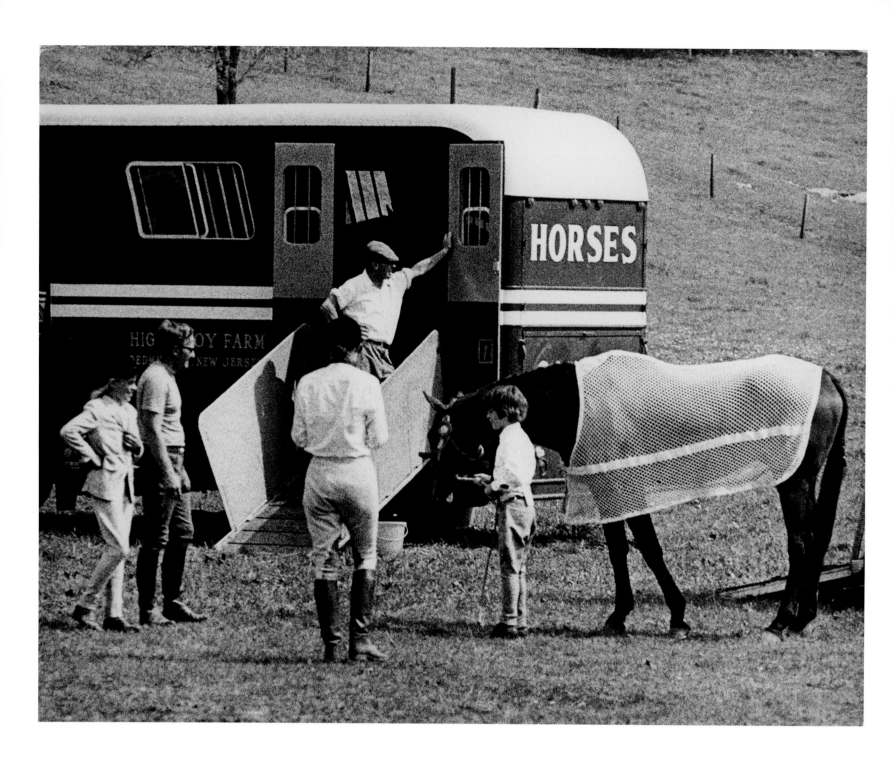

May 10, 1970 / Peapack, NJ / John Jr. was an accomplished rider. An avid horseback rider herself, Jackie had introduced John to the sport at an early age, taking him for long outings on ponies and, eventually, horses.

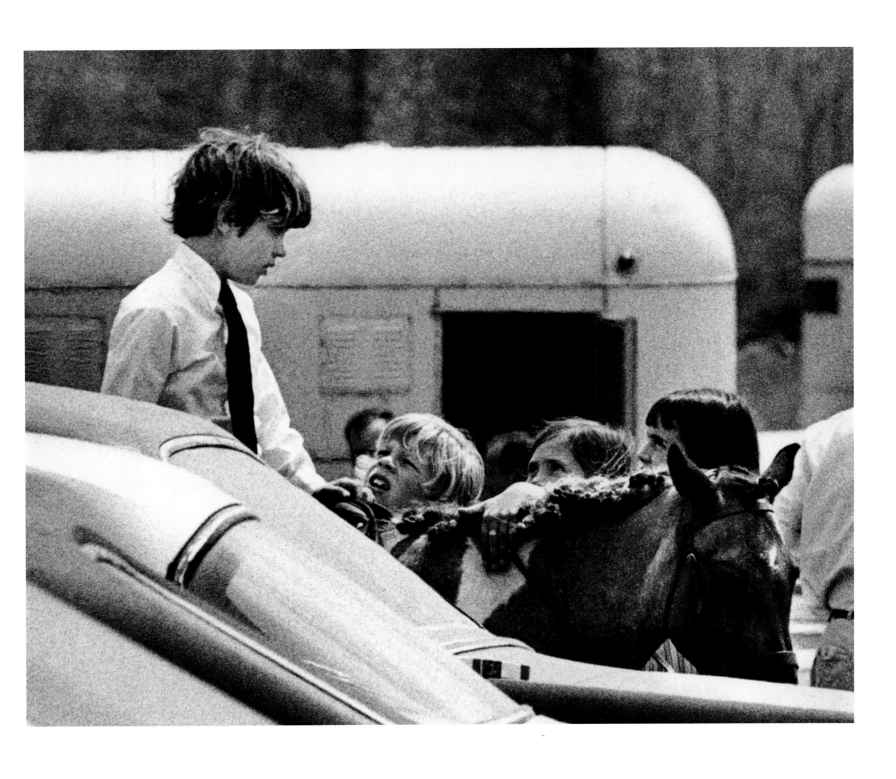

May 10, 1970 / Peapack, NJ / John Jr. wins the blue ribbon at the seventeenth annual Saint Bernardsville Horse Show.

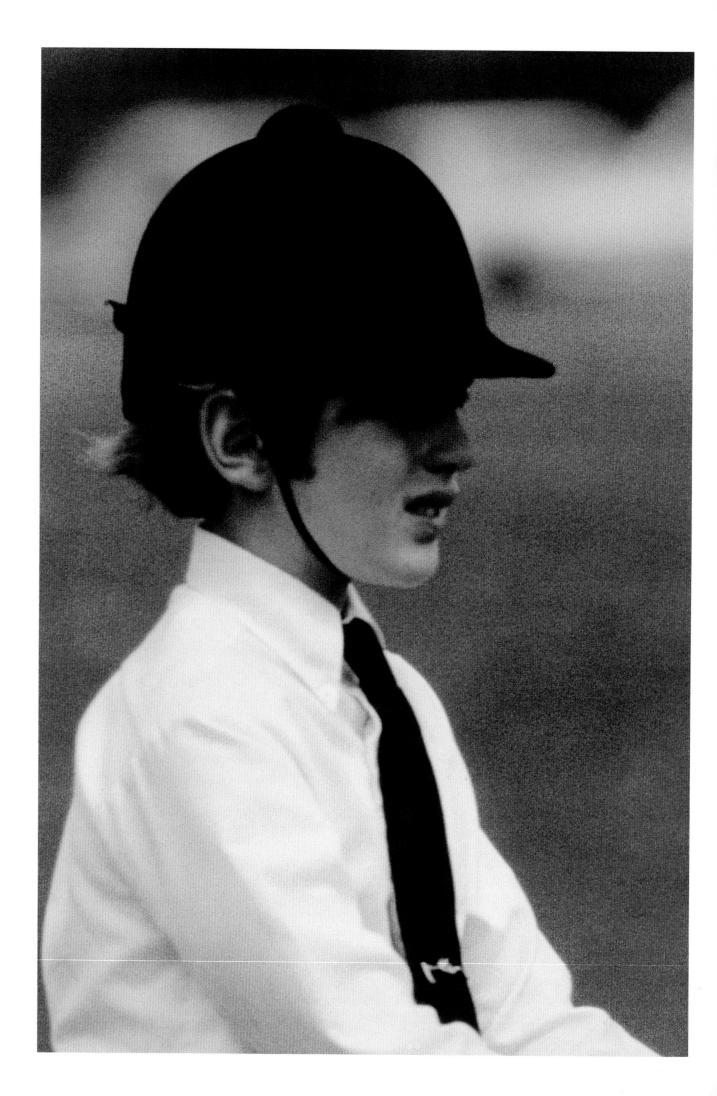

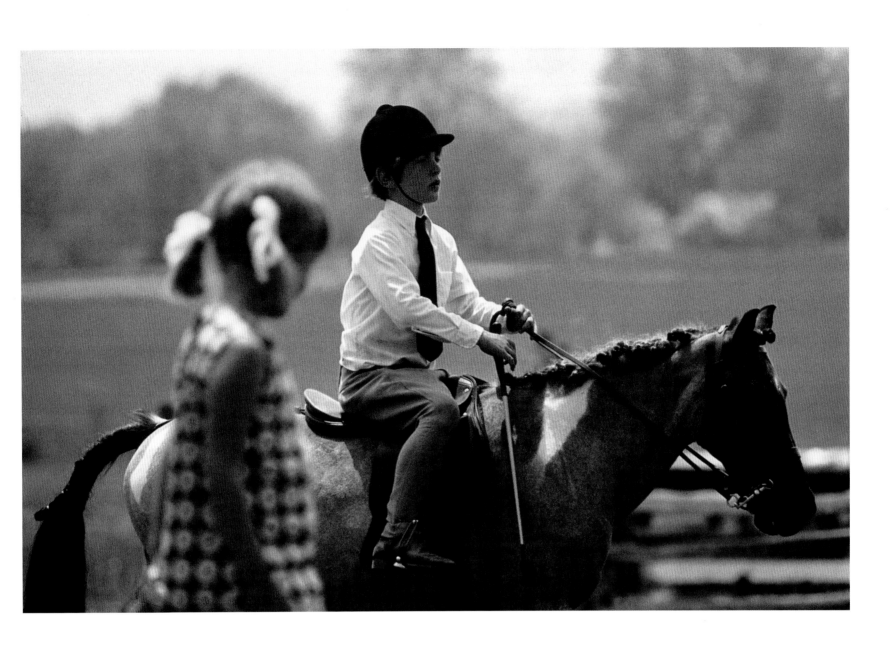

May 10, 1970 / Peapack, NJ / John Jr. competing in the Saint Bernardsville Horse Show.

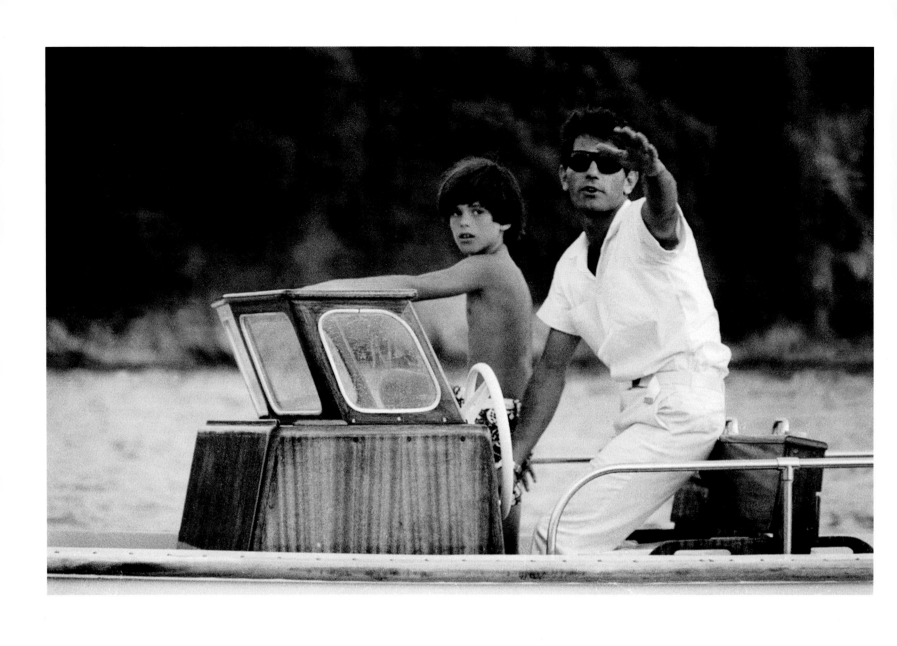

July 16, 1970 / Scorpios, Greece / John Jr. boards a motorboat on the shores of Scorpios, Aristotle Onassis's private island, where he had gone to fish and water ski with his sister and his cousins. The man steering the boat is one of Aristotle's bodyguards. Once he dropped off John, the bodyguard chased the photographer, insisting he leave Scorpios.

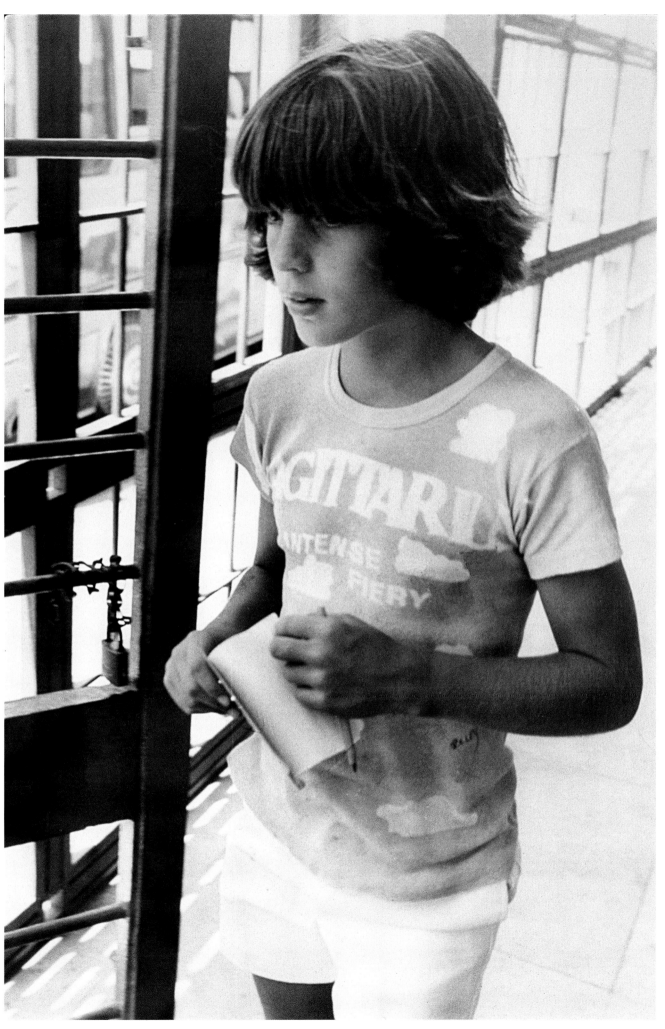

1970 / Scorpios, Greece /
Portrait of John Kennedy Jr., age nine.

95

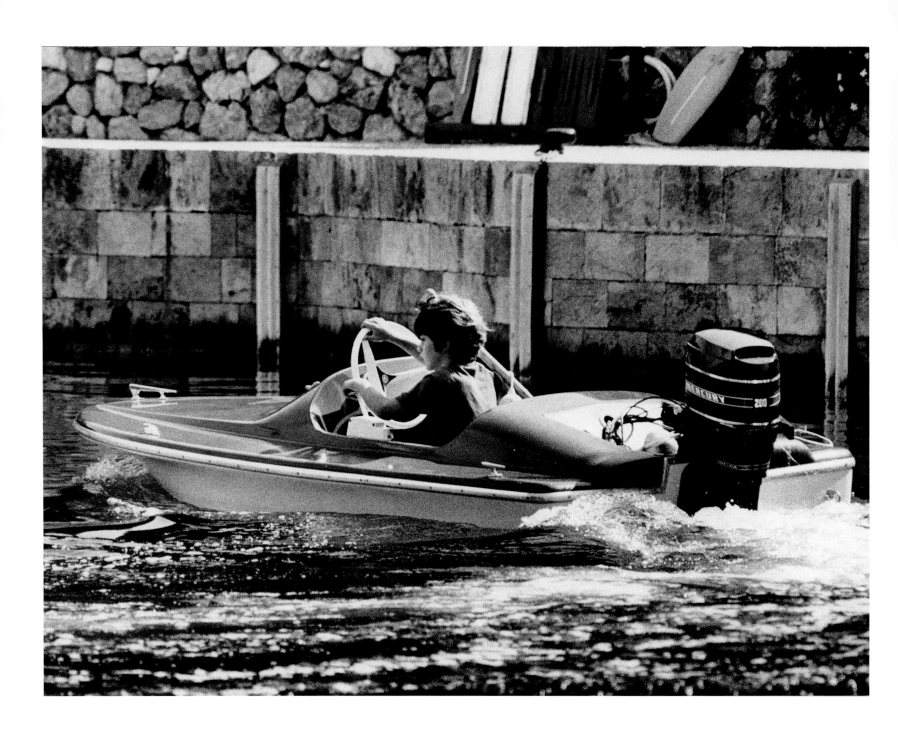

July, 1970 / Scorpios, Greece / John Jr. pilots the motorboat given to him by Aristotle Onassis.

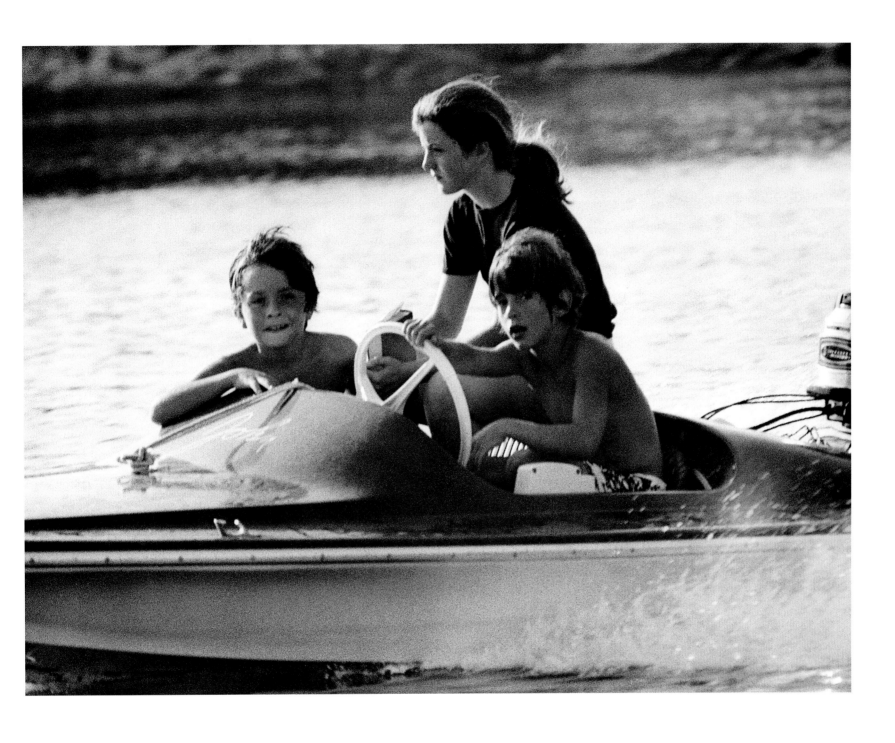

July, 1970 / Scorpios, Greece / John Jr., Caroline, and their cousin Anthony Radziwill sailing in their motorboat off Aristotle Onassis's private island.

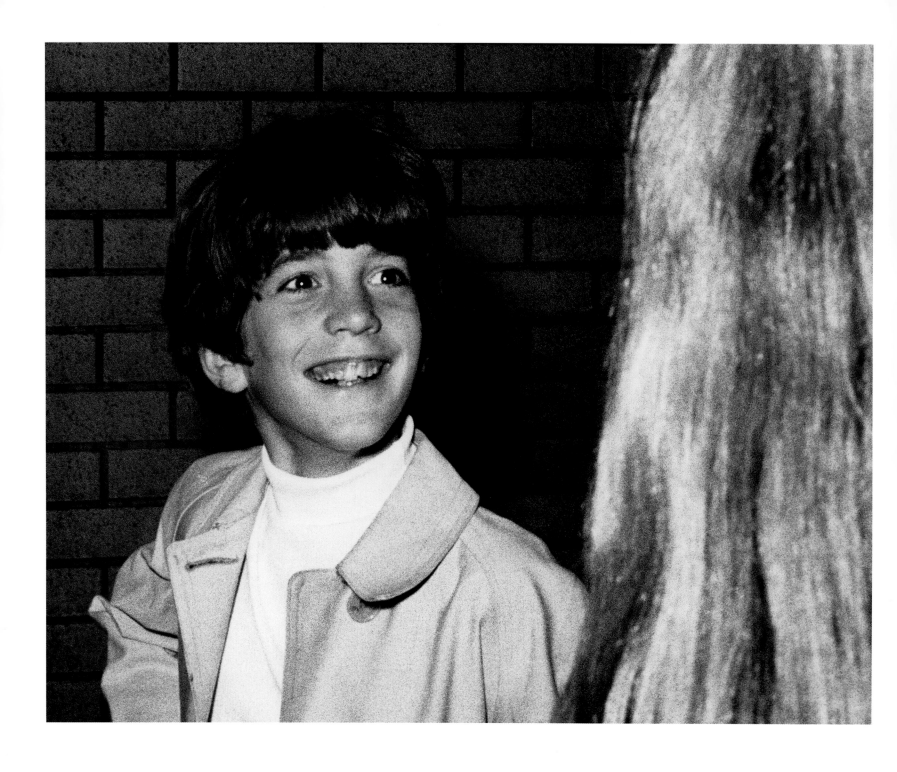

November, 1970 / New York, NY / John and his sister Caroline, thick as thieves, on their way to a private screening.

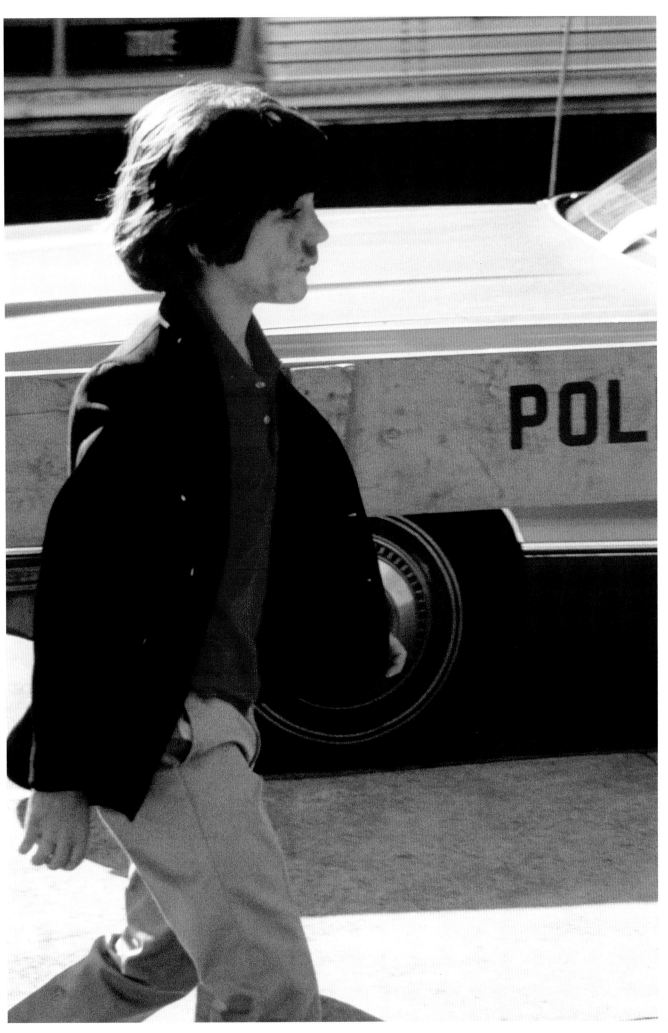

May 14, 1971 / New York, NY /
As a student at the Collegiate Boys
School, John was given a part in
Oliver, a play produced by his
teacher. His face remains partially
made-up as he heads home after
rehearsal.

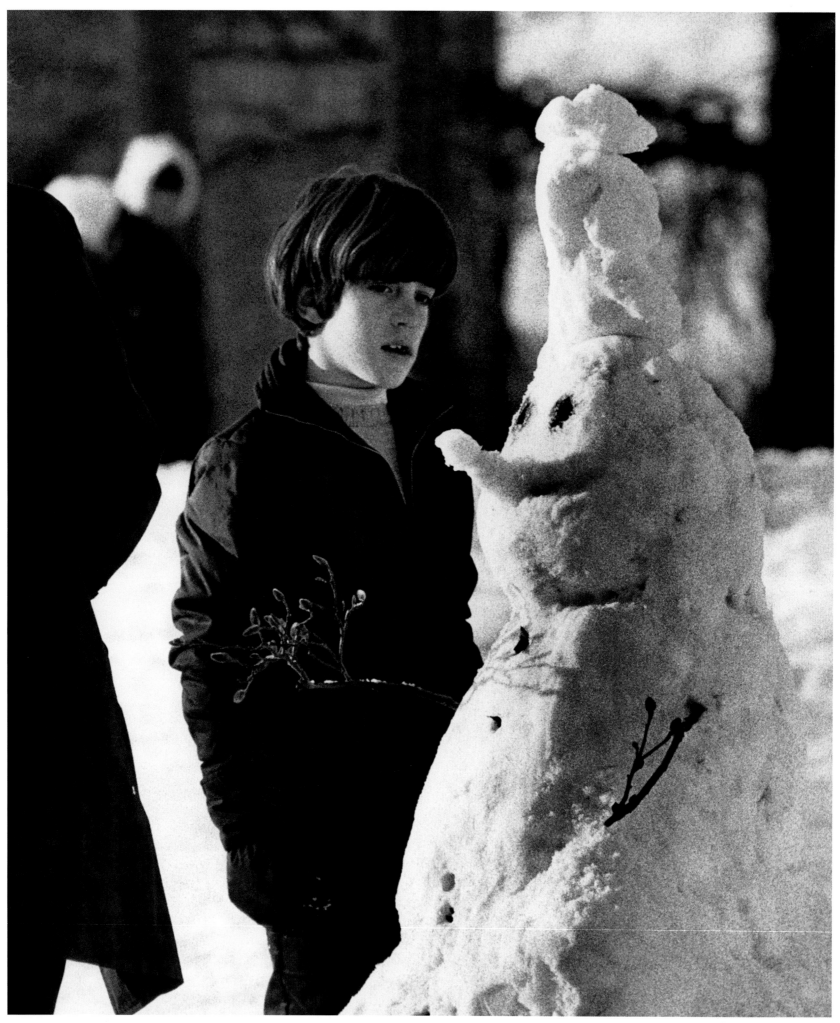

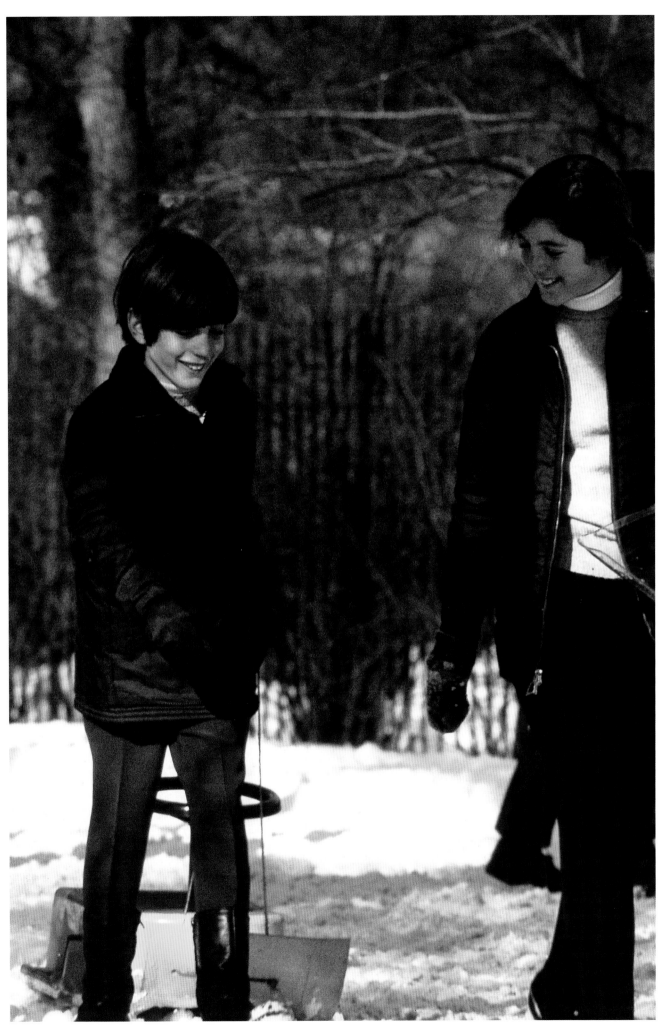

January 3, 1971 / New York, NY / John Jr. and his sister Caroline build a snowman in Central Park.

January 3, 1971 / New York, NY / John and Caroline Kennedy sledding in Central Park.

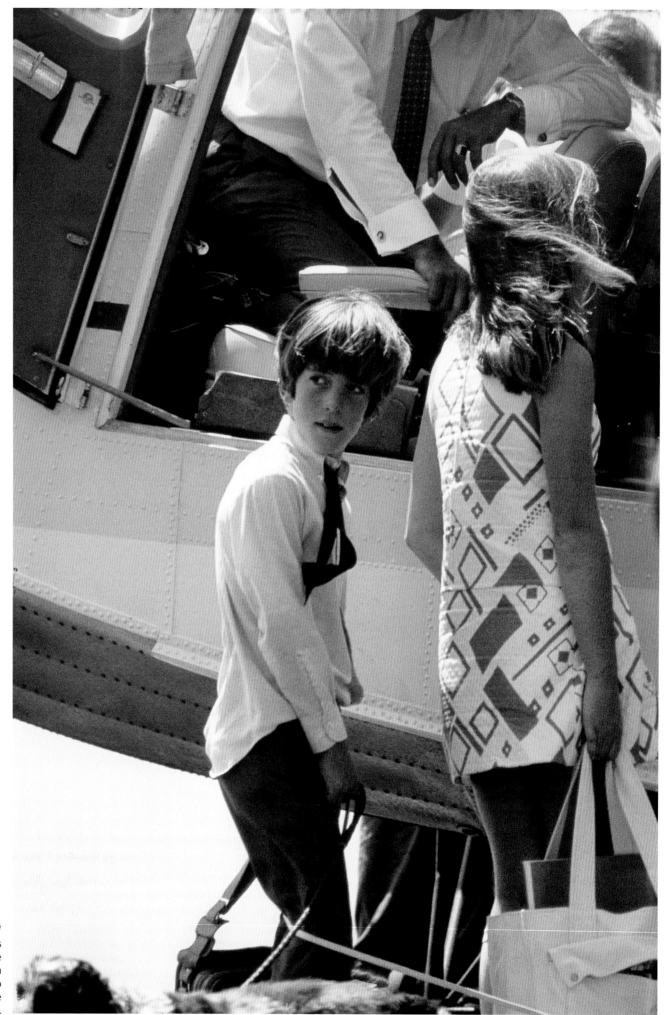

July, 1970 / Athens, Greece / John Jr., his sister Caroline, and his mother Jackie board a private helicopter which will take them from Athens International Airport to Scorpios, Aristotle Onassis's private island.

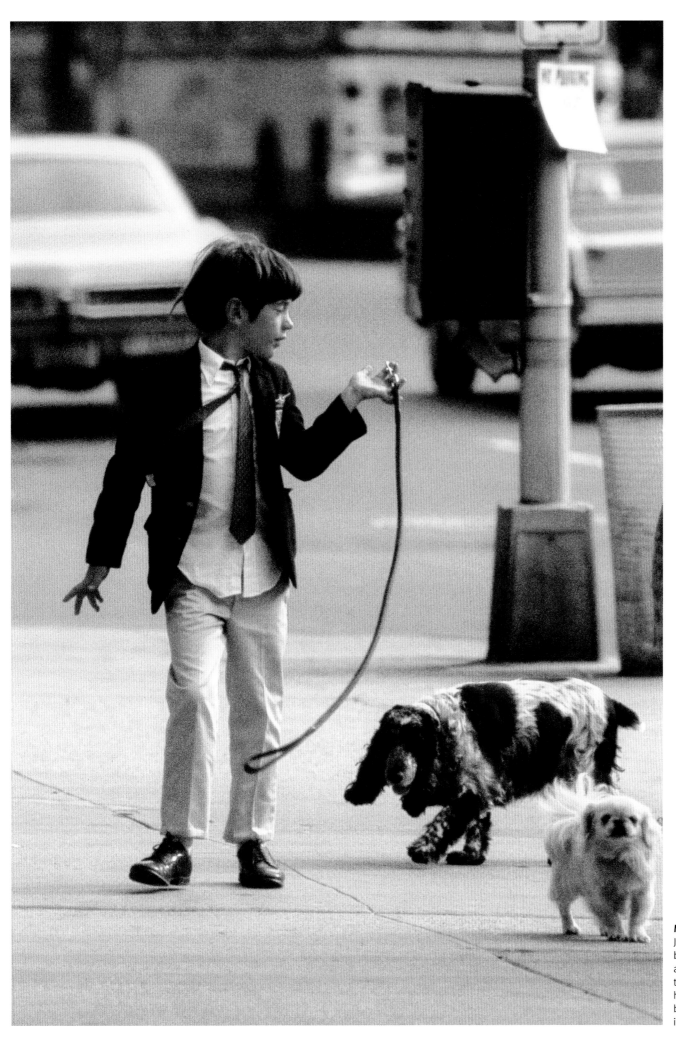

May 15, 1971 / New York, NY / John Jr. walking his dog outside his building. Jackie remained in her apartment at 1040 Fifth Avenue until the end of her life, surrounded by hundreds of photos, objets d'art, and books, all bearing witness to an incredibly rich and eventful life.

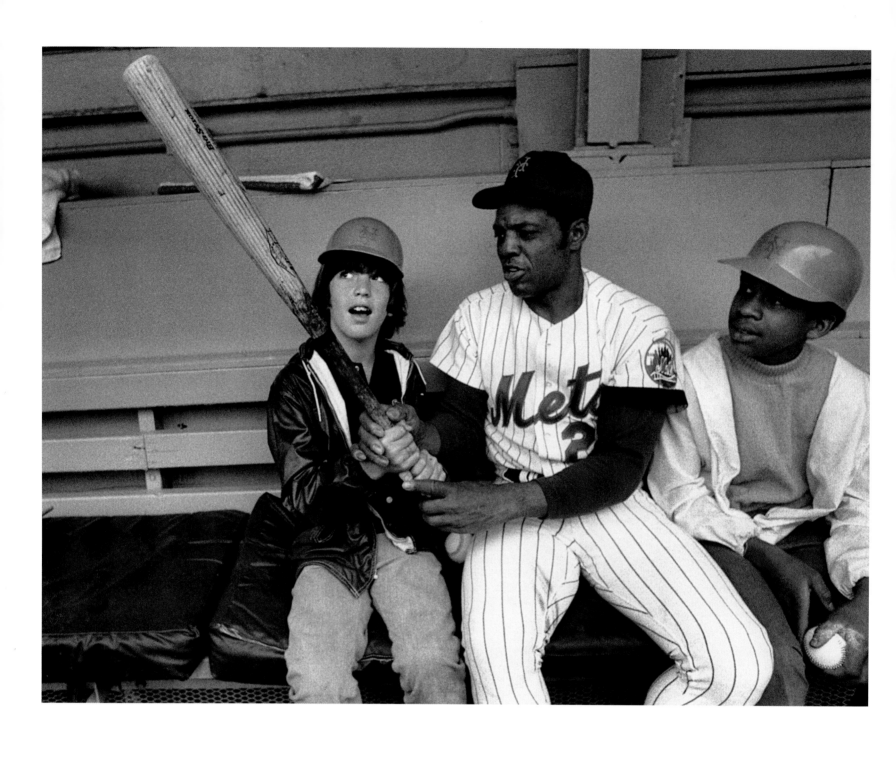

June 3, 1972 / Shea Stadium, Queens, NY / John Kennedy Jr. and his friend Eric Von Huguley, right, were invited into the New York Mets dugout in Shea Stadium before a game versus the Atlanta Braves. To John's right, centerfielder Willie Mays shows the boys the proper way to hold a baseball bat.

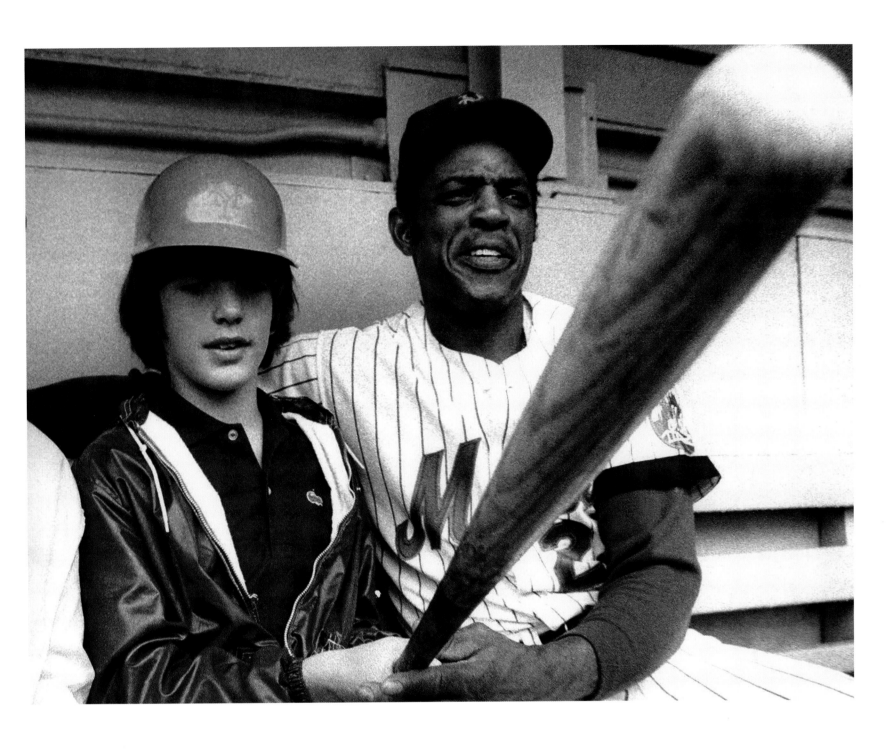

June 25, 1972 / Paris, France / Facing an onslaught of paparazzi, Aristotle Onassis invites John Jr. to get back in the car.

June 25, 1972 / Paris, France / John Jr. accompanies his mother as she shops at Le Drugstore shopping complex on the Champs Elysées.

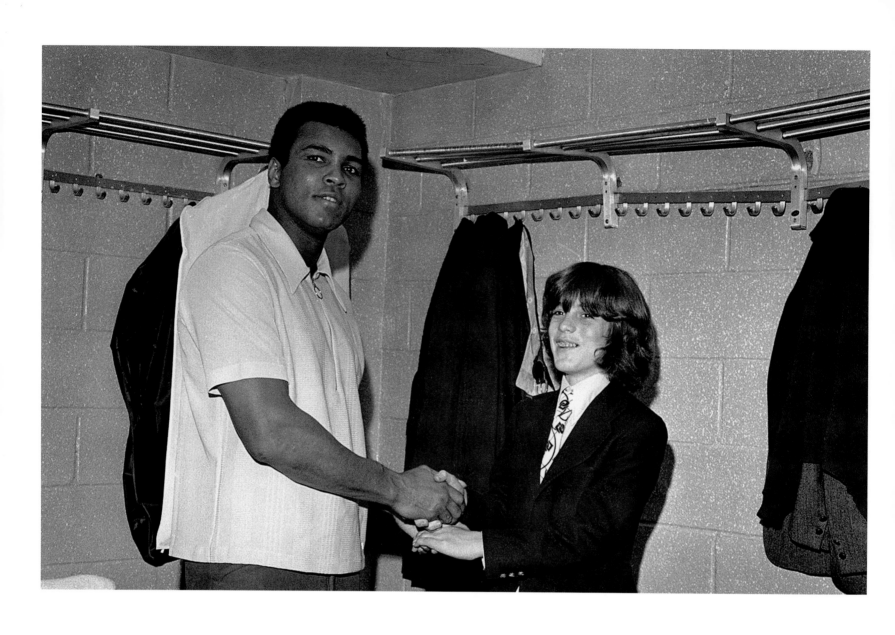

January 28, 1974 / New York, NY / John Jr. shakes hands with Muhammad Ali.

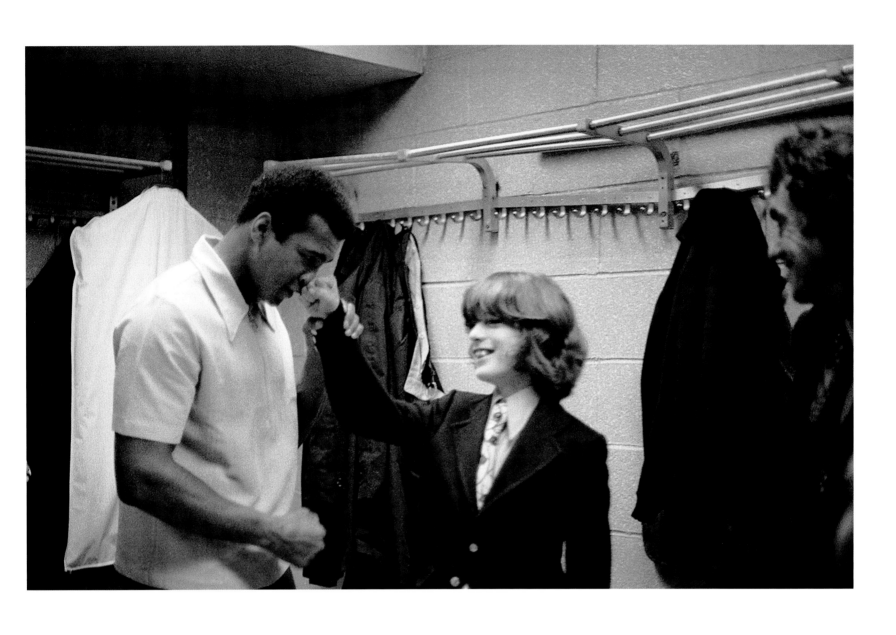

January 28, 1974 / New York, NY / John teases Muhammad Ali. Ali had first won the WBA (World Boxing Association) World Heavyweight Championship on February 25, 1964. He regained his title a few months after this picture was taken, in a bout in Kinshasa in October, 1974.

March 15, 1975

Neuilly, France: Death of Aristotle Onassis

March 21, 1975 / Scorpios, Greece / John, Caroline Kennedy, and Christina Onassis, on the day of Aristotle Onassis's funeral.

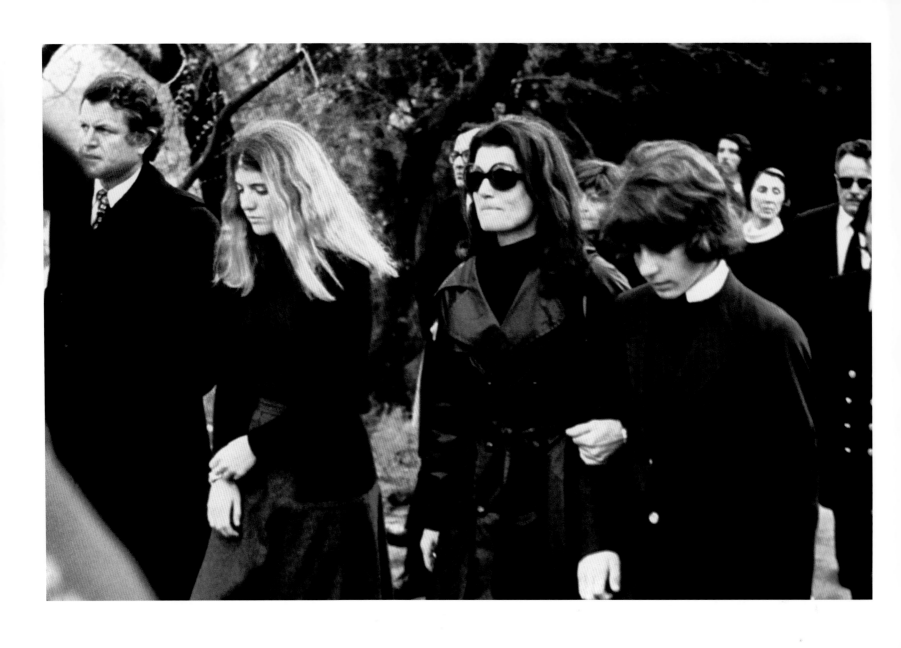

March 21, 1975 / Scorpios, Greece / Jackie with Caroline and John Jr. at the funeral of her second husband, the Greek billionaire Aristotle Onassis. As he had done at the funeral of his brother John, assassinated in Dallas in 1963, Senator Edward Kennedy took the place of the man of the family.

March 21, 1975 / Scorpios, Greece / Aristotle had decided to be interred on his private island, next to his son, who had died two years earlier in a plane crash. The funeral only lasted fifteen minutes, with the Onassis clan following Christina on the one side, and the Kennedy clan on the other.

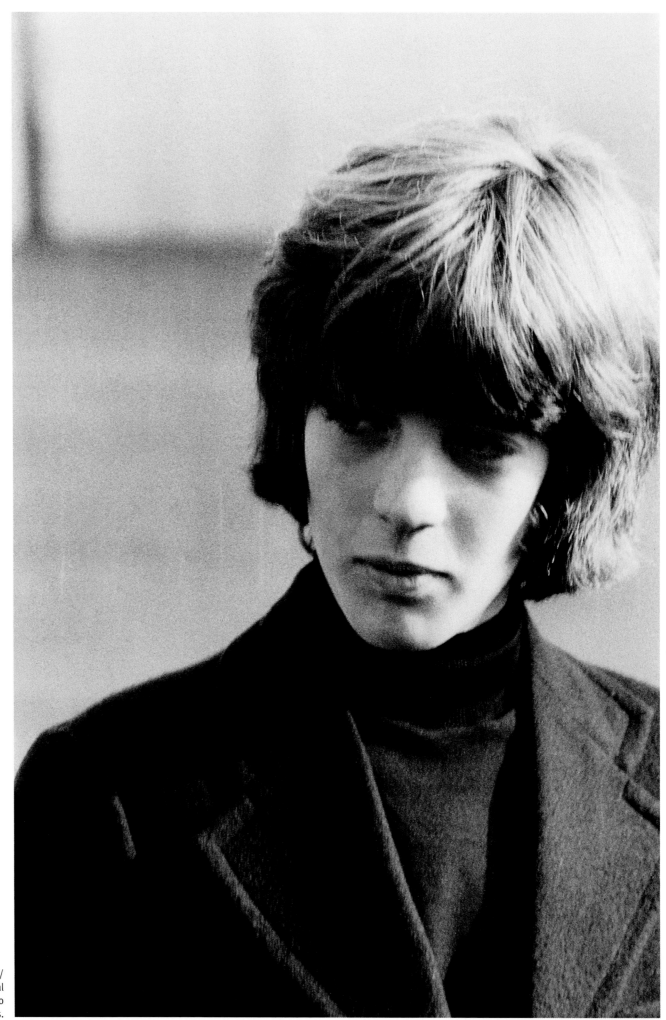

June 30, 1975 / Paris, France /
Following Aristotle Onassis's funeral
in Greece, Jackie took her children to
spend a few days in Paris.

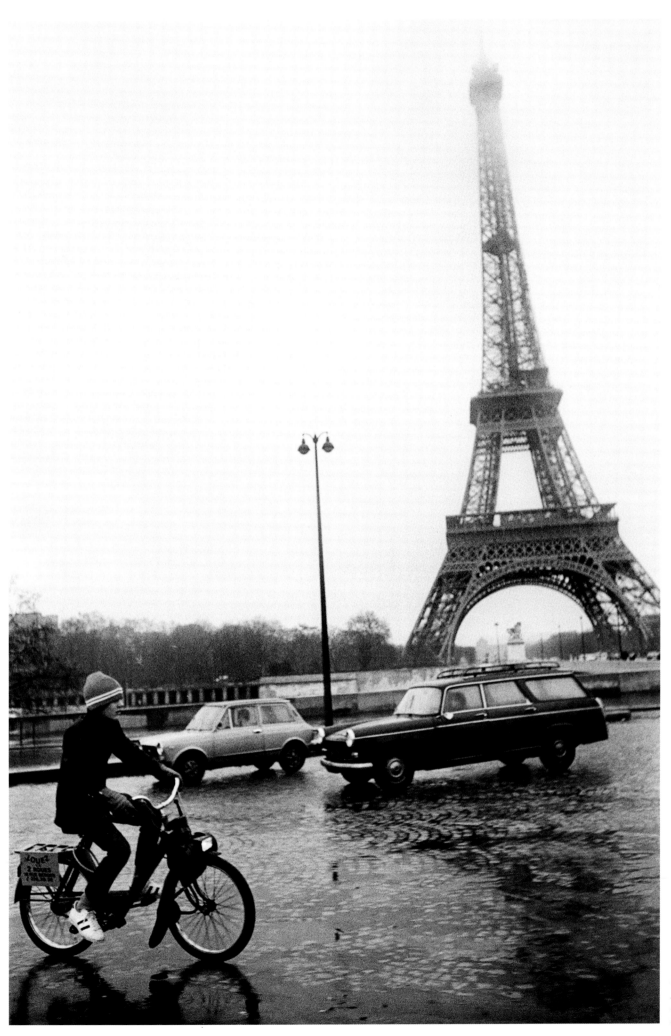

March 24, 1975 / Paris, France /
John, who had rented a moped to get
around Paris, on his way to a date
at the Trocadéro.

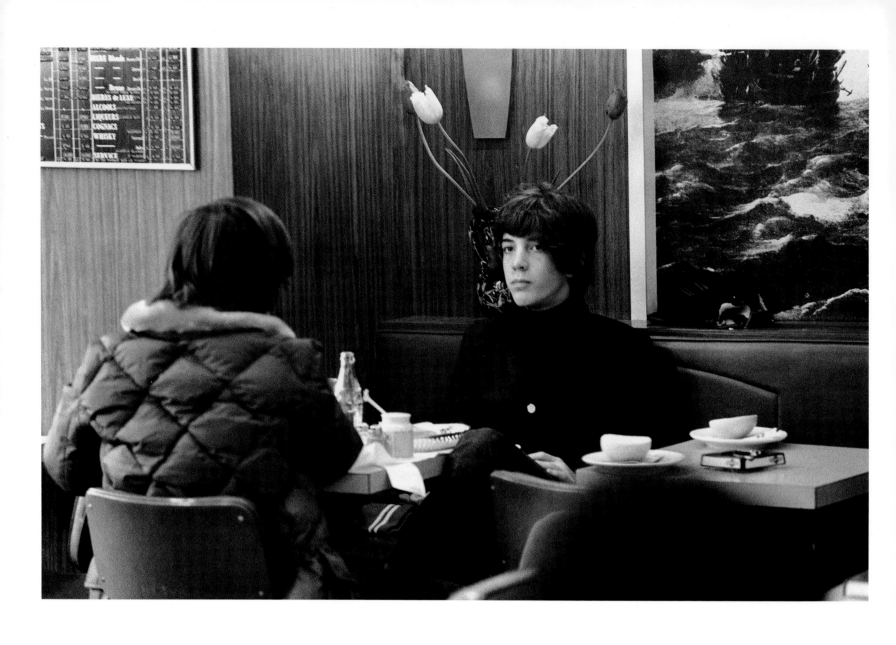

March 24, 1975 / Paris, France / Shortly after the death of Aristotle Onassis, Jackie's second husband, John Kennedy Jr. spent a few days in the French capital with his mother and sister. On this particular afternoon, he is having a drink with a friend at the brasserie Le Suffren.

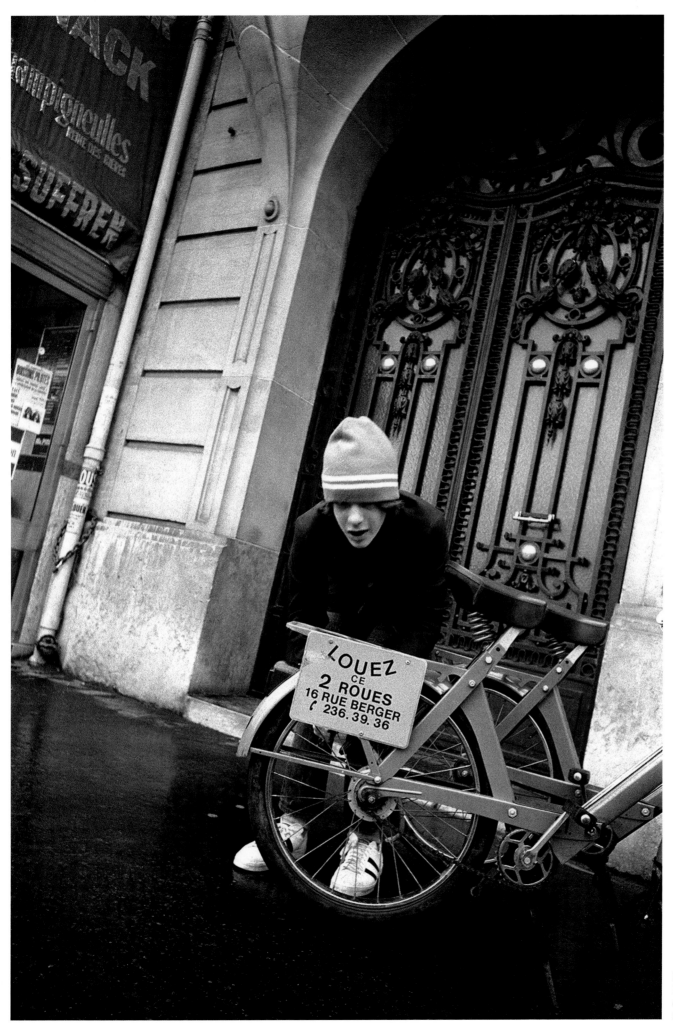

March 24, 1975 / Paris, France /
In order to get around Paris more
quickly, John decided to rent a
moped.

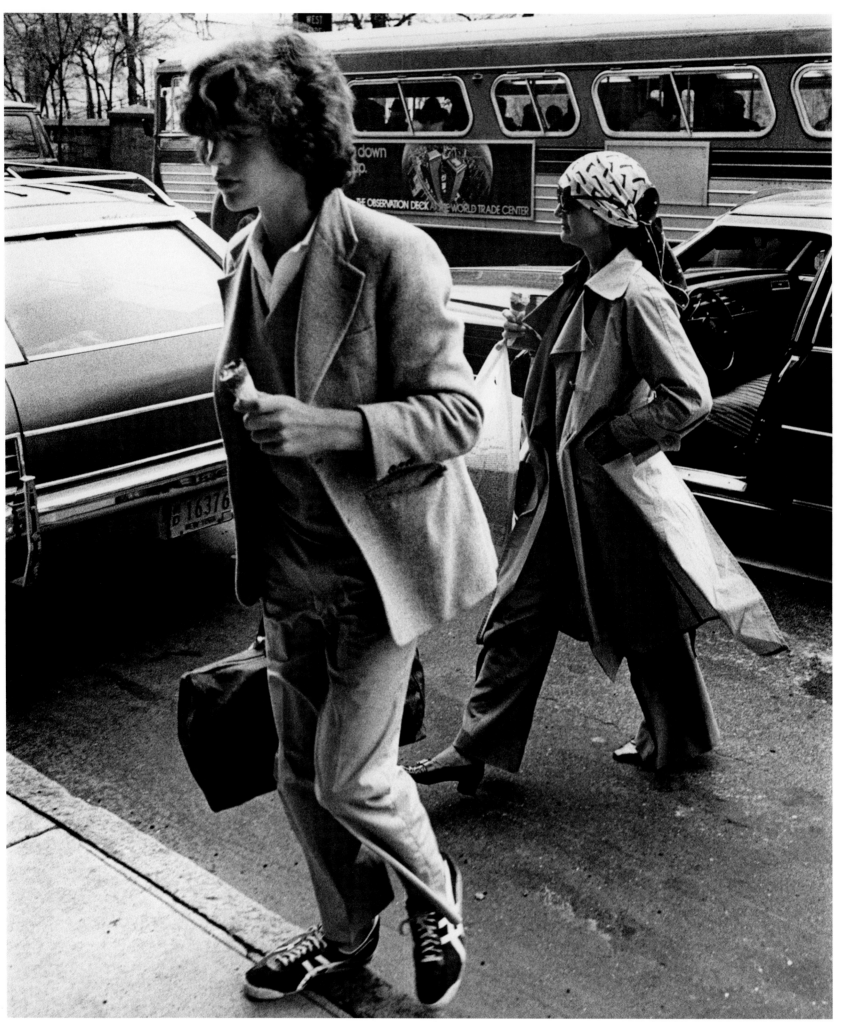

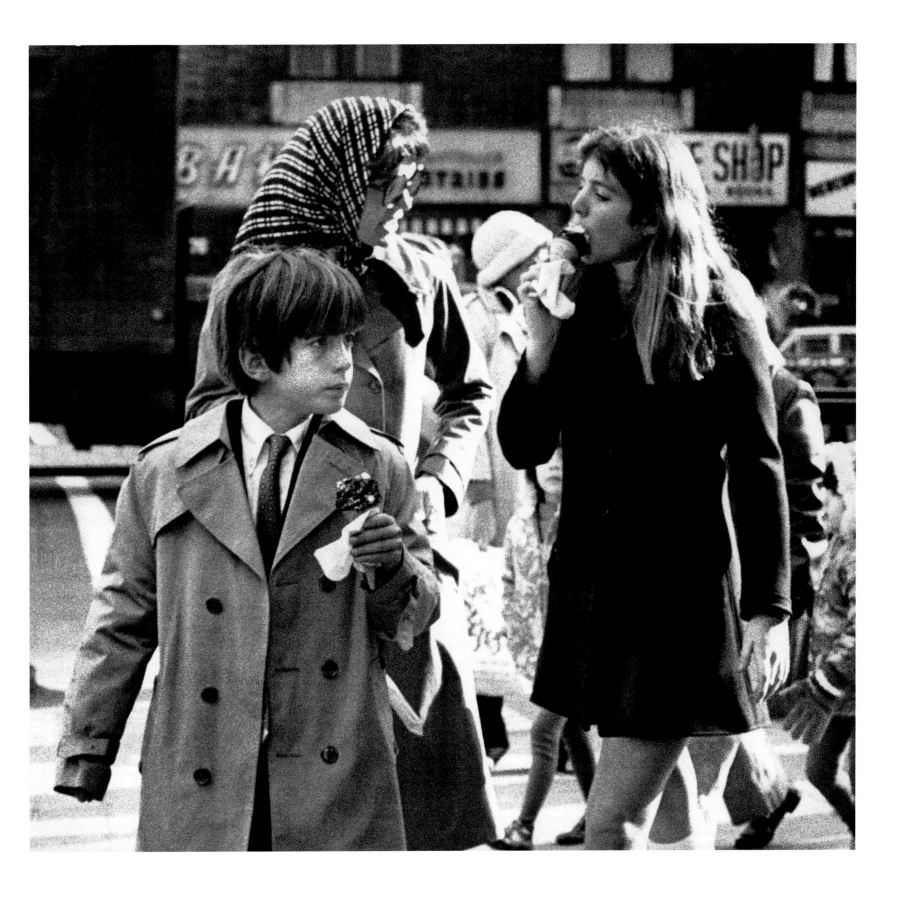

April 3, 1976 / New York, NY / Upon returning to New York from a stay in Jamaica, Jackie and her son John Jr. enjoy an ice cream.
December 17, 1970 / New York, NY / After school, John Jr., Caroline, and Jackie eat ice cream cones while walking down Broadway.

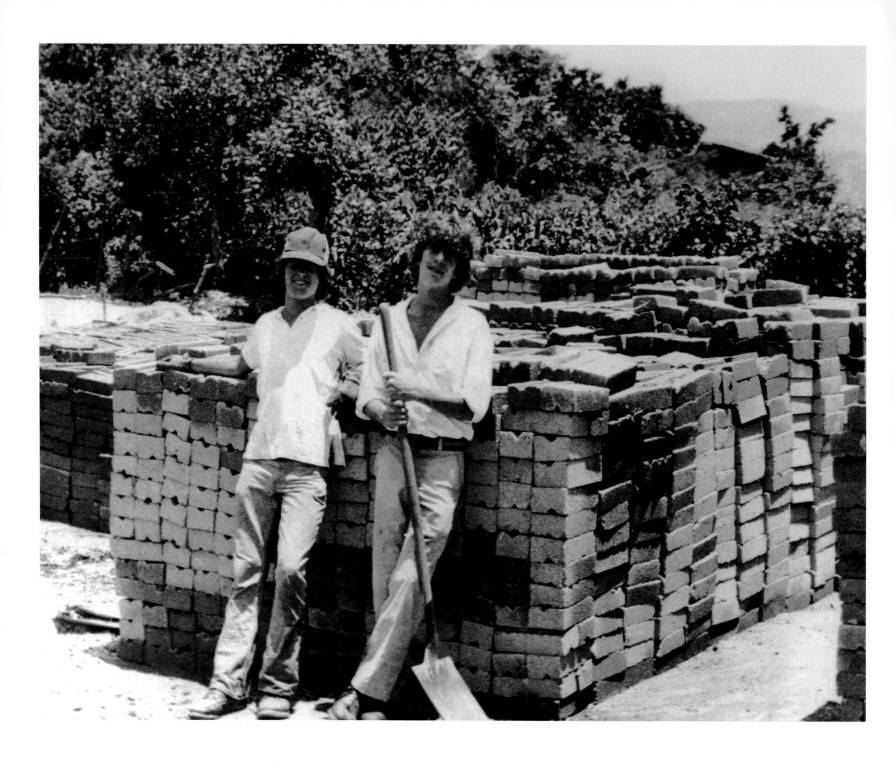

July 24, 1975 / Rabinal, Guatemala / John Jr. and his cousin Timothy Shriver, son of Sargent Shriver and Eunice Kennedy (President John F. Kennedy's sister), pose in front of a stack of bricks used to reconstruct the village of Rabinal, which had been destroyed by an earthquake five months earlier. The two young men were both members of a group of American volunteers spending the summer assisting Guatemalan disaster victims.

March 28, 1974 / Assouan, Egypt / John Jr. and Aristotle Onassis ride camels to the site of the Aga Khan's tomb.

August 26, 1977 / Forest Hills, Queens, NY / John and his girlfriend Meg Anzioni attend a Rainbow Room party thrown for the sixth annual RFK Tennis Tournament. A genuine charity event, founded in 1967 by Senator Robert F. Kennedy, this tennis tournament traditionally took place the night before the opening of the US Open, and pitted professional players against celebrities. The final RFK Tournament took place in the early eighties.

August 27, 1977 / Forest Hills, Queens, NY / John and his girlfriend Meg Anzioni attend the RFK Tennis Tournament.

"Once you run for office, you're in it. Sort of like going into the military—you'd better be damn sure that it is what you want to do and that the rest of your life is set up to accommodate that. It takes a certain toll on your personality, and on your family life. I've seen it personally." John Kennedy Jr.

December 8, 1979 / Portland, ME / John gives a passionate speech on the first day of his uncle Edward T. Kennedy's campaign for the Democratic presidential nomination, and is heartily applauded by an audience that includes the governor of Maine, Joseph E. Brennan, at right. John was accompanied by Governor Brennan on a five-day tour in support of candidate "Ted" Kennedy.

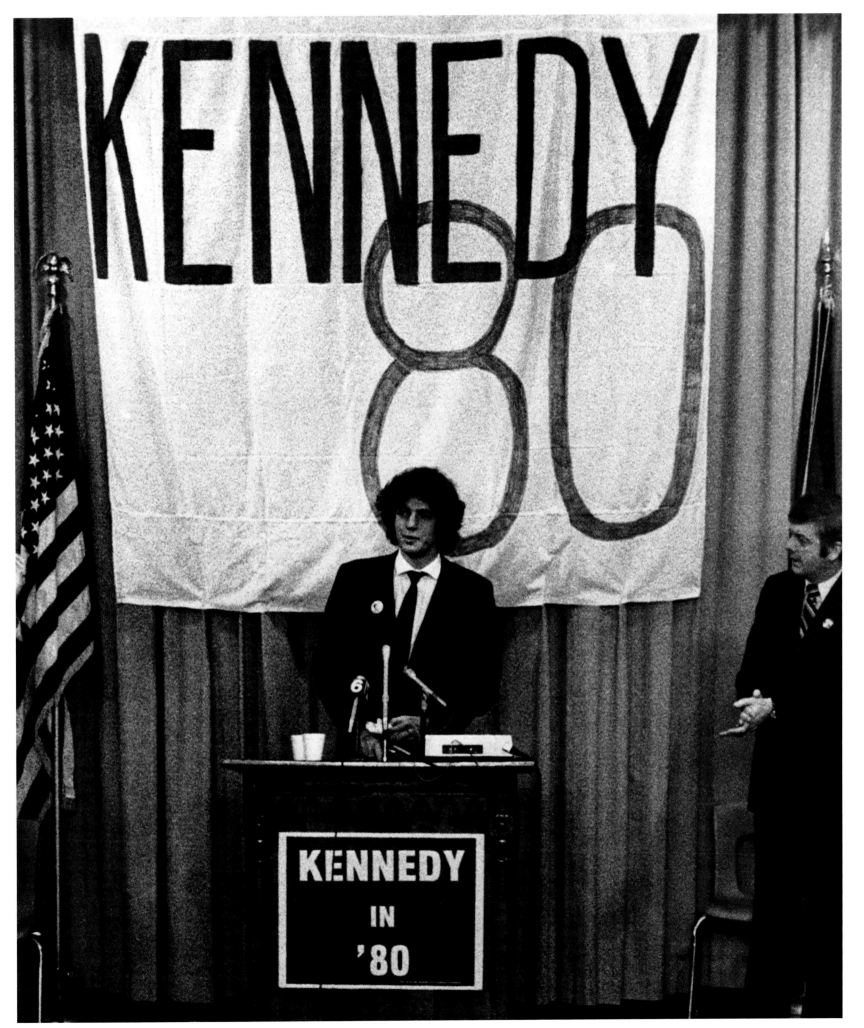

November 26, 1978 / New York, NY / John was harassed by paparazzi while he celebrated his eighteenth birthday with his friends at the nightclub Le Club. As tensions rose, John chased after the photographers to confront them.

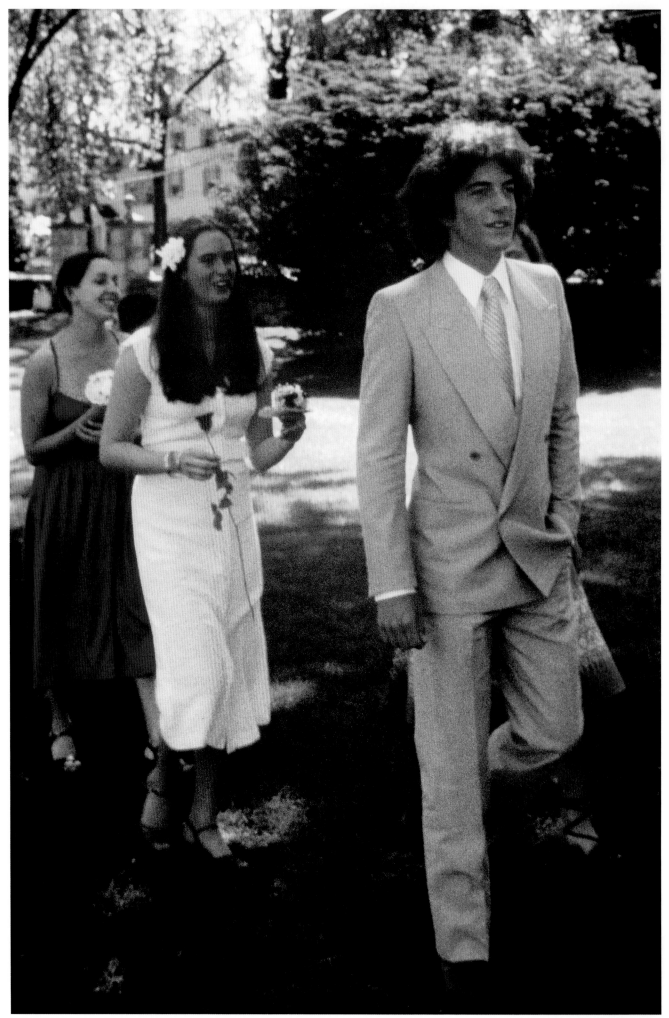

June 7, 1979 / Andover, MA / Graduation at Phillips Academy. John is followed by his girlfriend, Jeanne Christian. The next year, he entered Brown University, majoring in American history.

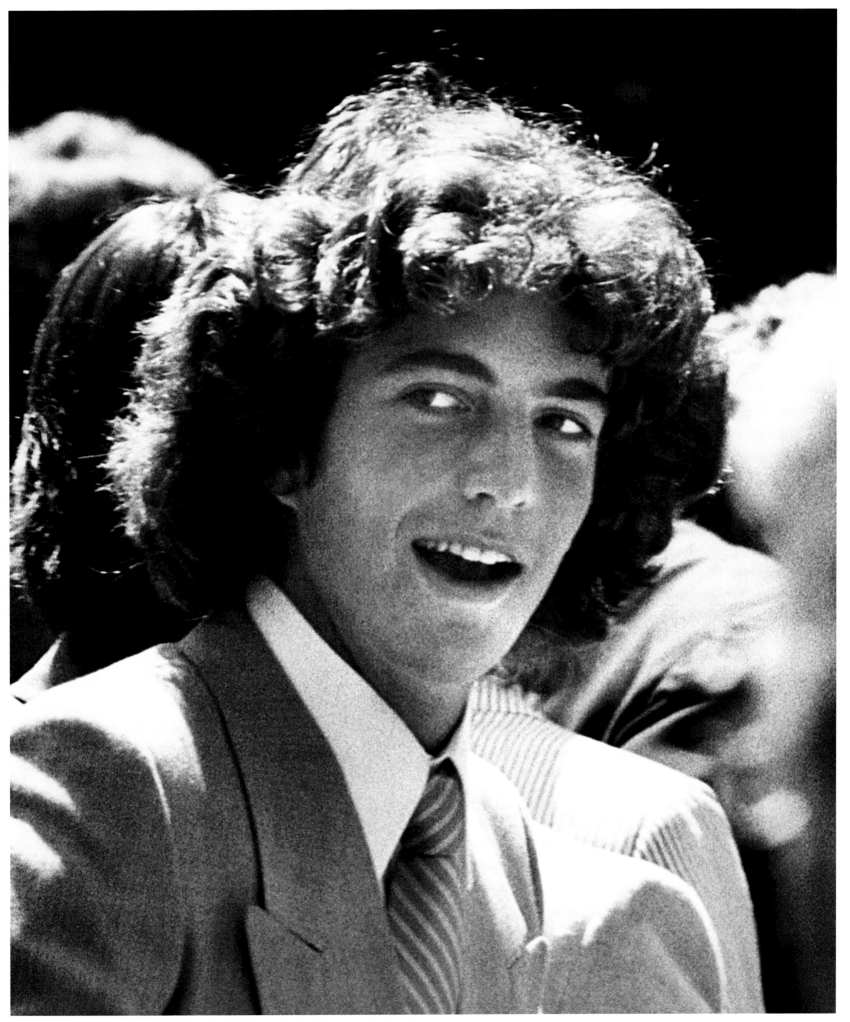

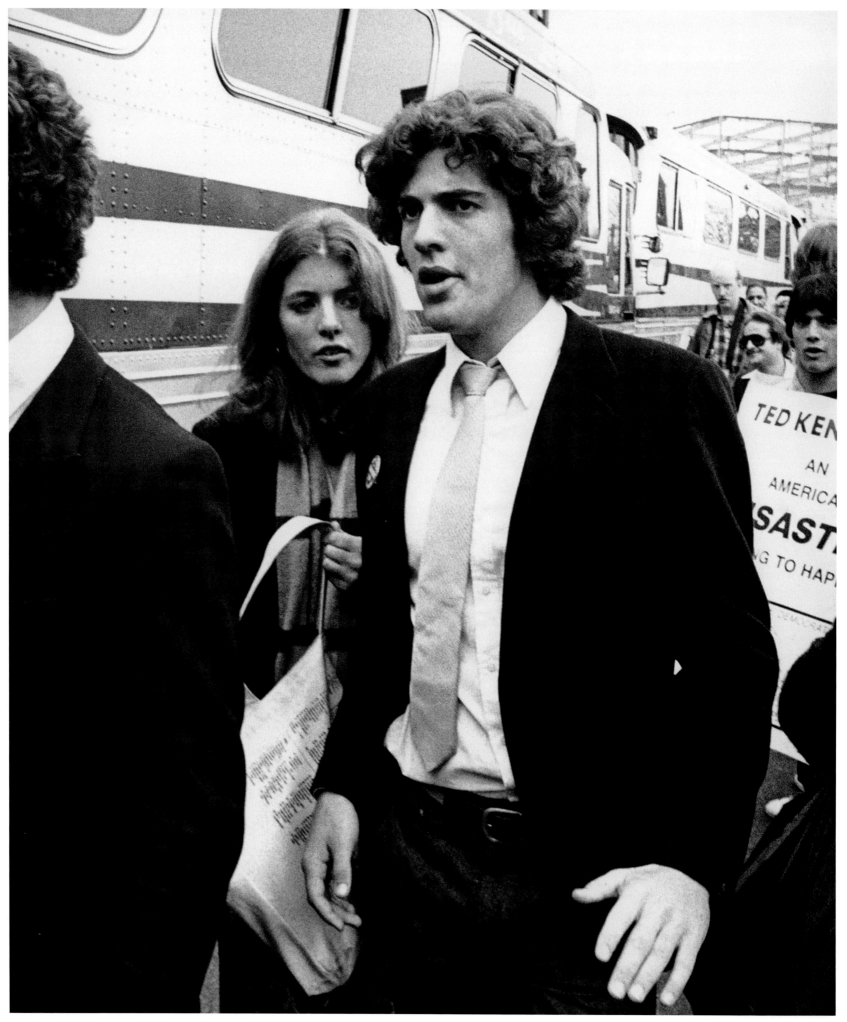

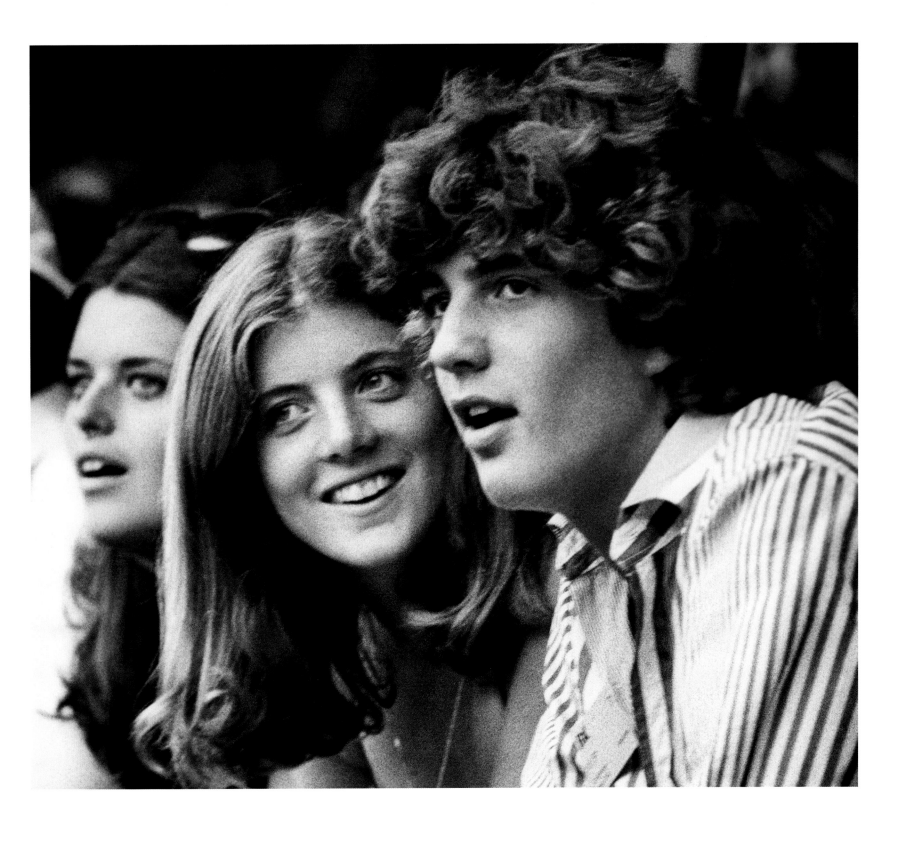

November 7, 1979 / Boston, MA / John Kennedy Jr. and his sister Caroline watch Senator Ted Kennedy announce his run for president during a press conference at Faneuil Hall.

August 26, 1977 / Forest Hills, Queens, NY / Caroline and John Kennedy Jr. attend the sixth annual Robert F. Kennedy celebrity tennis tournament, a charity event founded by Senator Robert Kennedy in 1967. The tournament consisted of a series of informal tennis games between professional players (including Arthur Ashe and Ilie Nastase) and celebrities.

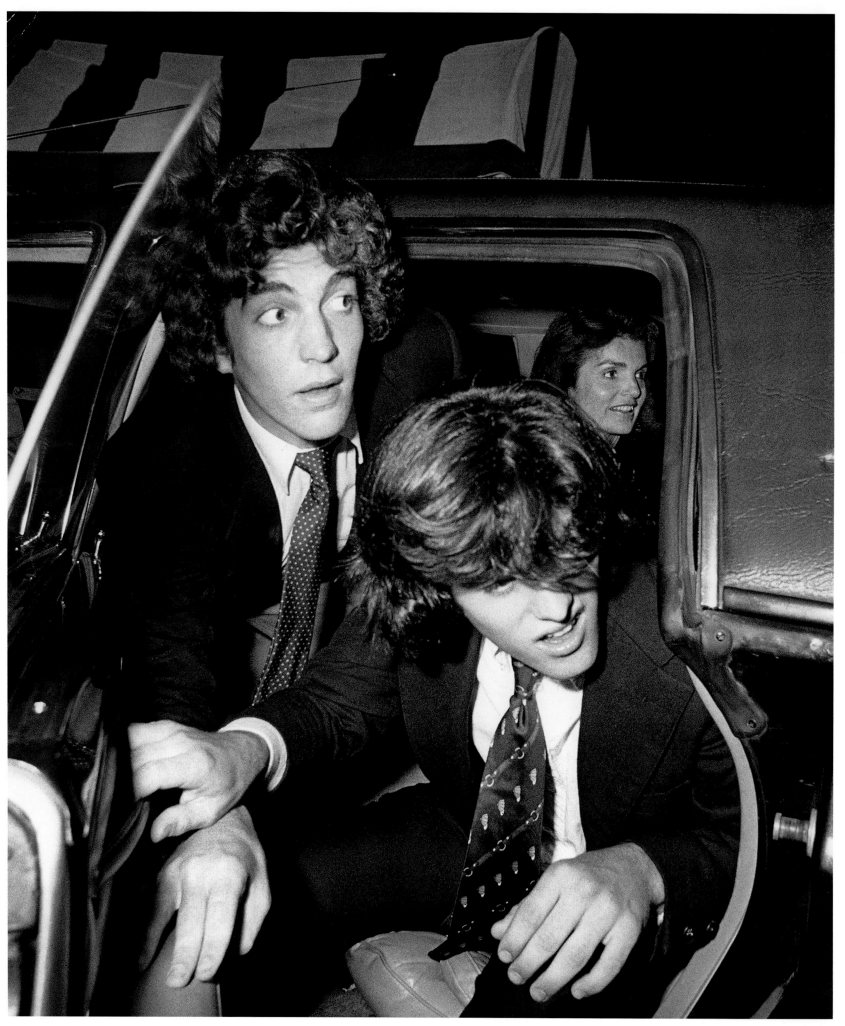

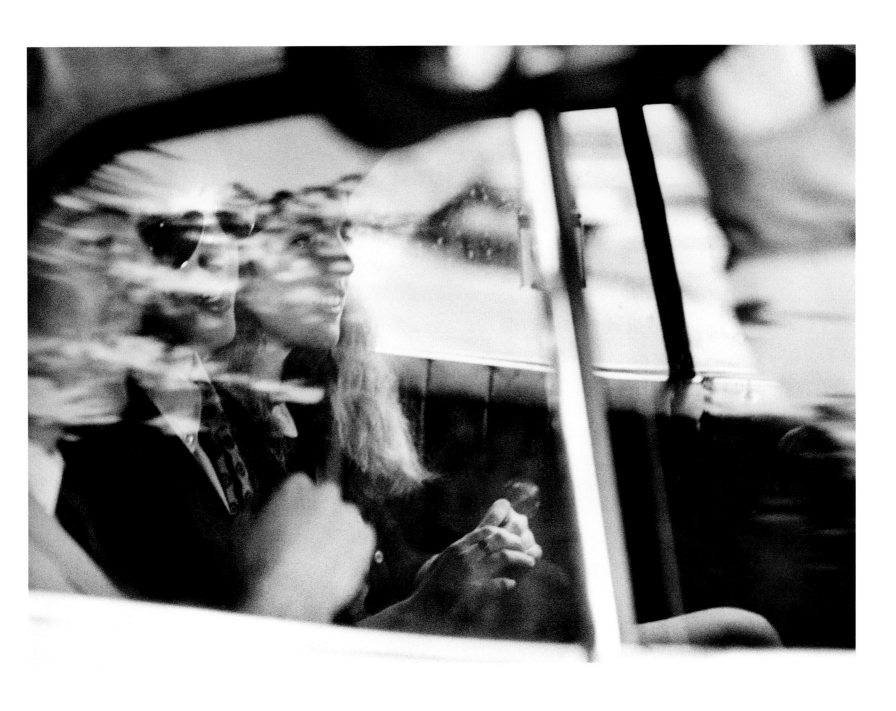

October 19, 1979 / Boston, MA / Jackie, John Jr., and his cousin wait for Caroline, who is running late, to go to the inauguration of the John F. Kennedy Library, on the campus of the University of Massachusetts.

June 4, 1975 / Concord, MA / After getting her high school diploma, Caroline Kennedy joins four friends in an old cabriolet parked behind the dorms to go celebrate.

"We're a family like any other. We look out for one another. The fact that there have been difficulties and hardships, or obstacles, make us closer." John, 1993

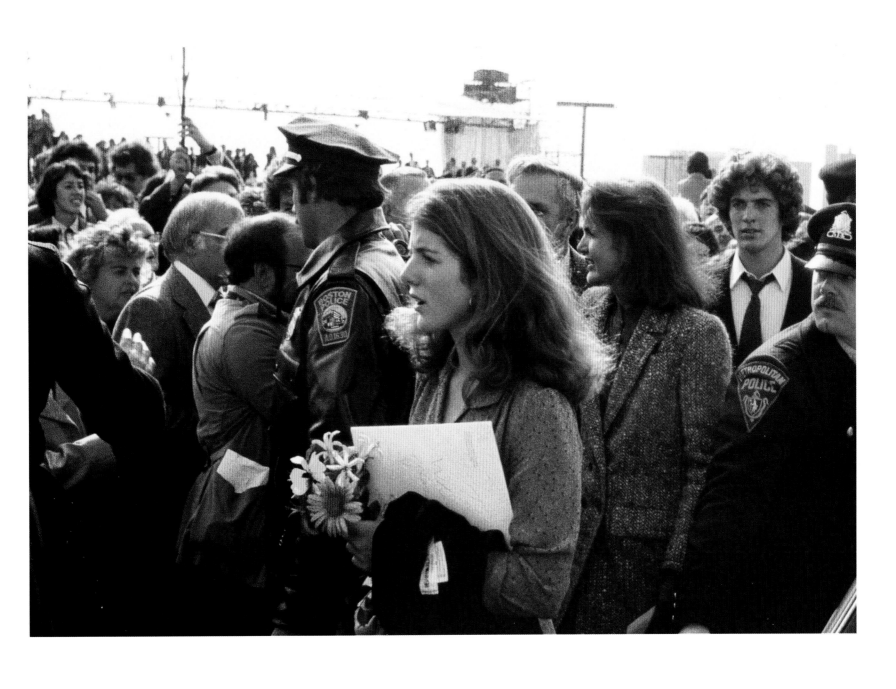

October 19, 1979 / Boston, MA / A large crowd gathered to applaud Jackie Kennedy and her children, Caroline and John Jr., as they inaugurate the JFK Library. This museum, dedicated to the memory of John Fitzgerald Kennedy and the archives of his presidency, was conceived by architect I.M. Pei, who also designed the Pyramide du Louvre in Paris.

June 5, 1980 / Cambridge, MA /
John Jr. watching his sister Caroline
and his cousin Michael's graduation
from Harvard.

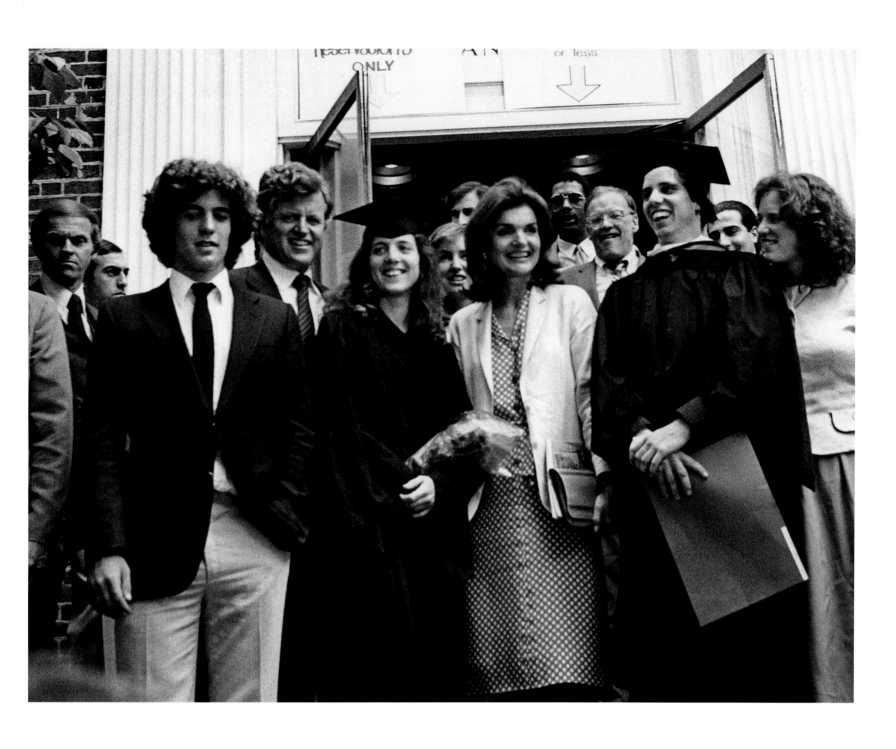

June 5, 1980 / Cambridge, MA / On the day of their graduation from Harvard, Caroline and Michael Kennedy pose with, from left to right, John, Ted, Courtney, Jackie, and Kerry Kennedy.

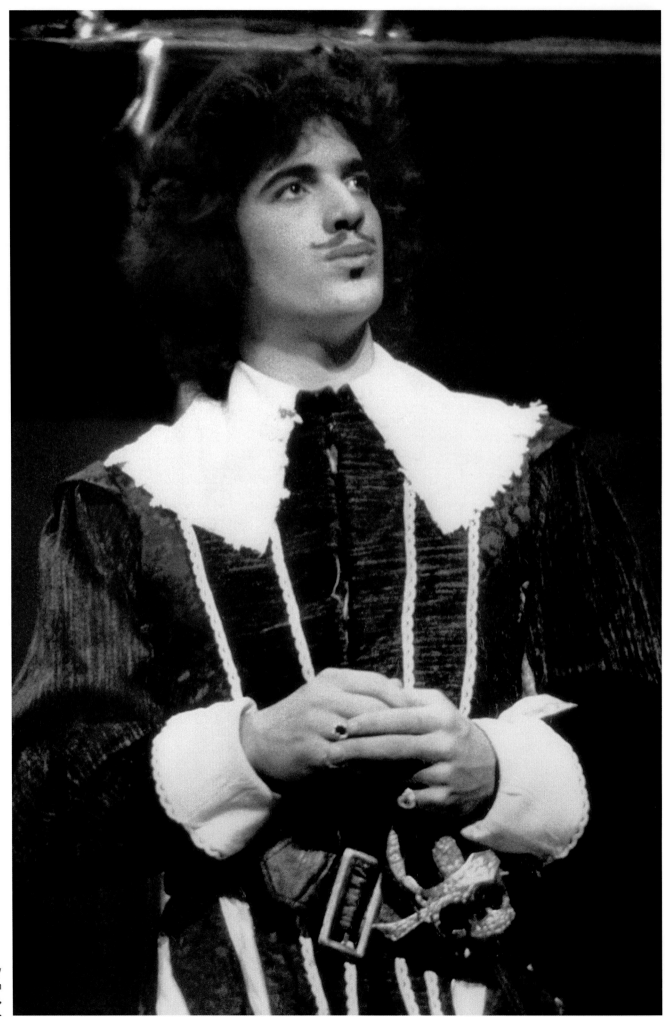

March 14, 1980 / Providence, RI /
As a first year student at Brown, John
played Bonario, a soldier in *Volpone*,
the 1606 play by Ben Johnson.

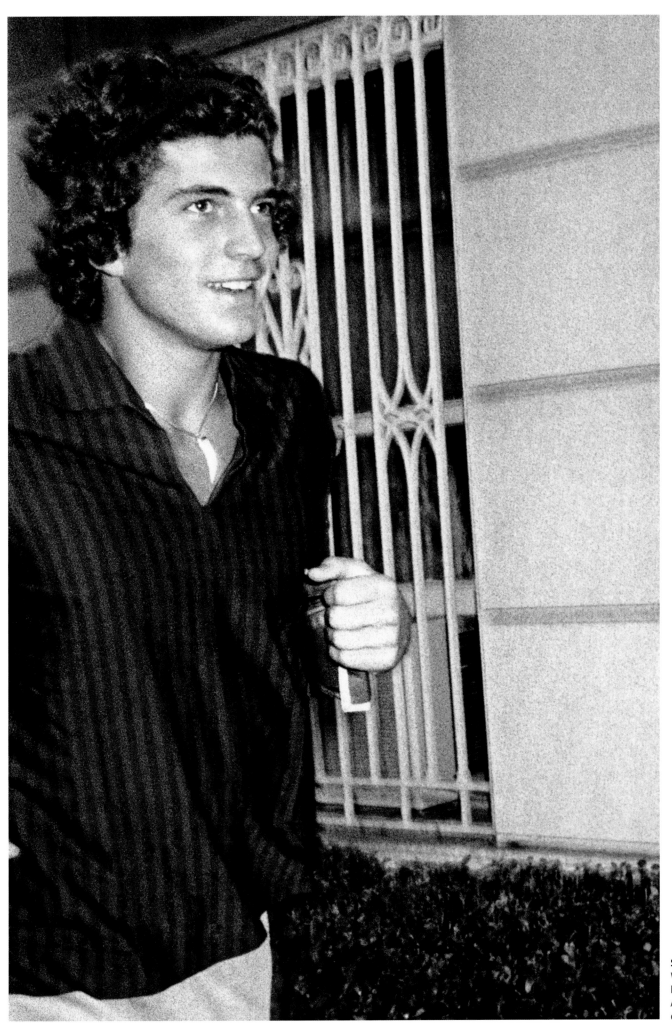

September 13, 1980 / New York, NY / Wearing casual clothes, John leaves his mother's apartment on Fifth Avenue to attend a free Elton John concert in Central Park.

"Flying is the most fun I've had with my clothes on." John

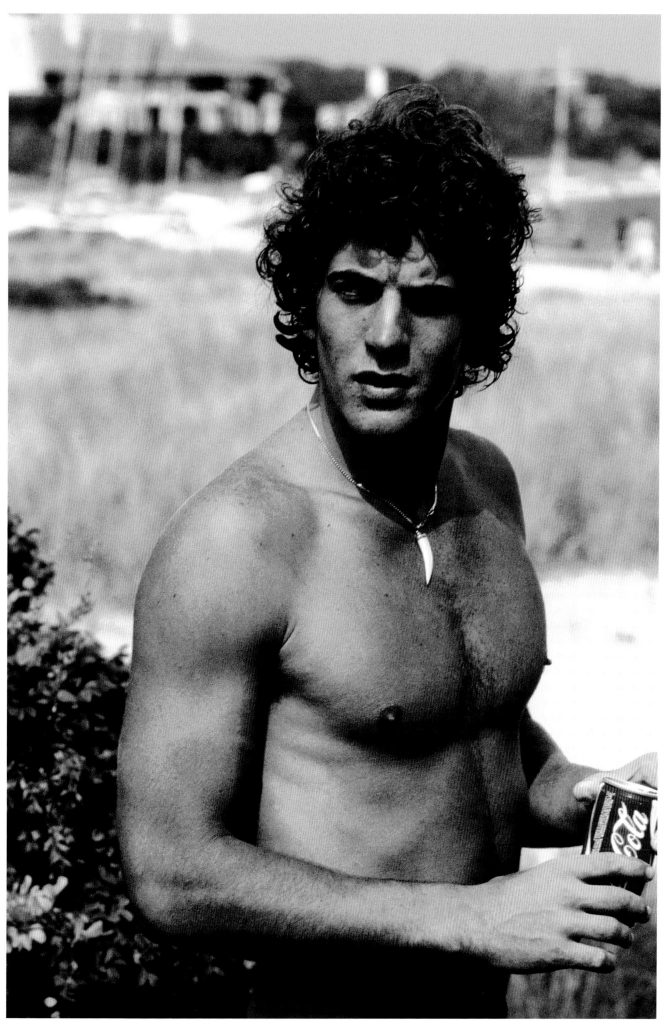

September 1, 1980 / Hyannis Port, MA / John takes advantage of Labor Day to go sailing with his cousins in Hyannis Harbor.

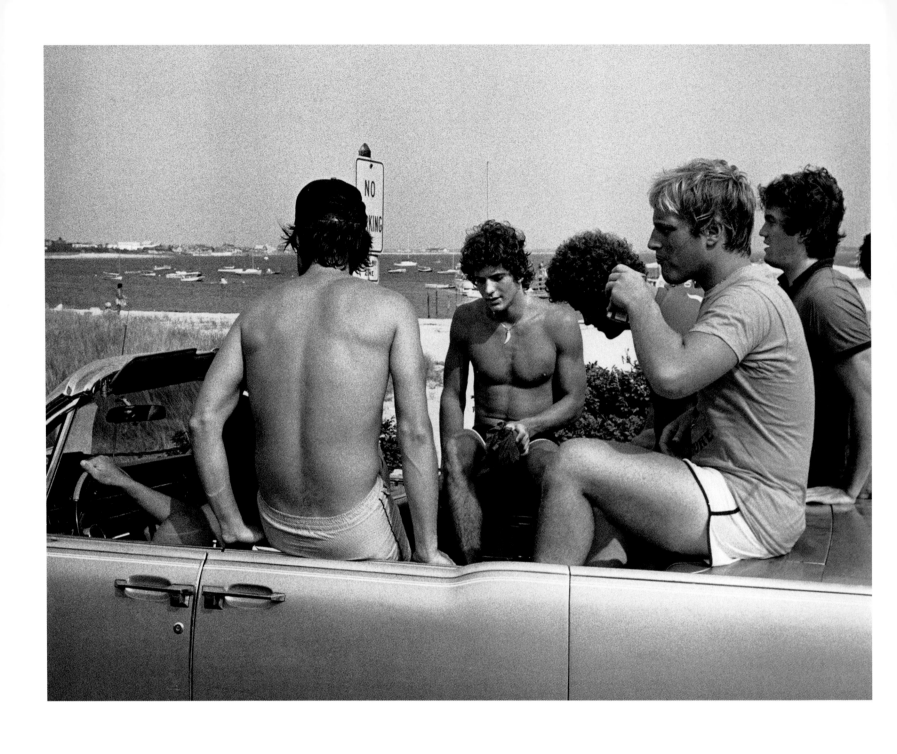

September 1, 1980 / Hyannis Port, MA / John Jr. goes to the beach to go sailing with a few friends over Labor Day weekend. He has just started his first year at Brown, where he has chosen to major in American History. At the time, when asked about his future plans, John would vacillate between committing to politics or beginning a career in Hollywood—much to his mother's chagrin.

August 31, 1980 / Hyannis Port, MA / After having spent the summer in Africa, John began his first year at Brown. Here, he sails with his cousins off Hyannis Port, where the Kennedy clan regularly gathered, on Labor Day.

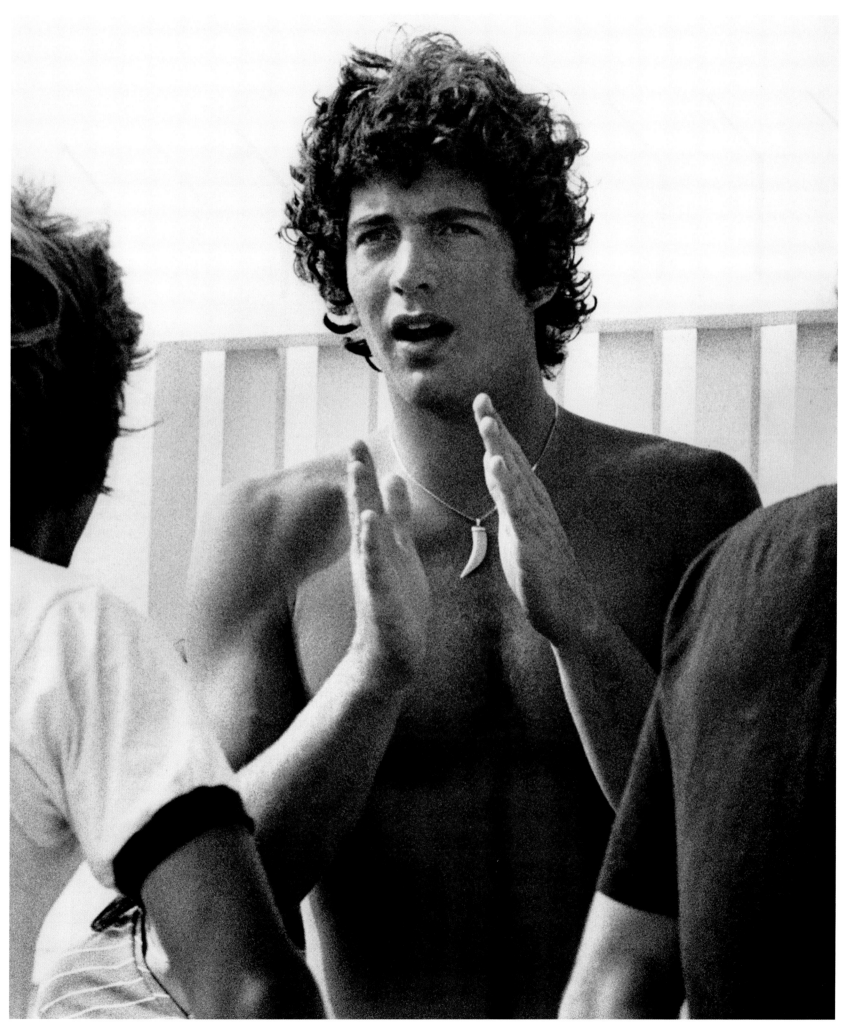

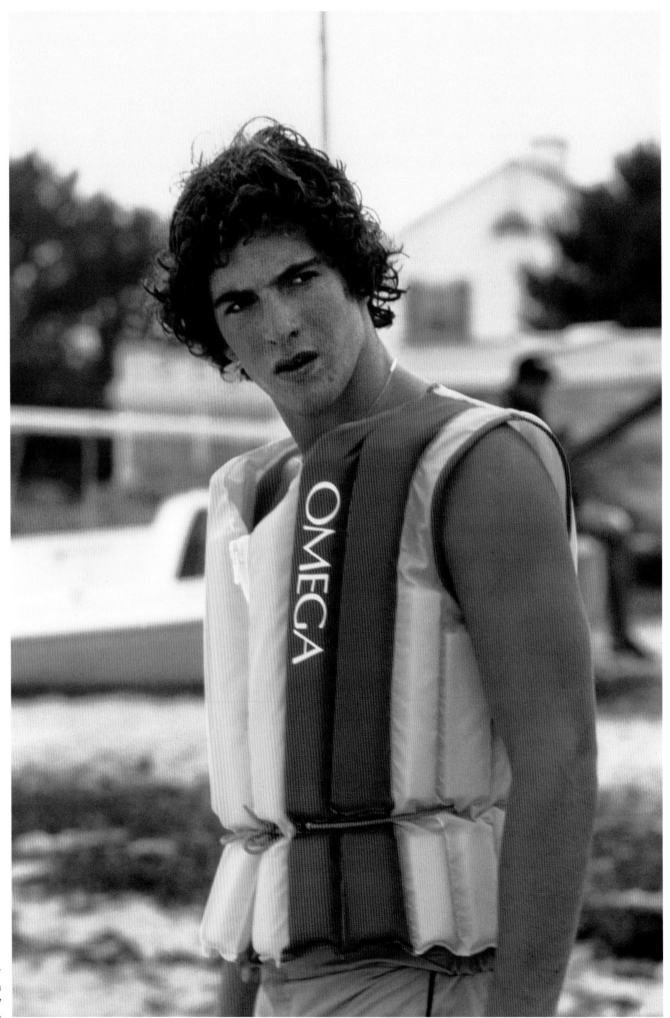

September 13, 1980 /
Hyannis Port, MA / John Jr. sailing on
Hyannis Harbor, near the family
compound.

144

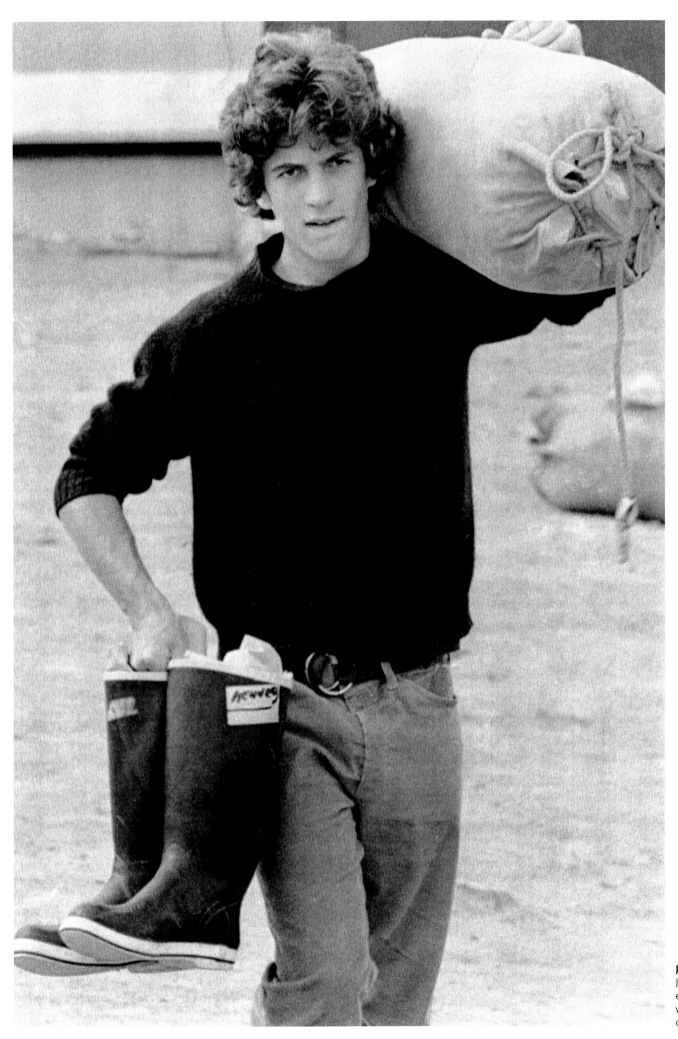

July 12, 1977 / Rockland, ME / John Kennedy Jr. carries his equipment onto a boat on which he will be sailing for twenty-six days.

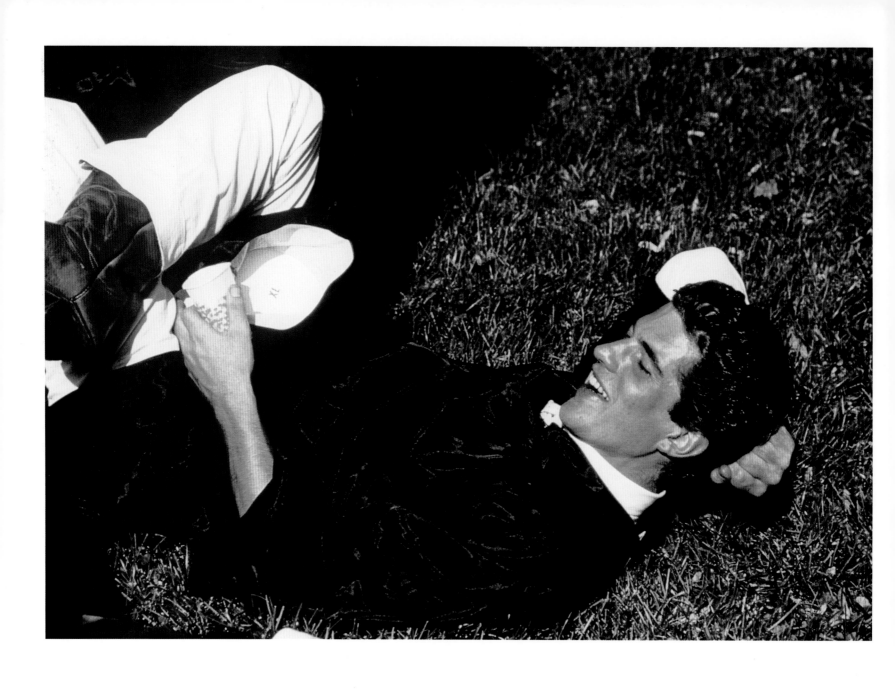

June 4, 1983 / Providence, RI / Graduation at Brown University, where John Kennedy Jr. studied Liberal Arts, and was pledged to the Phi Kappa Psi fraternity.

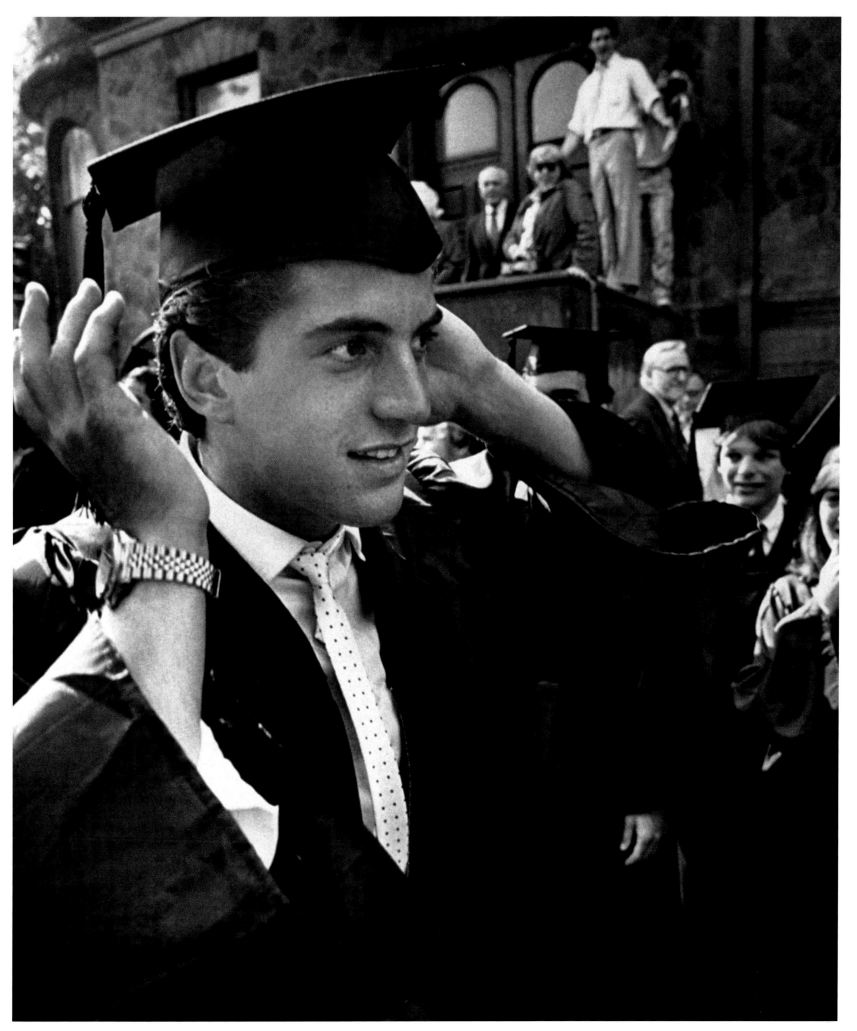

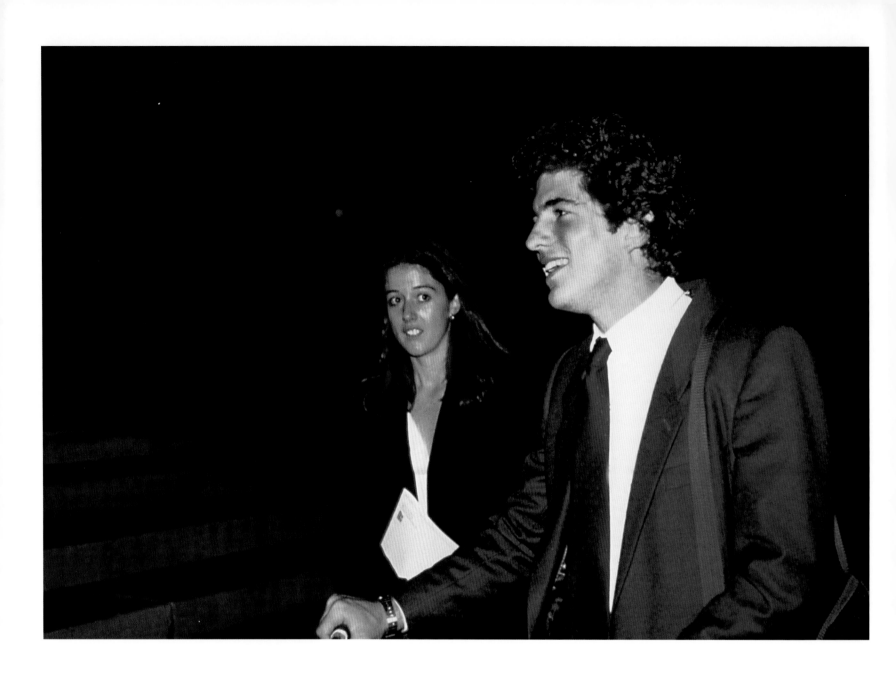

1984 / New York, NY / John Kennedy Jr. and his friend Sally Munro, a fellow student at Brown.

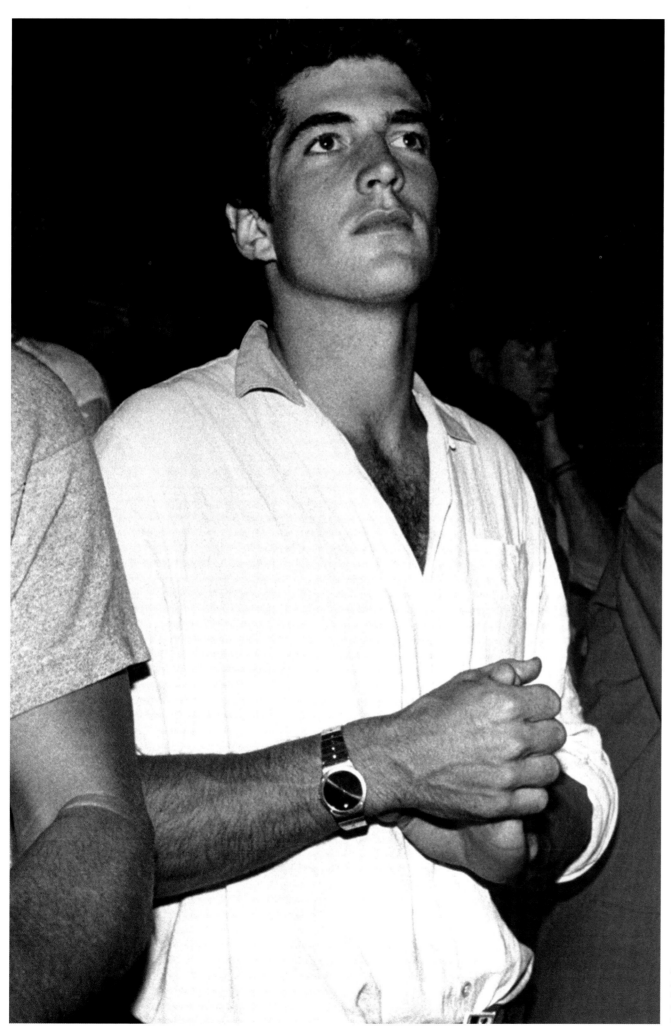

June 11, 1985 / New York, NY / John attends a Madison Square Garden concert by Madonna, with whom he would have a fling some years later.

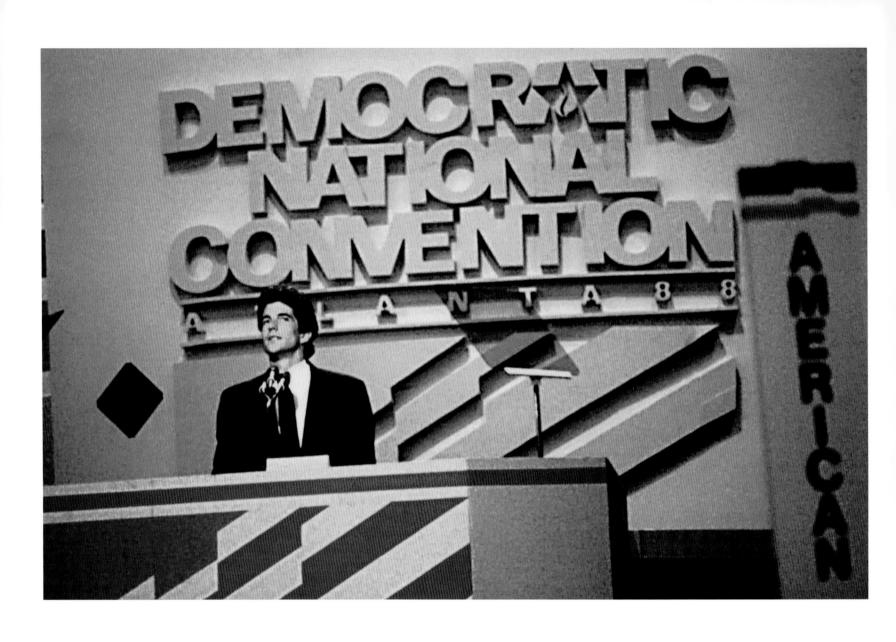

April 1, 1988 / New York, NY / John Kennedy Jr. gives an enthusiastically received speech at the Democratic National Convention.

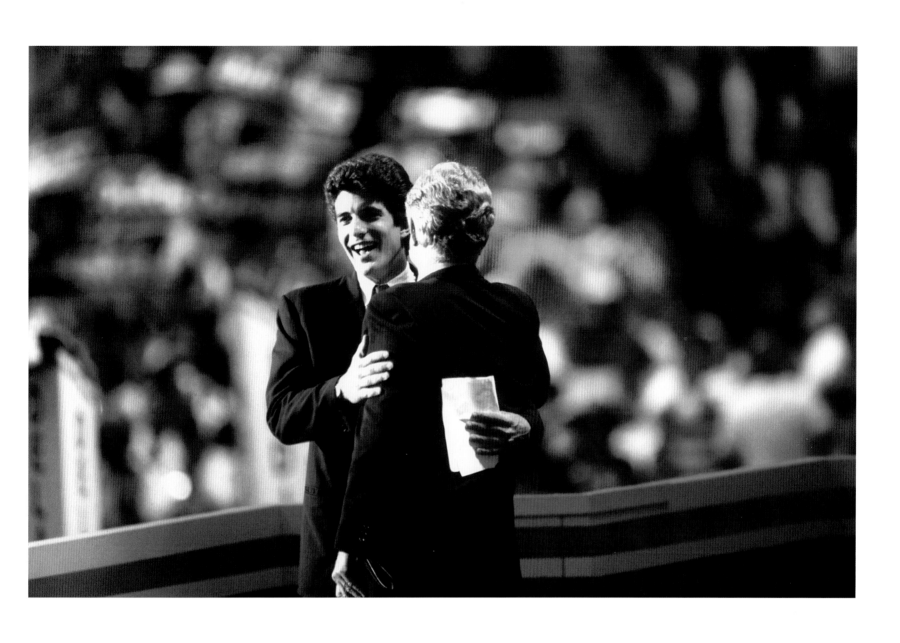

January 1, 1988 / Atlanta, GA / After receiving an ovation at the Democratic National Convention, John Kennedy Jr. welcomes his uncle Ted Kennedy, who has come to address his fellow Democrats.

"I always grew up living a fairly normal life. I thank my mother for doing that. I always took the bus. I always took the subway. Hotel suites and limos.... Whew! Forget it." John

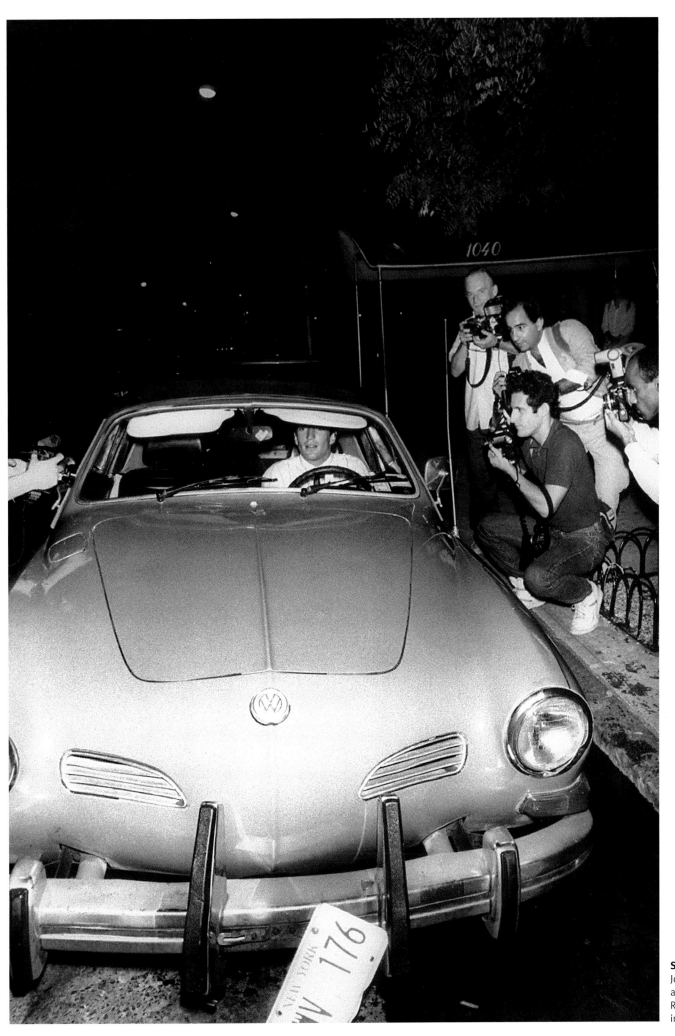

September 24, 1988 / New York, NY/ John is swamped by photographers as he arrives at his aunt Lee Radziwill's wedding to Herbert Ross in his Volkswagen Karmann Ghia.

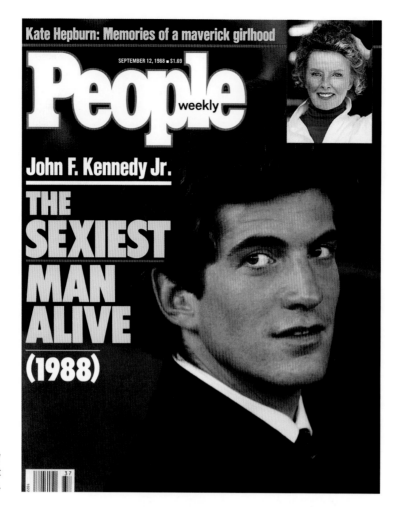

Kate Hepburn: Memories of a maverick girlhood

SEPTEMBER 12, 1988 • $1.69

People weekly

John F. Kennedy Jr.

THE SEXIEST MAN ALIVE

(1988)

September 12, 1988 / New York, NY / John Kennedy Jr. is dubbed the "Sexiest Man Alive" by *People* magazine.

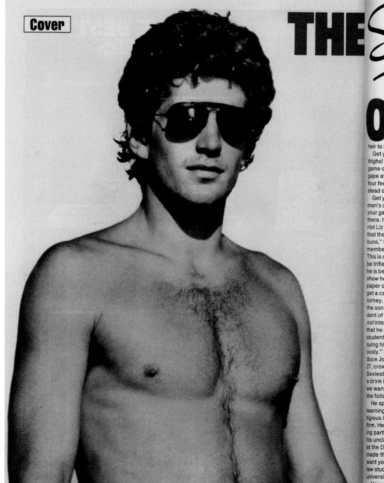

Cover

THE *Sexiest* KENNEDY

The pecs, the pedigree, the charm, the torso—who else but JFK Jr. could be the Hunk of the Year?

By Joyce Wadler

Okay, ladies, this one's for you—but first some ground rules. GET YOUR EYES OFF THAT MAN'S CHEST! He's a serious fellow. Third-year law student. Active with charities. Scion of the most charismatic family in American politics and heir to its most famous name.

Get your eyes off that man's extraordinarily defined thighs! What do you think, he strips down to his shorts for a game of touch football in Central Park so strangers can gape at them? They are fantastic, though. Measure three, four feet around. Legend has it that if he lived in Tahiti, instead of Manhattan, he could crack coconuts with them.

Get your eyes off that man's derriere! We saw your gaze wandering back there. It is true that columnist Liz Smith has noted that the boy "has gorgeous buns," but you've got to remember: He has a *mind* too. This is one hunk who won't be trifled with. Report that he is being courted as a talk show host, as a New York paper once did, and you'll get a call from the family attorney, reminding you that the son of the 35th President of the United States is *not* interested in showbiz, that he is a "full-time" law student and that he is "pursuing his studies very seriously." So before we introduce John F. Kennedy Jr., 27, crown him this year's Sexiest Man and stand him a drink (he likes tequila), we want to remind you of the following:

He spent the summer learning law at a *very* prestigious Los Angeles law firm. He attends roller-skating parties to raise funds for the inner city. He introduced his uncle Teddy (D-Mass.) at the Democratic National Convention in Atlanta and made the crowd misty-eyed and nostalgic. He is—and we want you to note we are saying this *three* times now—a law student, at New York University, no less, a major university.

Now you can look at his tushie.

John F. Kennedy Jr., unlike PEOPLE's previous selections as Sexiest Man of the Year—Mel Gibson, Mark Harmon and Harry Hamlin—isn't a professional actor. He doesn't make his living by being on public display. The folks around him argue that he is a private citizen, and his mother, Jacqueline Onassis, has gone to some lengths to keep the press away from her family. But he has been in the public eye for more of his life than any other figure except members of the British royal family—from the time we knew him by his private family name, "John-John," and watched him—as a 3-year-old boy—stand with his mother at the funeral of his father. The nation has followed his life through his studies at Phillips Academy in Andover, Mass., and on through Brown University, from which he graduated in 1983 with a B.A. in history.

When did we first notice his spirit? When, at 14, he belted paparazzi with snowballs on the slopes at Gstaad, or when, at 16, he spent three days alone on an uninhabited island off Maine during an Outward Bound project?

When did we first notice his social conscience? No, forget it. You really don't care about his work for his aunt Jean Kennedy Smith's Very Special Arts program for people with learning disabilities, or that he's considered a friendly, decent, remarkably down-to-earth guy who once followed a stranger down the street to return the five bucks the man had dropped.

You'd rather hear some wild tales about his showing up at a Halloween party in Manhattan at 3 a.m. last year as Golden Boy, covered in glitter, or how at Brown, he and his roommate kept a baby pig in the basement of the Phi Psi fraternity house.

There were some "obnoxious types" in the fraternity, an old frat brother says, "but John wasn't one of them. At Brown he was very undercover, and he didn't have any attitude."

What was that, C.W. in Tulsa? You want to know what he

What a difference a quarter century makes. "John-John," who romped with his father, President John F. Kennedy, in the Oval Office in 1962, has grown up (left)—and how!

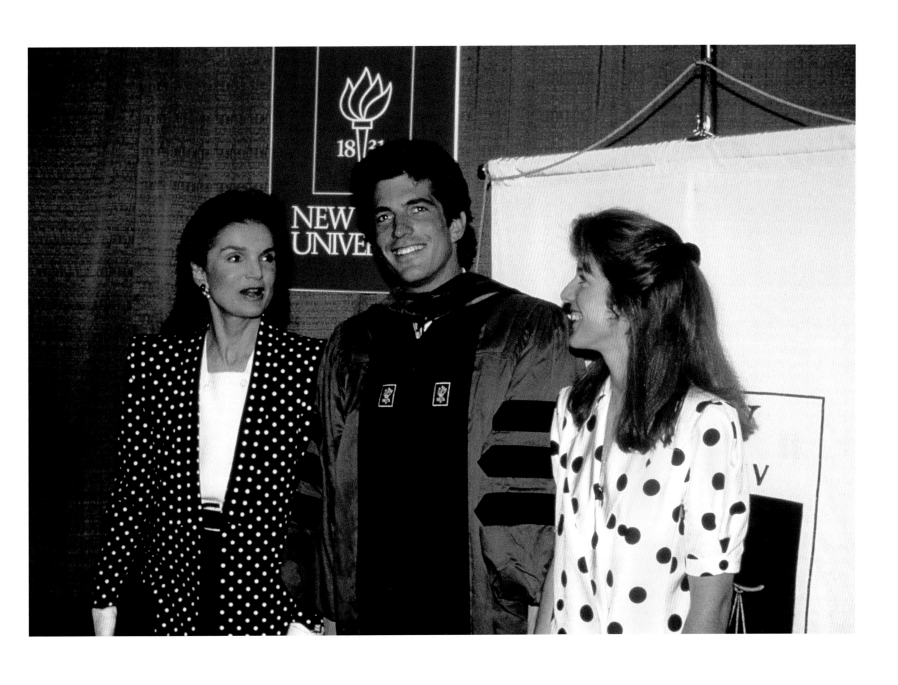

June, 1989 / New York, NY / Jackie and Caroline attend John's graduation from New York University School of Law.

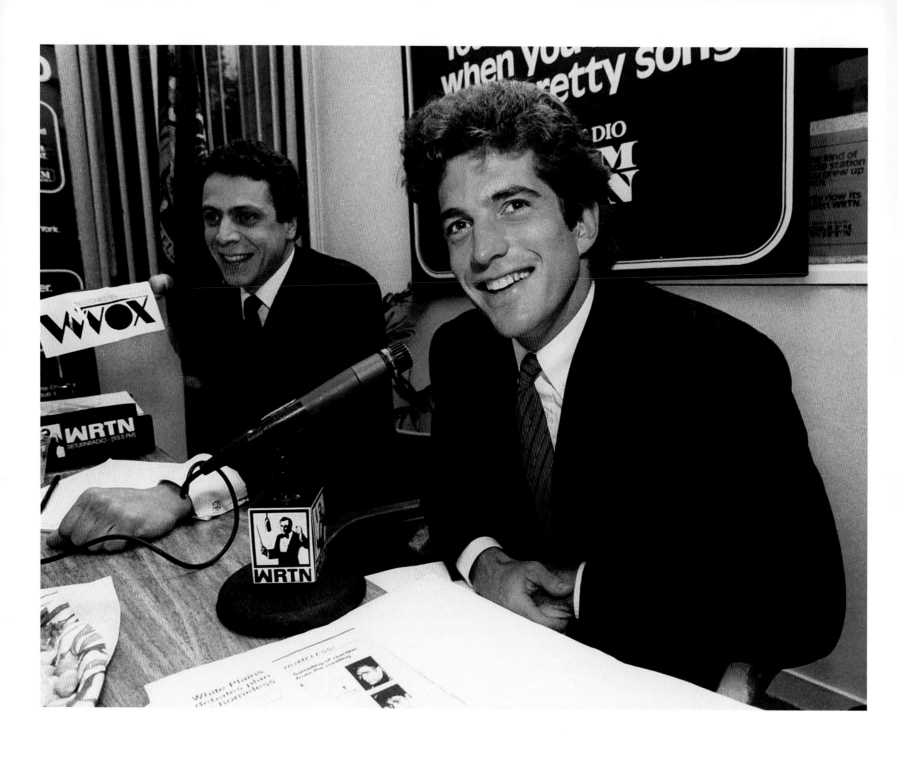

May 17, 1989 / New Rochelle, NY / Andrew Cuomo, the thirty-one-year-old son of the governor of New York, participates in a radio interview with John Kennedy Jr. At the time, Andrew Cuomo was the head of HELP, a non-profit organization devoted to building temporary shelters for homeless women and children. John told listeners he would have no problem seeing shelters built in Hyannis Port.

13 PPB 23 KODAK 5113 PPB · 24 KODAK

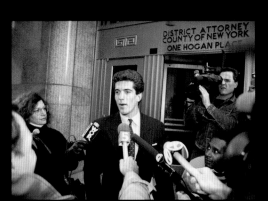

22A 23 ▷ 23A 24 ▭

13 PPB 25 KODAK 5113 PPB 26 KODAK 5113 PPB 27 KODAK 51

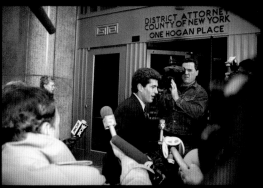
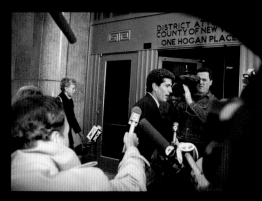

24A 25 ▷ 25A 26 ▷ 26A 27 ▷

August 21, 1989 / New York, NY / John smiles at the numerous journalists gathered to watch him start his first day of work for the Manhattan district attorney. Following his graduation from New York University School of Law, John began his public career as a prosecutor in the district attorney's office. The press saw this as a first step in a logical progression towards the post of district attorney, then to politics, but it was not to be.

"Sometimes I can't remember what really happened, and what I saw in pictures." John

158

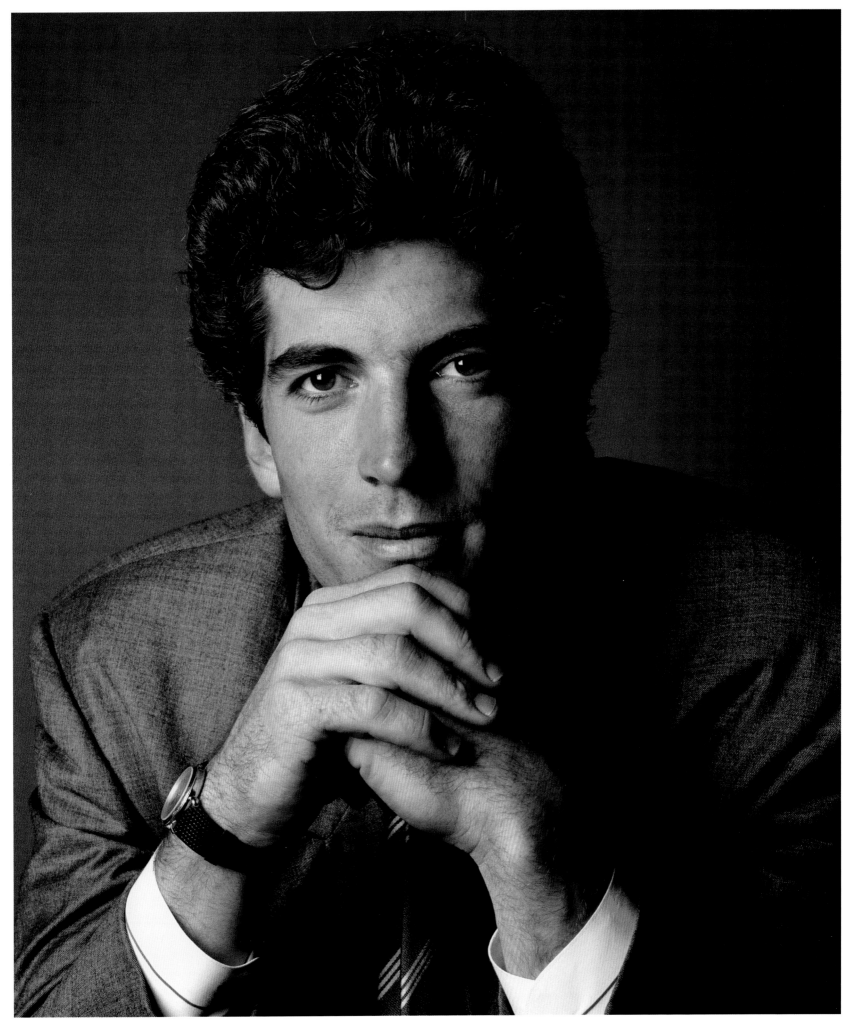

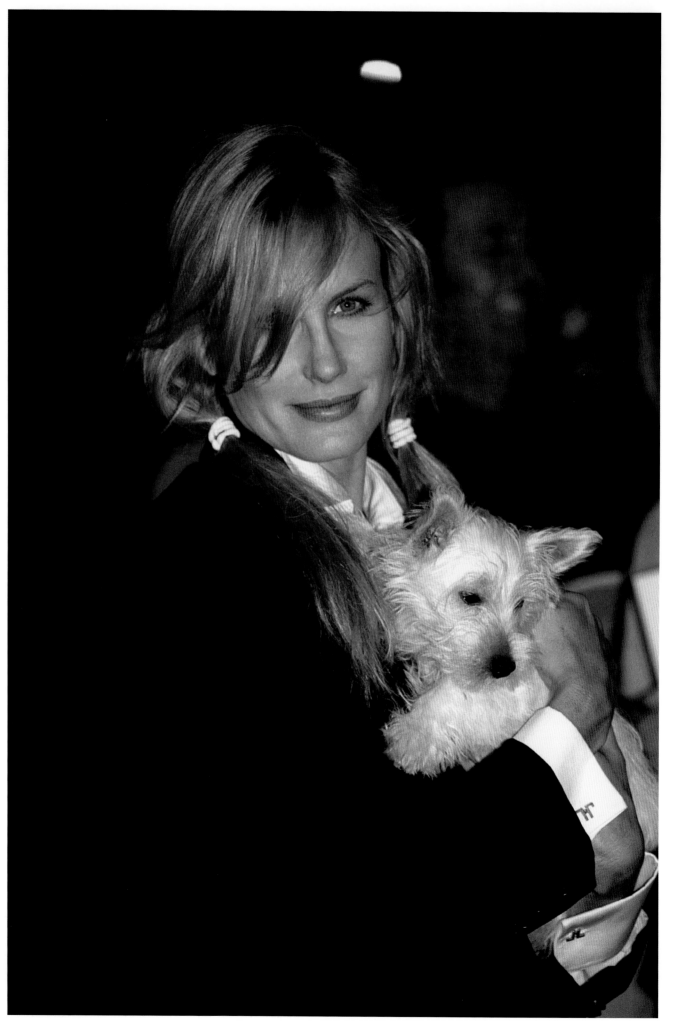

July 9, 1997 / New York, NY / Portrait of actress Daryl Hannah, John's girlfriend from 1990 to 1993. The prolific actress has appeared in *Splash*, *Wall Street*, and *Kill Bill*, among others.

March, 1993 / New York, NY / John and then-girlfriend, actress Daryl Hannah. Jackie Kennedy did not want her son to marry an actress, for she had witnessed her father, her father-in-law, and even her first husband put their family lives on the line for short term affairs with Hollywood actresses. She put tremendous pressure on John to put an end to the relationship.

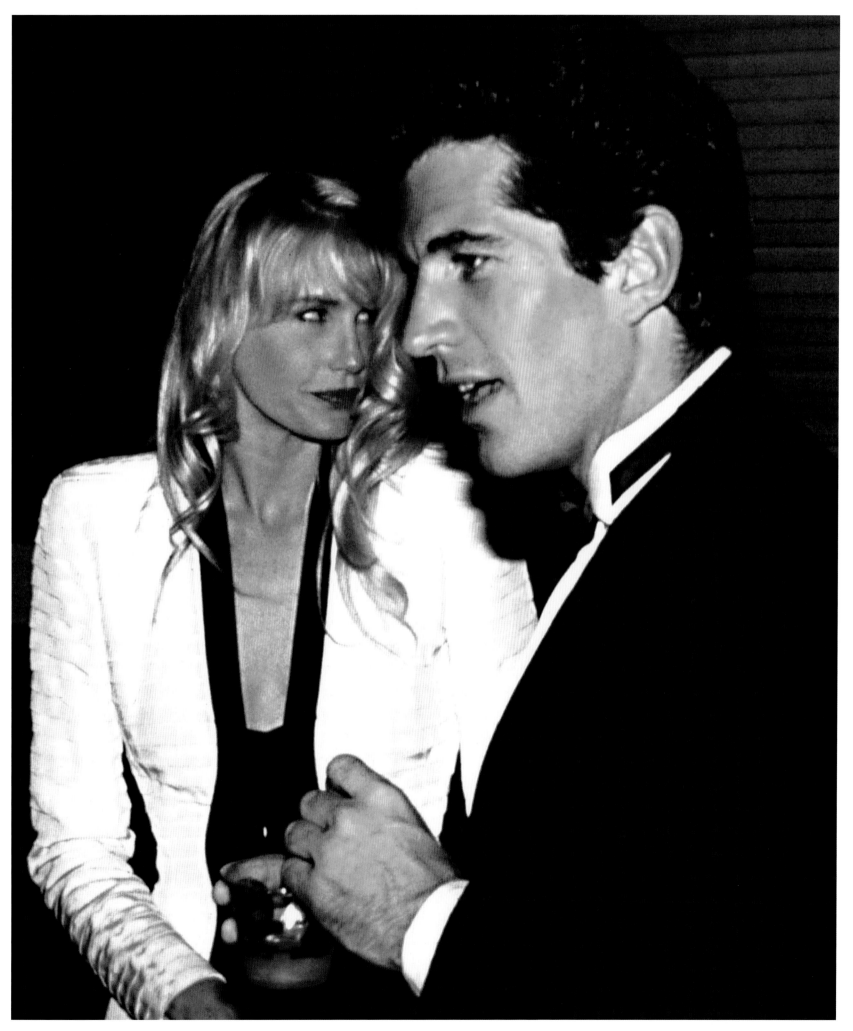

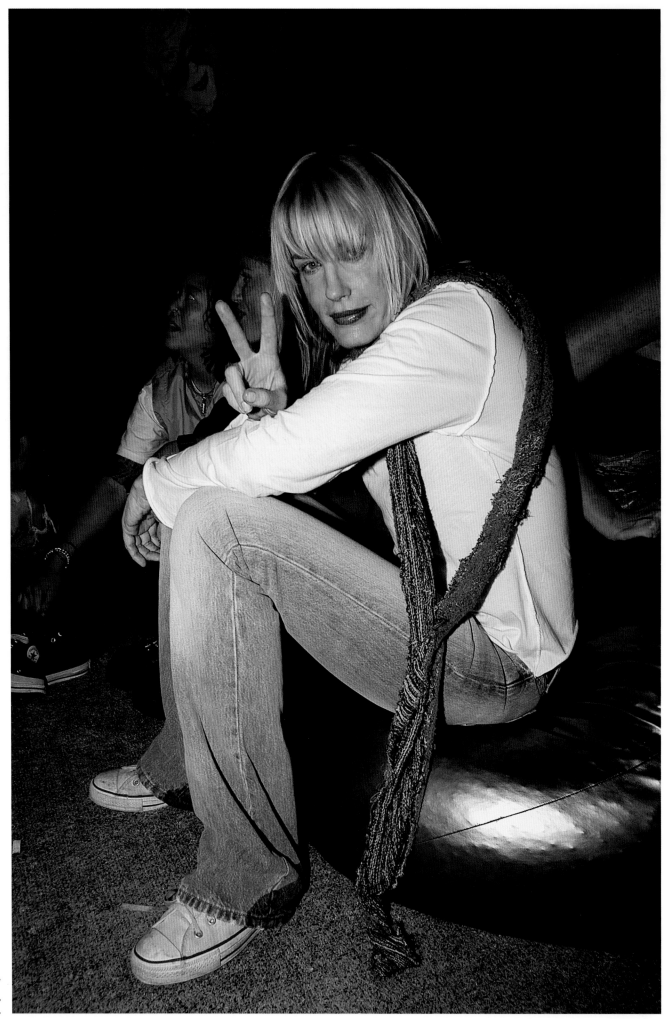

April 2, 2003 / Culver City, CA / Portrait of actress Daryl Hannah, John's girlfriend from 1990 to 1993.

August 7, 1993 / Manila, Philippines / John Kennedy and Daryl Hannah at Manila International Airport, upon arriving for a short holiday.

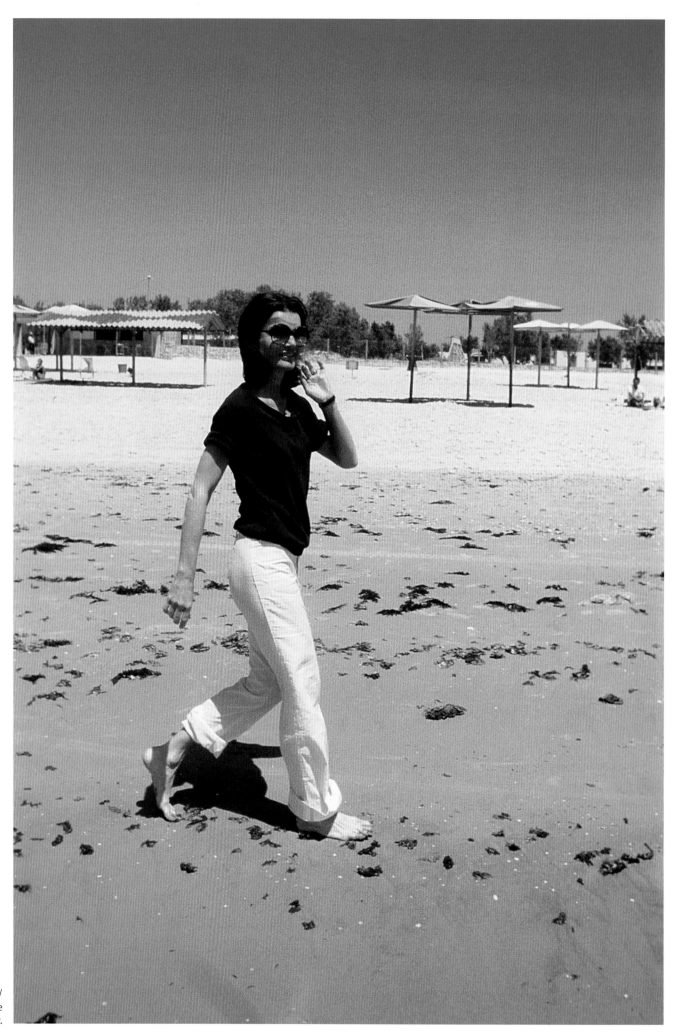

May 15, 1978 / Tel Aviv, Israel /
Jackie Onassis taking a walk on the
beach in Tel Aviv.

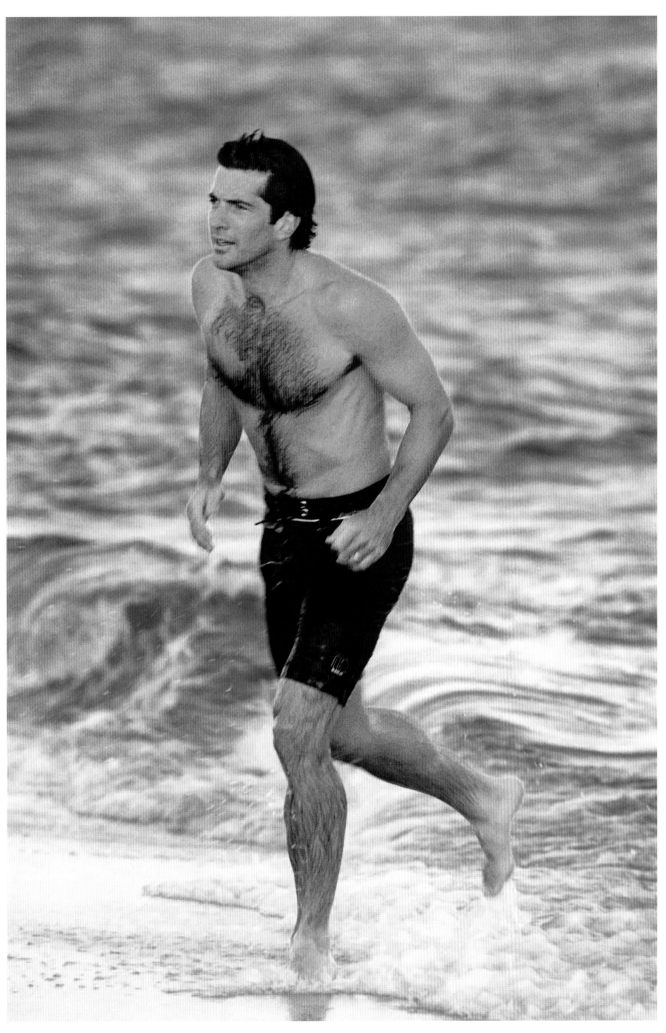

August 29, 1997 / Hyannis Port, MA / John enjoying a short holiday in the Kennedy compound at Hyannis Port.

165

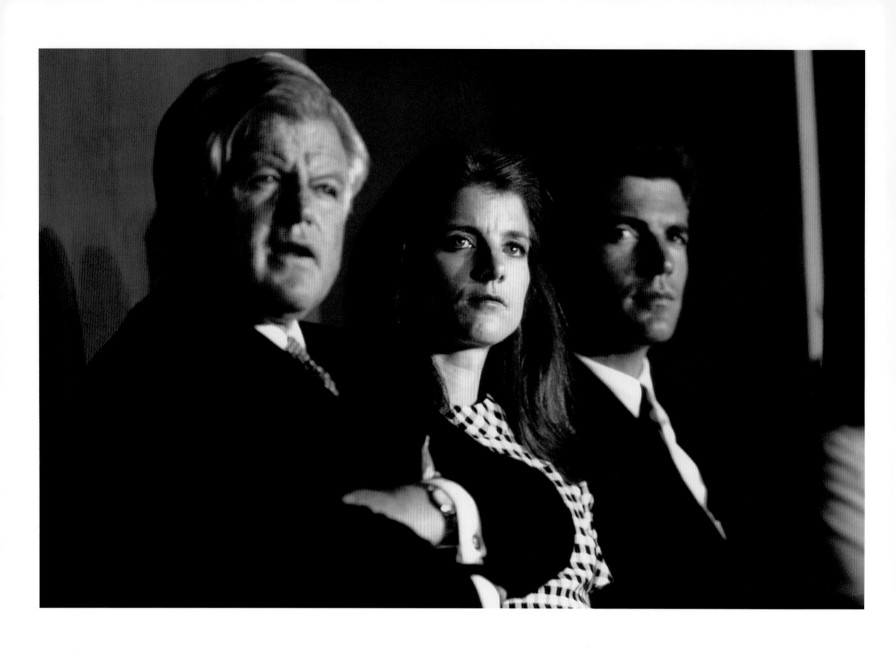

May 8, 1995 / Boston, MA / Ted, Caroline, and John at the ceremony for the JFK Profile in Courage Award, an annual prize given to political figures who have supported a just cause regardless of its effect on their careers or popularity.

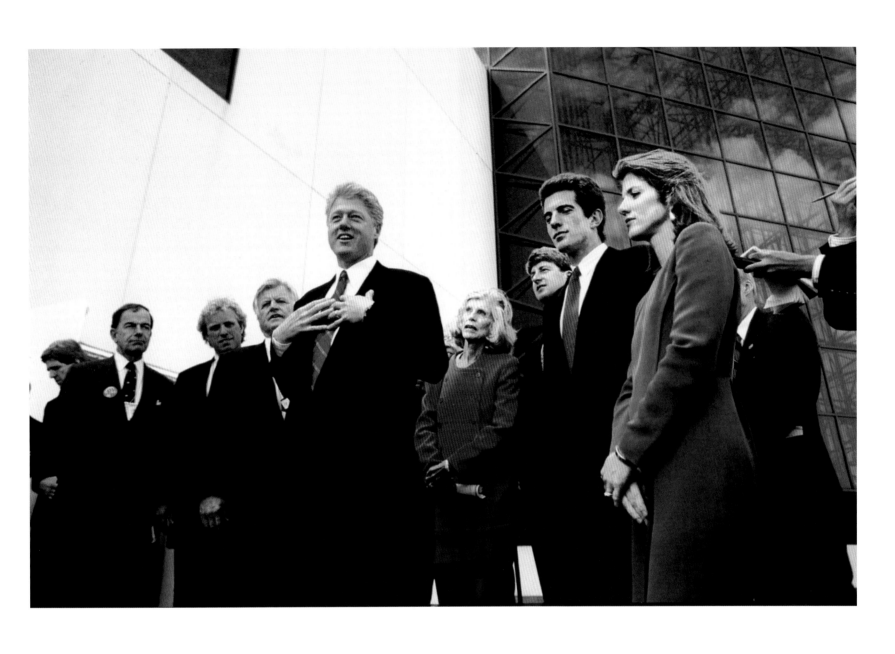

October 29, 1993 / Boston, MA / President Bill Clinton and the Kennedy family inaugurate the JFK Library. From right to left, Caroline, John Jr., Eunice Shriver, Bill Clinton, Ted Kennedy, Joe Kennedy II, Paul Kirk, president of the JFK Library, and John Kerry.

May 19, 1994

New York, New York: Death of Jackie Kennedy Onassis

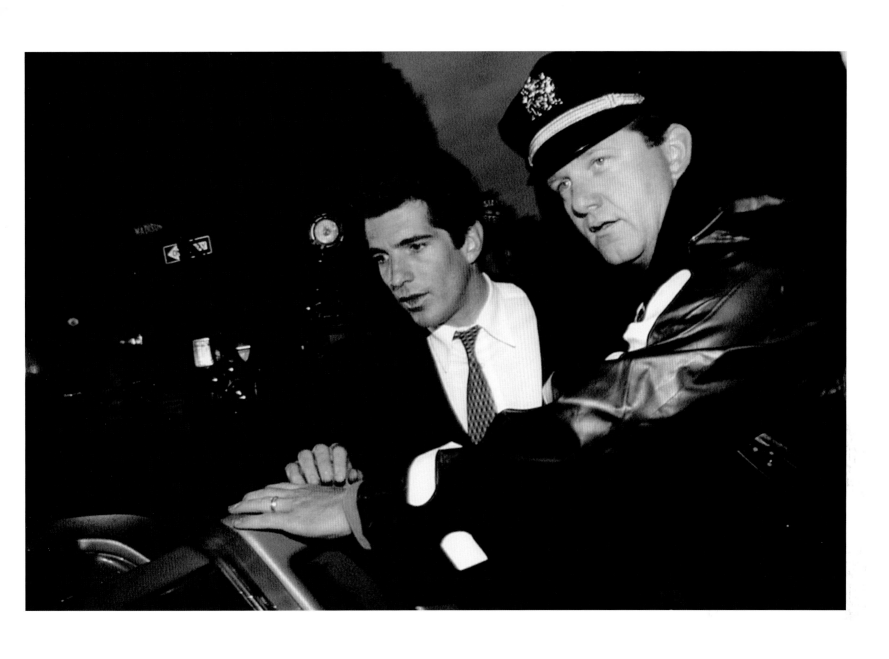

May 19, 1994 / New York, NY / John leaving his mother's apartment shortly after the official announcement of her death. The police try to protect John from the crowd of journalists and gawkers who have gathered by Jackie Kennedy's Fifth Avenue building.

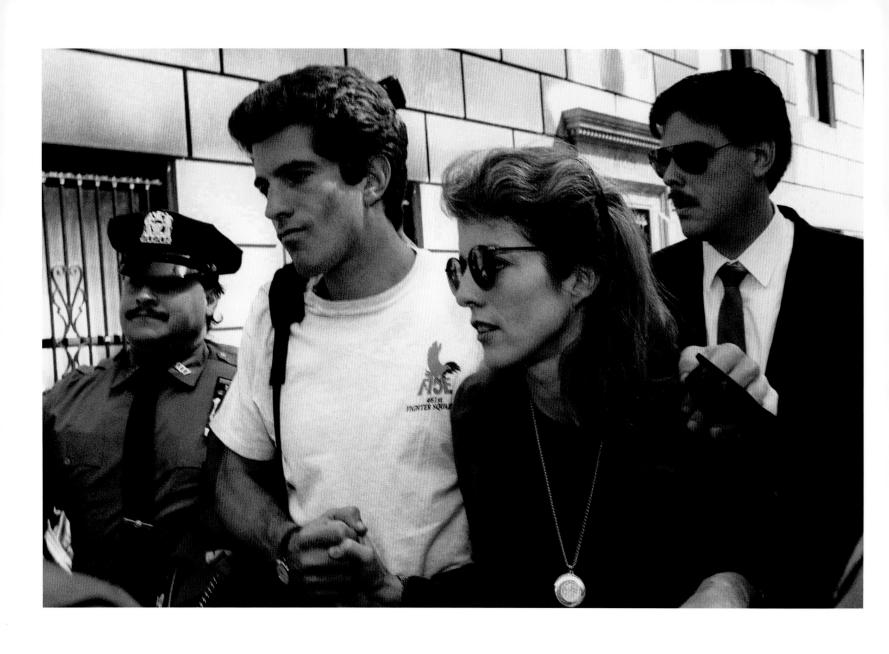

May 22, 1994 / New York, NY / John Kennedy and his sister Caroline Kennedy Schlossberg, shortly after the announcement of the death of their mother, Jackie Kennedy.

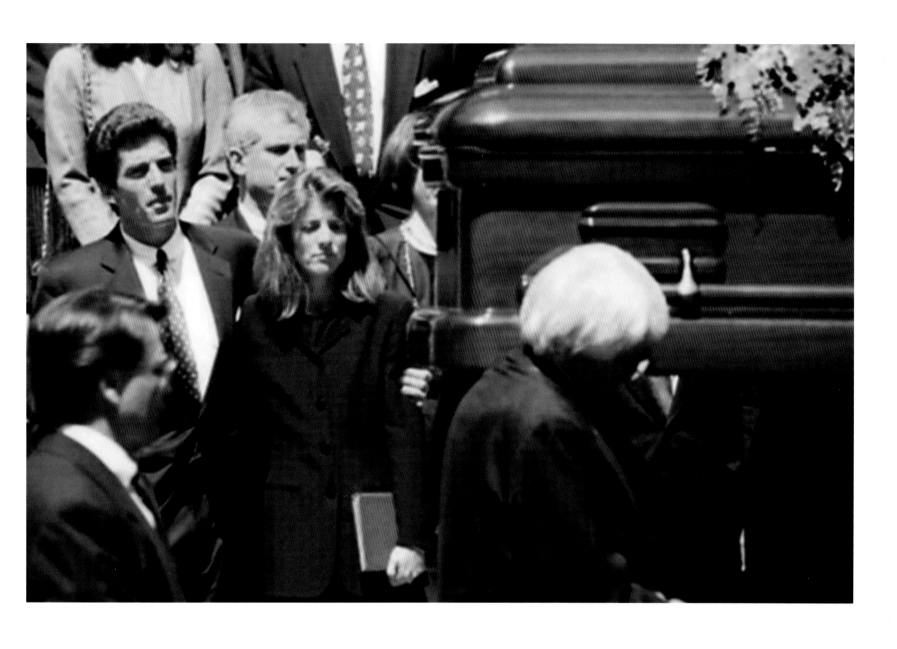

May 23, 1994 / Arlington, VA / John Kennedy and his sister Caroline Kennedy Schlossberg, at the funeral of their mother, Jackie Kennedy.

"A person never really becomes a grown-up until he loses both his parents." John

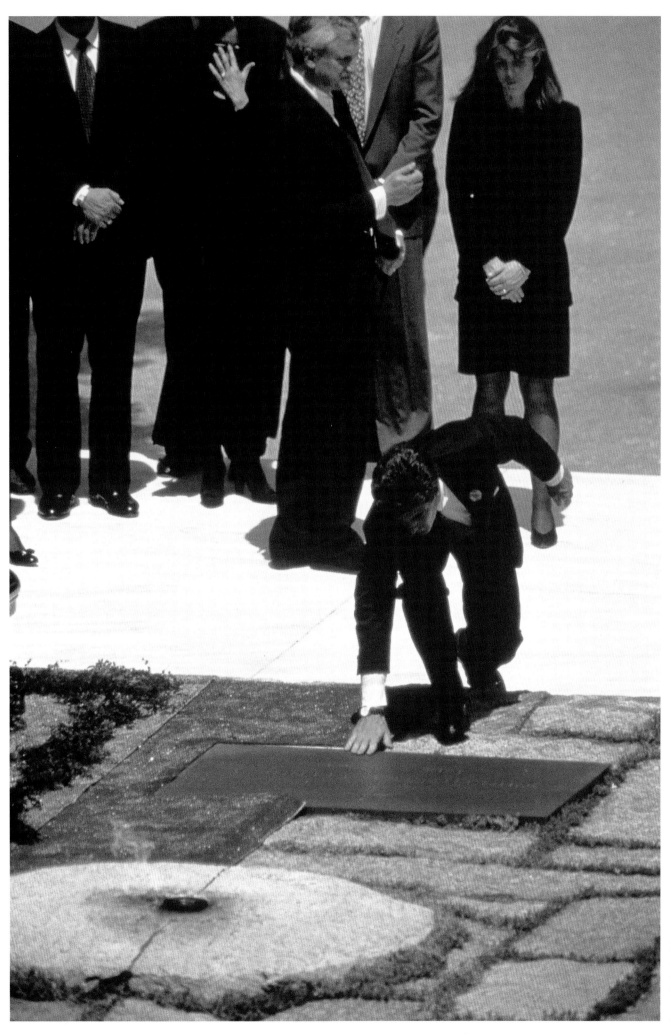

May 24, 1994 / Arlington, VA / John Kennedy Jr. kisses the grave of his mother, Jackie Kennedy Onassis, in Arlington National Cemetery. Jackie had decided to be laid to rest next to President Kennedy and their children Arabella and Patrick.

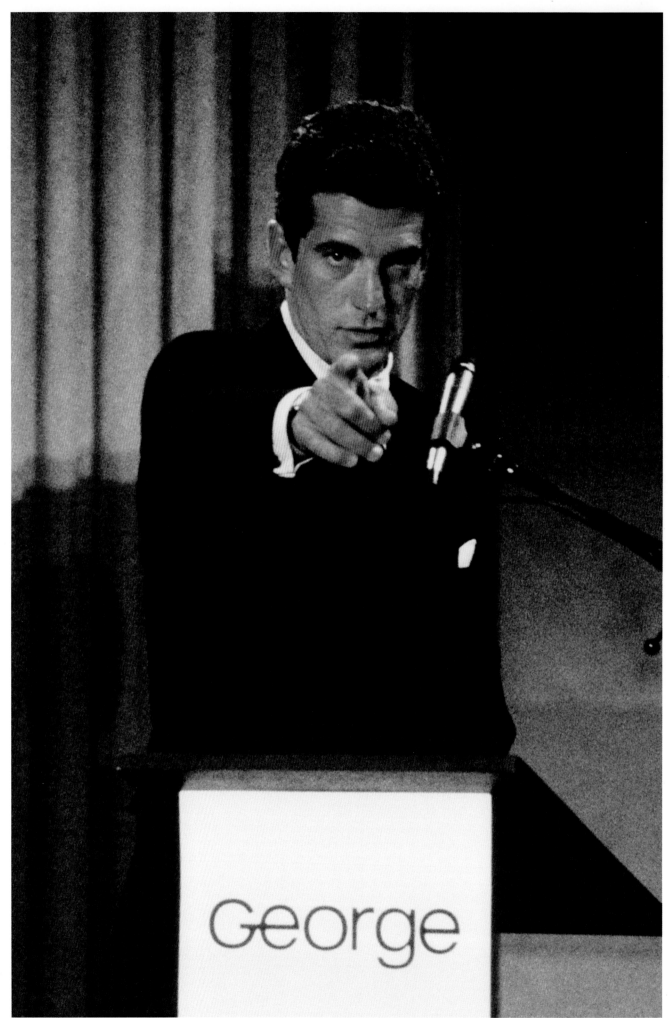

September 7, 1995 /
Federal Hall, New York, NY /
John Kennedy Jr. takes questions
from a journalist during
the press conference launching
George, the new political magazine
he founded with the support
of the Hachette group.

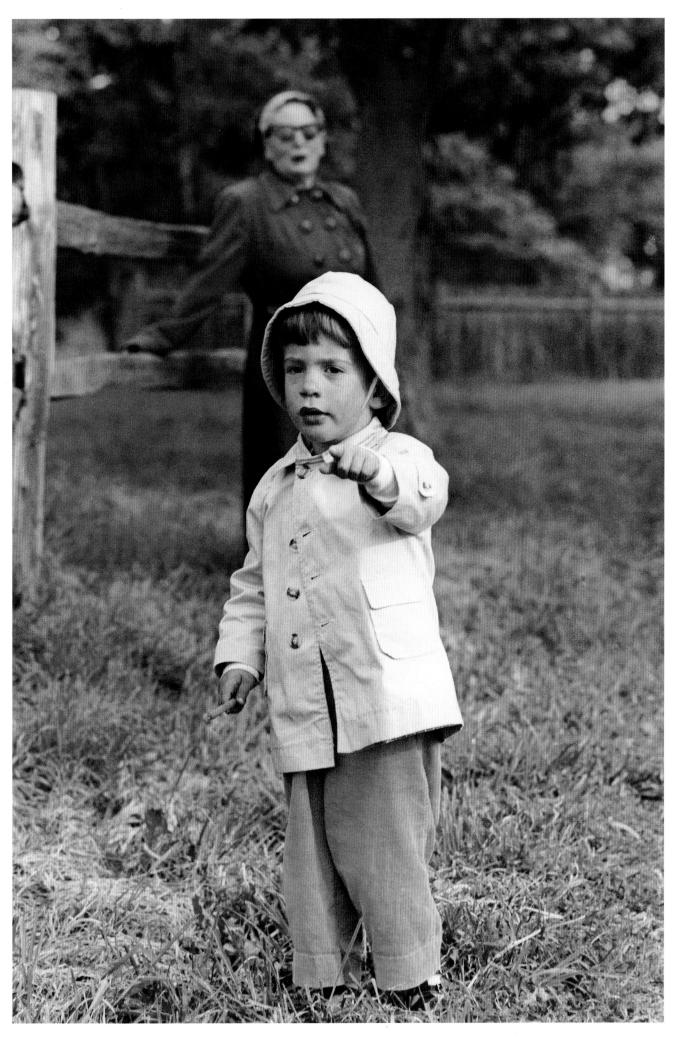

September 14, 1963 /
Camp David, MD /
John Jr. takes a weekend walk
in the country with his sister
Caroline, their nanny, and Agent
Foster, the Secret Service agent
assigned to protect the Kennedy
children.

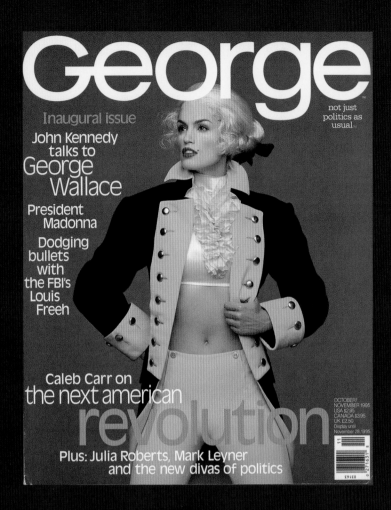

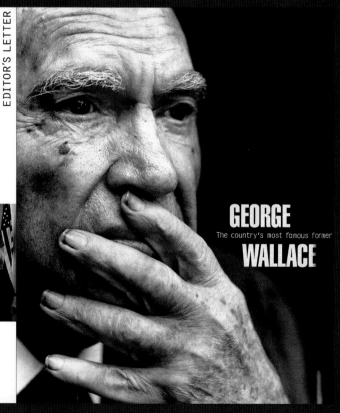

GEORGE

The country's most famous former

WALLACE

If, as some historians suggest, Americans renew their passion for politics every 30 years, perhaps this reawakening is due less to changes of heart than to changes in how the elected communicate with the electorate. During the '30s, radio brought FDR's fireside chats into the homes of a nation frightened and worried by the Depression. In 1960, the Nixon-Kennedy debates ushered in the television age of politics. Thirty years later, during the 1992 election, the means by which politicians defined themselves changed yet again.

During that presidential campaign, candidates supplemented their frenetic tours from city to city with satellite feeds that hooked them into 10 to 15 local markets at a time. When Bill Clinton and Al Gore climbed aboard a bus and rode through towns like Corsicana, Texas, and Parrott, Georgia—places that hadn't seen a presidential candidate since World War II— I watched along with millions of others from across the country as the spectacle was beamed back to us in a microsecond.

Empowered by technology and emboldened by a desire to take their case directly to the people, politicians broke all the old rules: Clinton played his sax on Arsenio Hall, George Bush appeared on MTV, and Ross Perot shocked us all by announcing his candidacy on Larry King Live.

Over dinner one evening during the early months of the Clinton administration, my partner, Michael Berman, and I noted that friends who had never turned an eye toward things political were suddenly taking notice of the new faces coming to power in Washington. Whether it was because of who they were or how they were covered, these new personalities were proving fascinating to a freshly engaged public. Since that time, the trend has only accelerated. Political figures are increasingly written about as the personalities and pop icons they have become. Politics has migrated into the realm of popular culture, and folks can't turn away.

That's not to say the prospects for a successful political magazine were encouraging when Michael and I started developing the idea for George two years ago. Despite what we perceived as a surge of interest in the personalities of politics, the public's

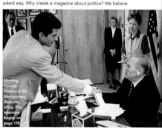

Meeting George Wallace in his Montgomery, Alabama, office. The interview begins on page 178

cynicism toward government itself was as pervasive as ever. A magazine devoted entirely to covering a system widely regarded as broken was a tough sell.

But voters nevertheless seemed energized by their anger and eager to experiment with alternatives. And perhaps because we were publishing neophytes, we stuck with the idea even after the instructor in our two-day seminar called "Starting Your Own Magazine" told us, "You can successfully launch a magazine in just about anything except for religion and politics." Fortunately, one company that knows a thing or two about publishing disagreed. After 14 months of dubiously successful fundraising, we brought our idea to the people at Hachette Filipacchi, and from the start, they recognized its viability. Today, they are our partners in this venture.

All along the way, the question we never stopped being asked was, Why create a magazine about politics? We believe that if we can make politics accessible by covering it in an entertaining and compelling way, popular interest and involvement in the process will follow.

But calling George a political magazine isn't entirely accurate, since we aim to be a breed apart from traditional political magazines. Our coverage of politics won't be colored by any partisan perspective—not even mine. George is a lifestyle magazine with

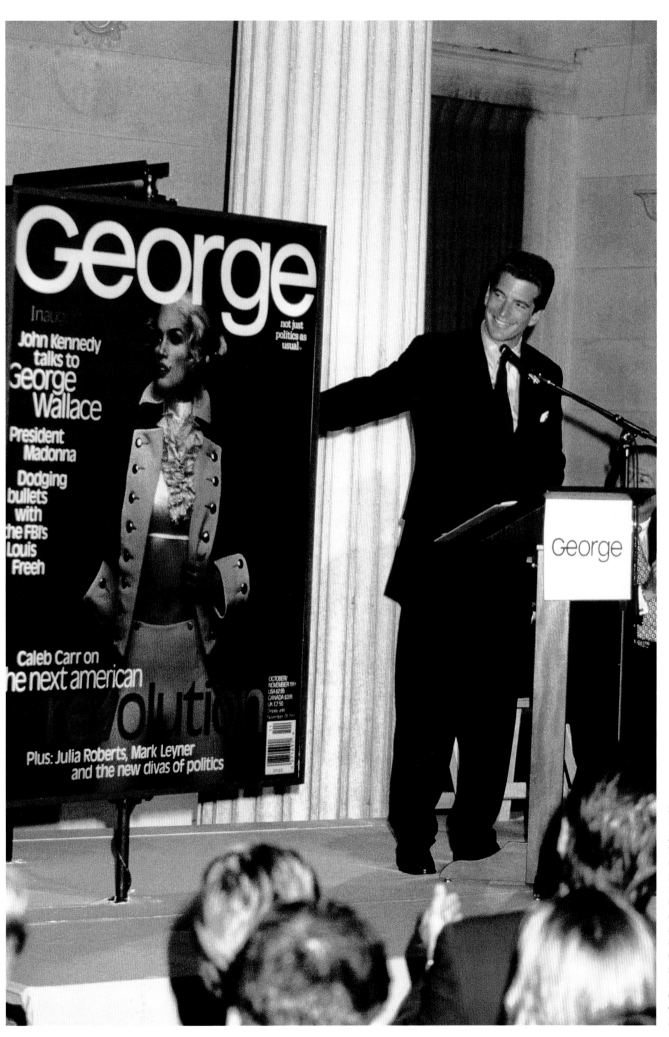

September 7, 1995 /
Federal Hall, New York, NY /
John Kennedy Jr. introduces *George*,
the new magazine he is launching in
collaboration with the Hachette
group, to the press. The monthly
magazine was named in honor of
George Washington, and was
dedicated to important social issues
and, particularly, to politics. The
concept of dressing up celebrities as
George Washington for the cover shot
succeeded in making a big splash.
For the first issue's cover, Cindy
Crawford posed for Herb Ritts. She
was followed by Robert de Niro, Demi
Moore, George Clooney, and others.

John Kennedy's Promise to You

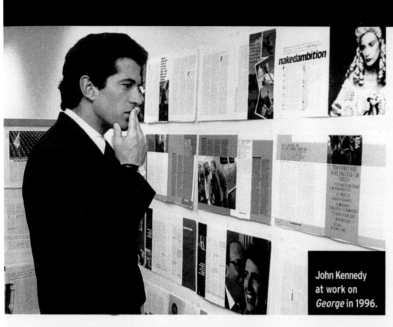

John Kennedy at work on *George* in 1996.

"Who Are We? Why Are We Here?" by John Kennedy

"EDITOR'S LETTER," PREMIER ISSUE, 1995

Over dinner one evening during the early months of the Clinton administration, my partner Michael Berman and I noted that friends who had never turned an eye toward things political were suddenly taking notice of the new faces coming to power in Washington. Whether it was because of who they were or how they were covered, these new personalities were proving fascinating to a freshly engaged public.

Since that time, the trend has only accelerated. Political figures are increasingly written about as the personalities and pop icons they have become. Politics has migrated into the realm of popular culture.

That's not to say the prospects for a successful political magazine were encouraging when Michael and I started developing the idea for *George* in 1993. Despite what we perceived as a surge of interest in the personalities of politics, the public's cynicism toward government was as pervasive as ever. A magazine devoted entirely to covering a system widely regarded as broken was a tough sell.

Along the way, the question skeptics never stopped asking was, Why create a magazine about politics?

We believe that if we can make politics accessible by covering it in an entertaining and compelling way, popular interest and involvement in the process will follow.

George aims to be a breed apart from traditional political magazines. Our coverage of politics won't be colored by any partisan perspective—not even mine. *George* is a lifestyle magazine with politics at its core, illuminating the points where politics converges with business, media, entertainment, fashion, art, and science. Whether it's violence in the movies or free speech on the Internet, culture drives politics.

We will define politics extravagantly, from elected officials to media moguls to movie stars to ordinary citizens. And we will cover it exuberantly, showing the unexpected, meaningful, and whimsical ways that it affects your daily life.

The fact that *George* is post-partisan doesn't mean that we don't have opinions. It just means we don't believe that party affiliation is the only hook on which to hang one's political identity. With a recent poll showing that nearly 40 percent of Americans no longer have any loyalty to an organized party, we suspect that Americans want to know more about the people who seek to govern and less about the correctness of their politics. When "progressives" find themselves defending the status quo and "conservatives" are advocating wholesale change, labels serve less to define than to obscure. In *George*, you will hear all the voices in today's political dialogue, because today's opposition can become tomorrow's ruling party.

If we can do just one thing at *George*, we hope it's to demystify the political process, to enable you to see politicians not just as ideological symbols, but as lively and engaging men and women who shape public life. As a lifelong spectator of the giant puppet show that can turn public people into barely recognizable symbols of themselves, I hope we can provide something far more useful than that.

George also will be the first feature magazine launched simultaneously on newsstands and on the World Wide Web. Our Web site (www.georgemag.com) will offer readers the opportunity to converse with one another and to discuss the magazine and politics in general, as well as serve as a resource guide for particular issues.

So that's *George*. We hope you enjoy reading it as much as we've enjoyed creating it. It's the first of its kind, like founding father George Washington, its namesake. We've set out to make a magazine about politics in which the images are as compelling as the prose and where you might find something to feed your enthusiasm, spark your curiosity, or even ease your disaffection.

We hope you'll be informed, provoked, and entertained—but mainly, we hope you'll get involved, because as a wise man once said, Politics is too important to be left to the politicians. ∎

Yellow Dog on the Hunt

BY ROY BLOUNT JR.

HOUSE MAJORITY LEADER RICHARD ARMEY IS IN CHARGE OF KEEPING THE REPUBLICAN REVOLUTION IN LINE—ONE OF THE MOST POWERFUL PEOPLE IN THE FEDERAL GOVERNMENT, YOU MIGHT SAY. BUT THEN ARMEY DOES NOT APPROVE, FOR MOST INTENTS AND PURPOSES, OF THE FEDERAL GOVERNMENT... "WHAT THE GOVERNMENT DOES, FUNDAMENTALLY, IS TO COMPEL SOMEONE TO DO SOMETHING THAT THEY WOULD NOT DO VOLUNTARILY," HE SAYS.

"WHEN I WAS GROWING UP IN THE SOUTH," I PUT IN, "WHITE PEOPLE WERE MAKING THEMSELVES HAPPY BY KEEPING BLACK PEOPLE OUT OF THINGS, AND THE FEDERAL GOVERNMENT HAD TO FORCE THEM TO CHANGE."

"ONE OF THE DAMNABLE UNHAPPY CONDITIONS OF LIFE IS SOMETIMES GOVERNMENT HAS TO MAKE PEOPLE BE CIVIL," ARMEY SAYS. "AND I HATE THAT. BUT IF, IN FACT, MY CHOICE IS BETWEEN AN UNCIVIL SOCIETY AND A GOVERNMENT THAT COMPELS CIVILITY, I WILL ACCEPT A GOVERNMENT THAT COMPELS CIVILITY."

"WHERE WERE YOU DURING THE CIVIL RIGHTS MOVEMENT?"

"AS I SAY, THE '60S PASSED ME UP TO A LARGE EXTENT...."

AS HE HELD FORTH, ARMEY WAS AT HIS DESK, EATING A HAMBURGER WITH NOTHING BUT ONION. "HE DOESN'T LIKE ANYTHING SQUISHY," SAYS [PRESS SECRETARY ED] GILLESPIE, WHO HAD ORDERED LUNCH ... TO THE QUITE CIVIL AND COOPERATIVE BUT APPREHENSIVE GILLESPIE, I MADE MYSELF CLEAR: "I AM A YELLOW-DOG DEMOCRAT"—SOMEONE SWORN TO VOTE FOR A YELLOW DOG SOONER THAN FOR A REPUBLICAN.

"HOWEVER," I TOLD GILLESPIE, "I AM RUNNING OUT OF YELLOW DOGS. I DECIDED I HAD TO START TALKING TO REPUBLICANS."

—"ONE MAN ARMEY," DECEMBER/JANUARY 1996

If I Were President

BY MADONNA

It seems funny to start a sentence with the words "If I were president" because I'm sure I'd never want to be. I vaguely remember being asked the question in fifth-grade history class, but that was the year I discovered boys, and my political ambitions took a backseat to my libido. (I know what you're thinking—some things never change.)

Don't get me wrong. I like the idea of being a leader and effecting change. I like the idea of being an inspiration to the downtrodden, of educating the masses. I like the idea of fighting for equal rights for women and gays and all minorities. I like the idea of embracing other countries and cultures and promoting world peace. But I'd rather do it as an artist. Because artists are allowed to make mistakes and to have unconventional ideas and to be overweight and dress badly and have an opinion. Artists are allowed to have a past. In short, artists are allowed to be human. And presidents are not. How can someone be a good leader if he or she isn't allowed to be human?

But if I were the president, then:

1. Schoolteachers would be paid more than movie stars and basketball players.

2. Rush Limbaugh, Bob Dole, and Jesse Helms would be sentenced to a hard-labor camp for the rest of their lives.

3. Howard Stern would get kicked out of the country, and Roman Polanski would be allowed back in.

4. The entire armed forces would come out of the closet.

That's just off the top of my head, but don't get me started: I have enough problems.

—"IF I WERE PRESIDENT," OCTOBER/NOVEMBER 1995

The Secrets of Larry King's Success

BY MARK LEYNER

As we walk briskly down the corridor back to CNN, Larry King sustains his patter, undeterred by requests every five yards or so for an autograph or a photo. "You know what the first question I'm gonna ask Bob Dole is? 'Is it true, Bob Dole, you weren't really in World War II? That it was a car accident? Because we have the driver backstage! We'll be right back.'" King hugs and mugs with one last senior citizen.

Just what is it that Larry King does night after night that makes his show such a coveted booking for office seekers and other assorted self-promoters, and so popular with zillions of loyal viewers?

King's primary instinct is to accommodate. He's a mensch. That's why guests have such abundant affection for the man. King's great genius, though, is his ability to reinterpret hostile phone calls. Guests are never forced to answer offensive questions unmediated by Larry. The vile and the psychotic are refracted through King's patented gemütlichkeit. The phoned-in "Is it true you blew Darryl Zanuck to get the lead?" is translated by King into, "Was there a special camaraderie between stars and studio executives?" "Weren't you arrested for a string of cattle mutilations when you were a teenager?" becomes "It is said you were something of an amateur veterinarian before you took up the violin."

What of the audience's affection for Larry King? There's just something reassuringly familiar about him. Familial, in fact. And although the extremes in King's biography are not so stark, he represents for us that enduring myth of the American dream—that you can be huddled over a heating grate gnawing a discarded chicken wing one day, and sitting across from Sharon Stone on your own talk show the next.

—"KINGMAKER," FEBRUARY/MARCH 1996

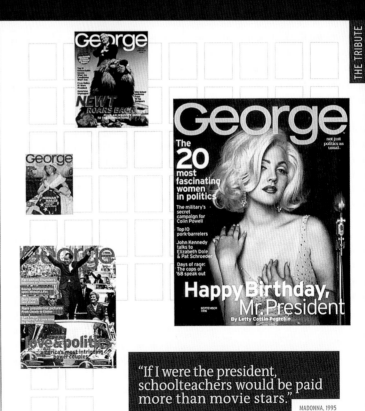

> "If I were the president, schoolteachers would be paid more than movie stars."
>
> MADONNA, 1995

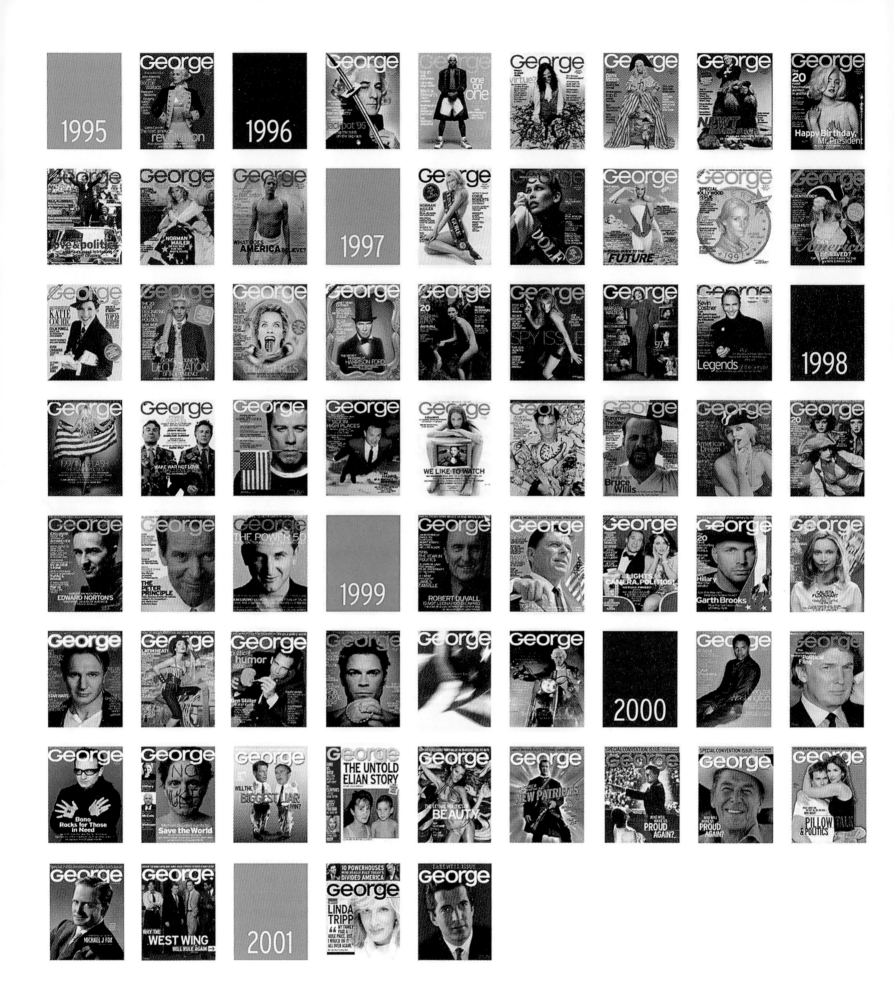

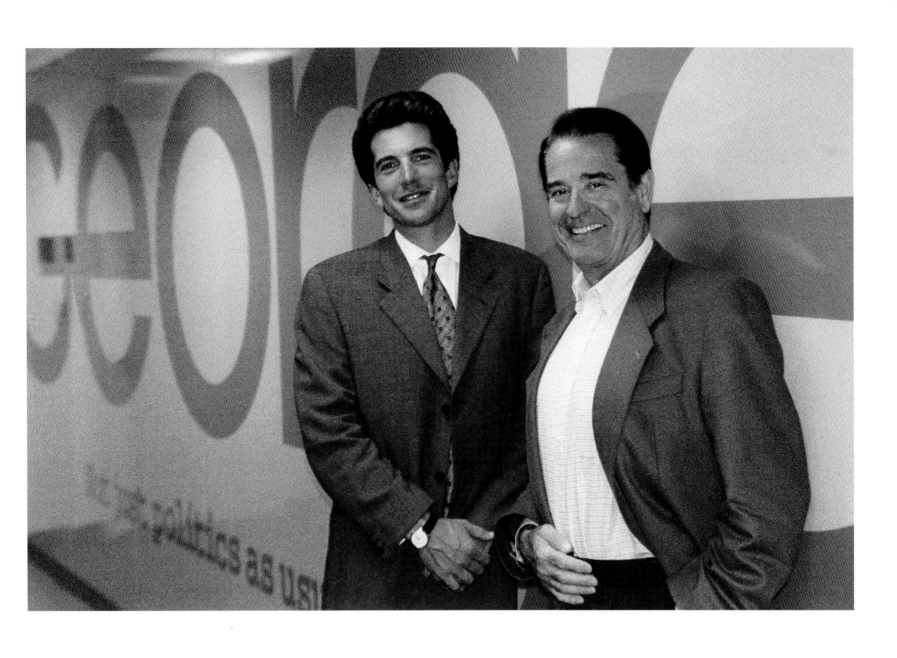

September 15, 1995 / New York, NY / John poses with publisher Daniel Filipacchi in the offices of *George* magazine, located on Broadway near Times Square. Filipacchi and Jean-Louis Ginibre, who was then director of Hachette-Filipacchi in the United States, were immediately convinced by John's idea for a magazine. Their participation assured the project immediate and international attention.

FAREWELL ISSUE

George

NOT
JUST
POLITICS
AS
USUAL

U.S. $3.50
CANADA $4.50

03163

15

Founding Editor
JOHN KENNEDY

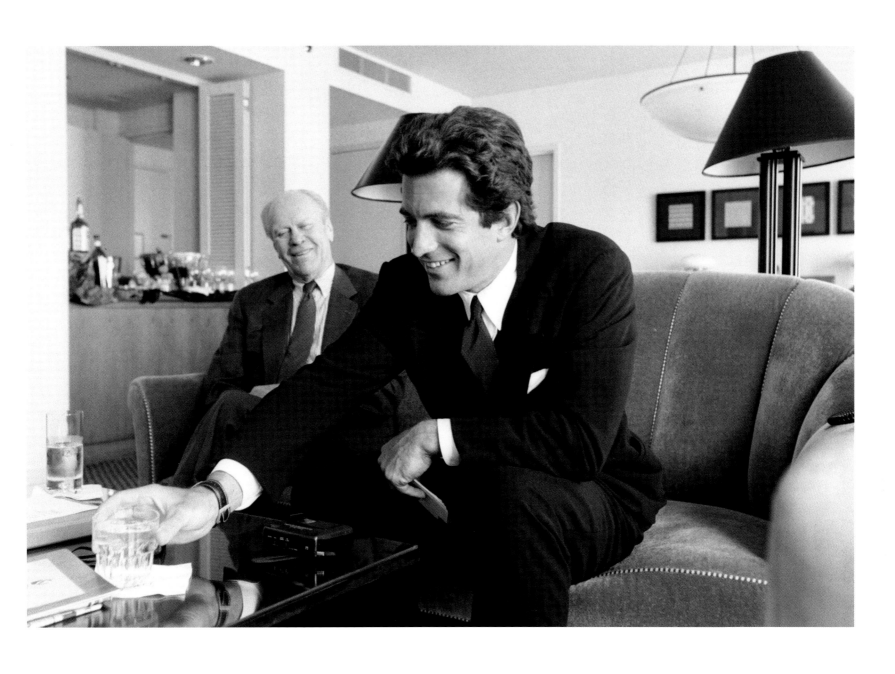

September 1, 1996 / San Diego, CA / As editor-in-chief of *George* magazine, John Kennedy interviews ex-president Gerald R. Ford during the Republican National Convention.

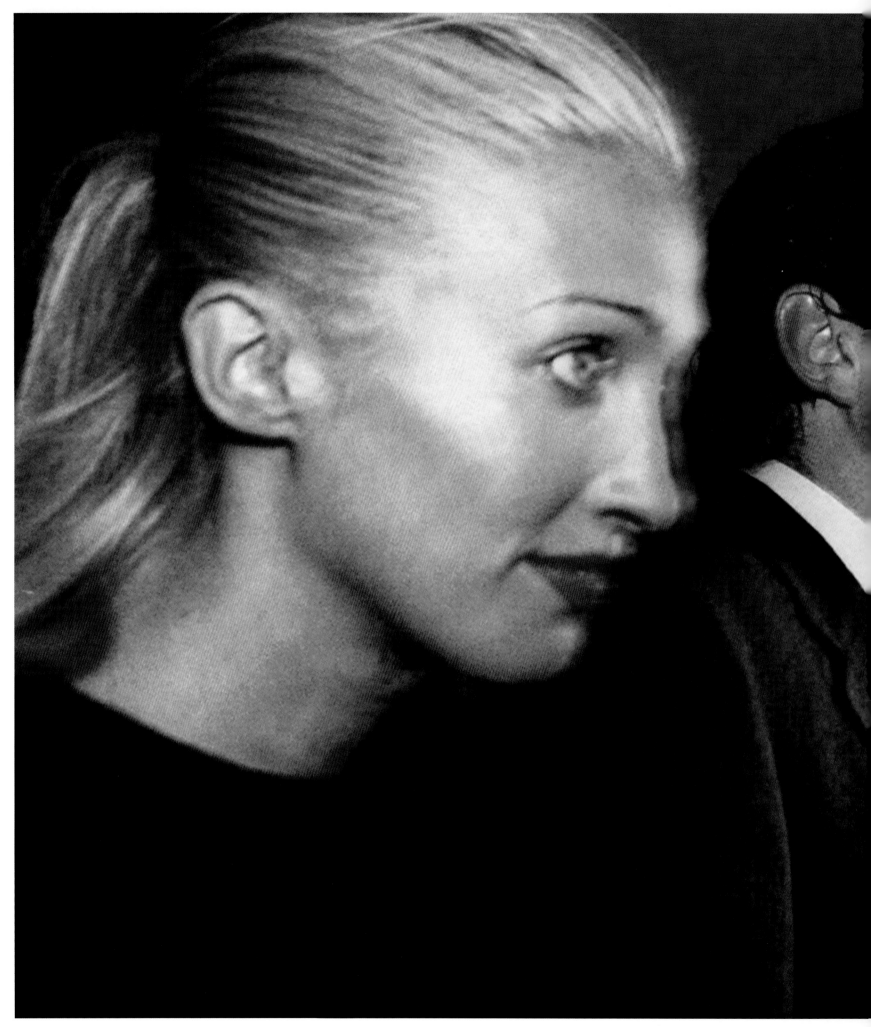

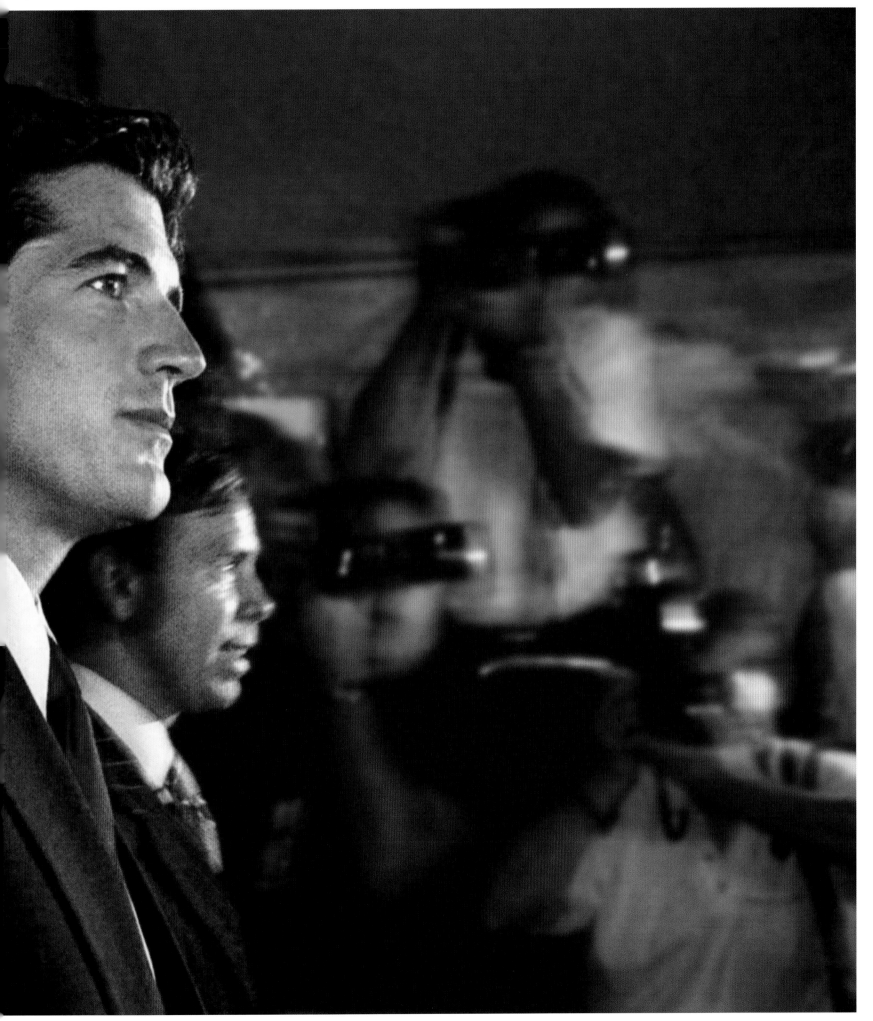

pp. 184-185:
July 23, 1997 / Washington, DC / John and his wife Carolyn arrive at the opening of *Air Force One*, a film in which Harrison Ford plays the president of the United States.

May 17, 1995 / New York, NY / Jennifer Aniston and Carolyn Bessette, during the latter's career with Calvin Klein, participate in "Seventh on Sale," a charity clothing sale intended to raise funds for AIDS research.

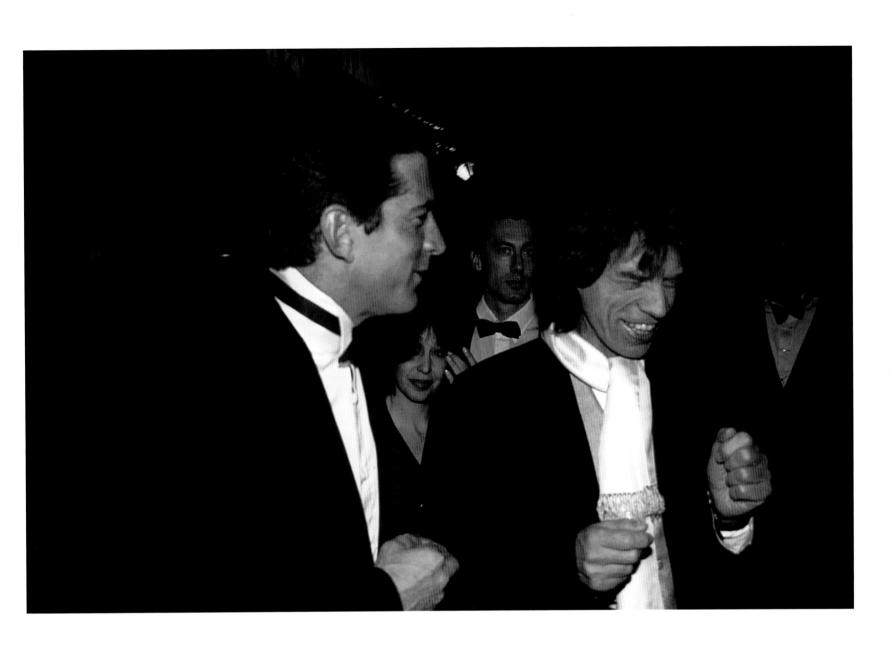

February 12, 1996 / New York, NY / John chats with Mick Jagger at the CFDA Fashion Awards, a prize given to talented fashion designers.

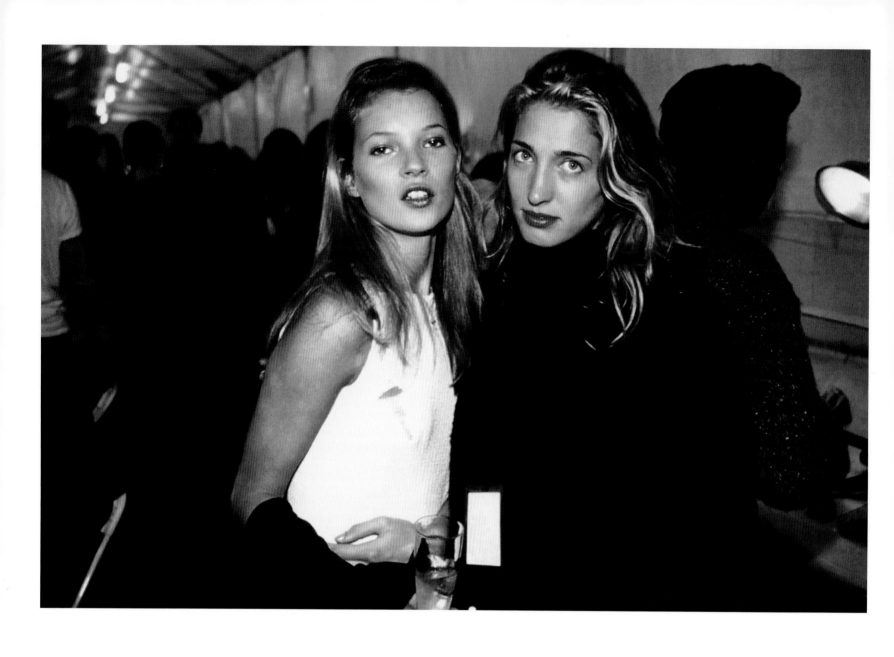

September 29, 1996 / New York, NY / Carolyn Bessette poses with her friend, supermodel Kate Moss, at a party organized by Calvin Klein. At the time, Carolyn was working for Klein, who had handpicked her as a New York publicist for his company.

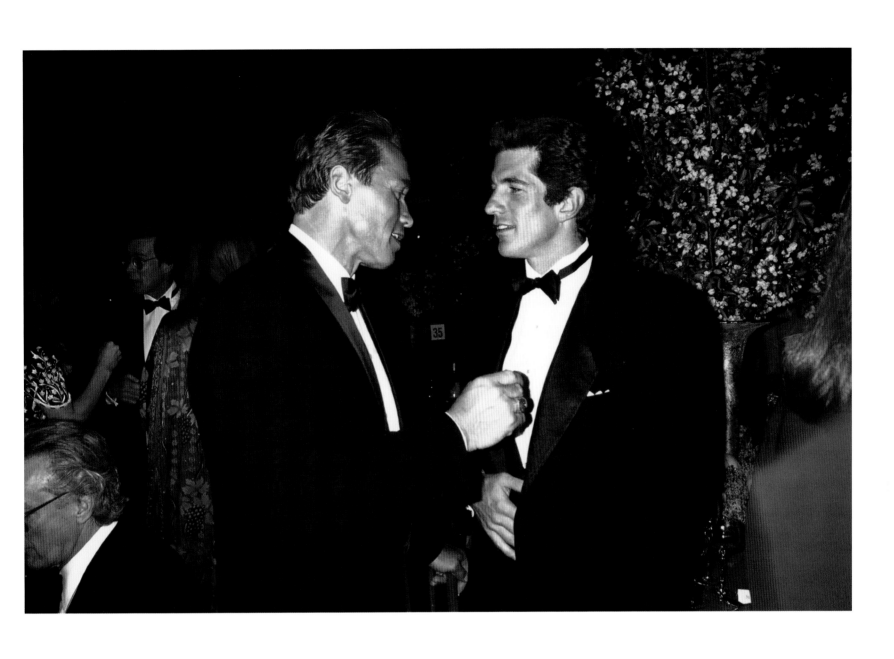

January, 1995 / New York, NY / John talking with actor Arnold Schwarzenegger, his cousin Maria Shriver's husband since 1986. Schwarzenegger undertook a career in politics and was elected governor of California in 2003. The press went wild over this actor elected to public office as a Republican, who was none the less a member of the Kennedy clan—committed Democrats for four generations.

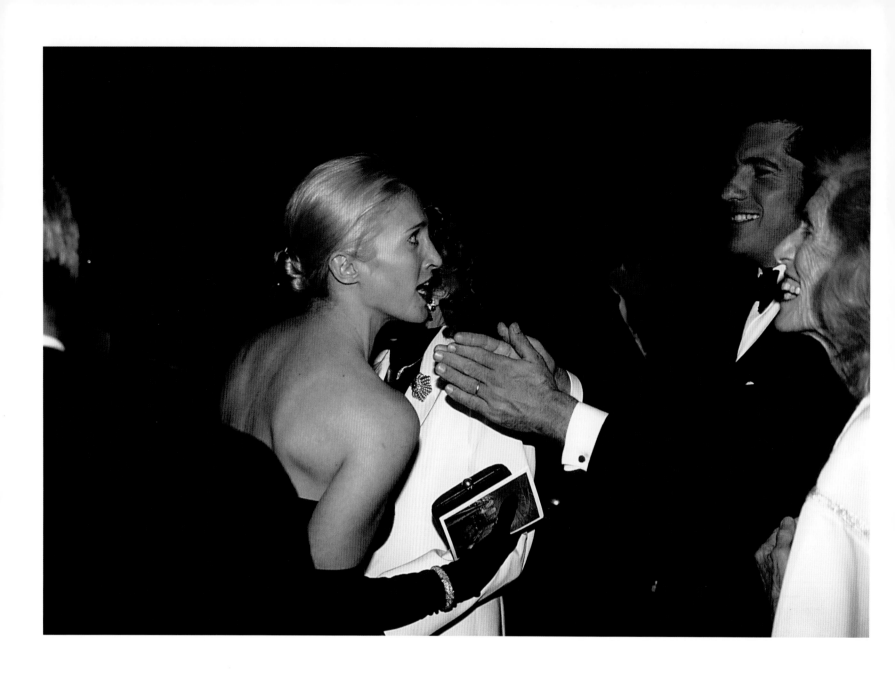

October 5, 1998 / New York, NY / John Kennedy and Carolyn Bessette attend a gala benefit for the restoration of Grand Central Station.

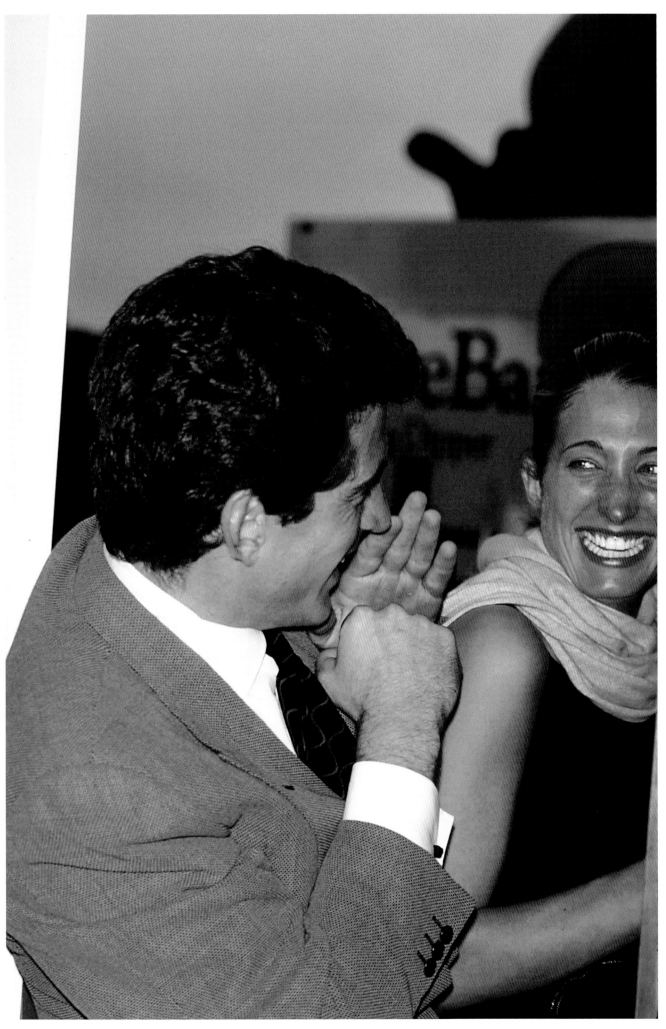

July 1, 1995 / New York, NY /
John Kennedy and Carolyn Bessette,
a year before their wedding.

191

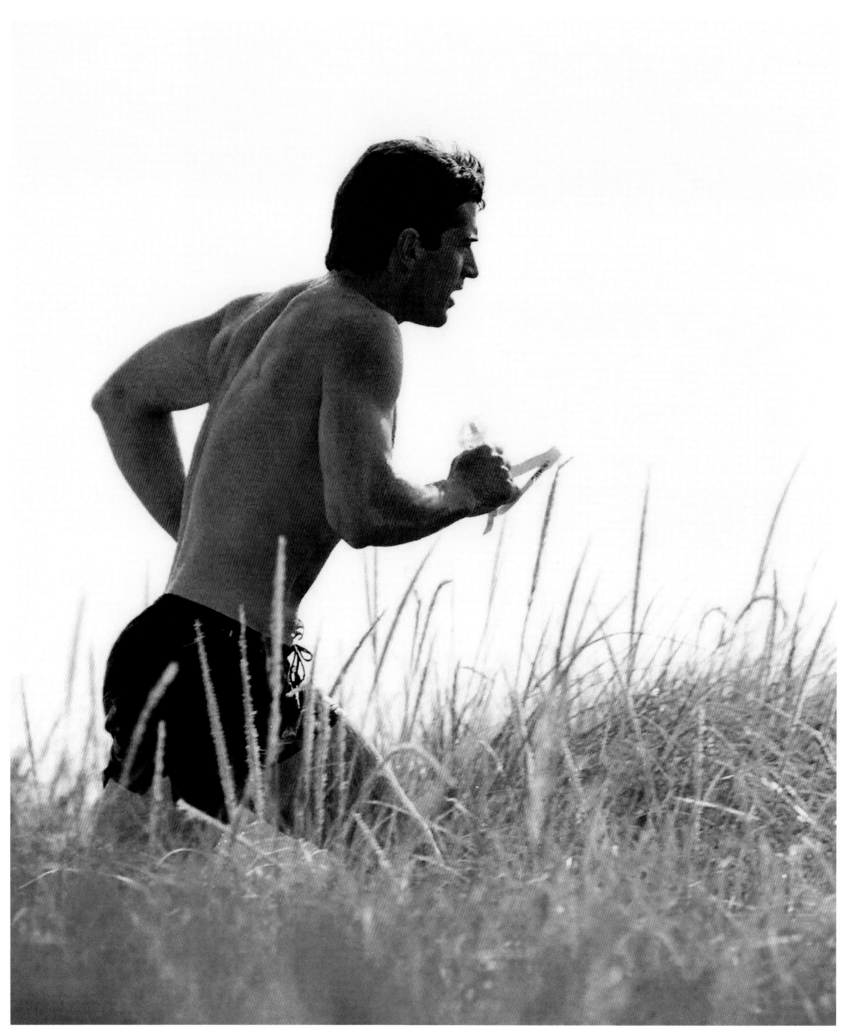

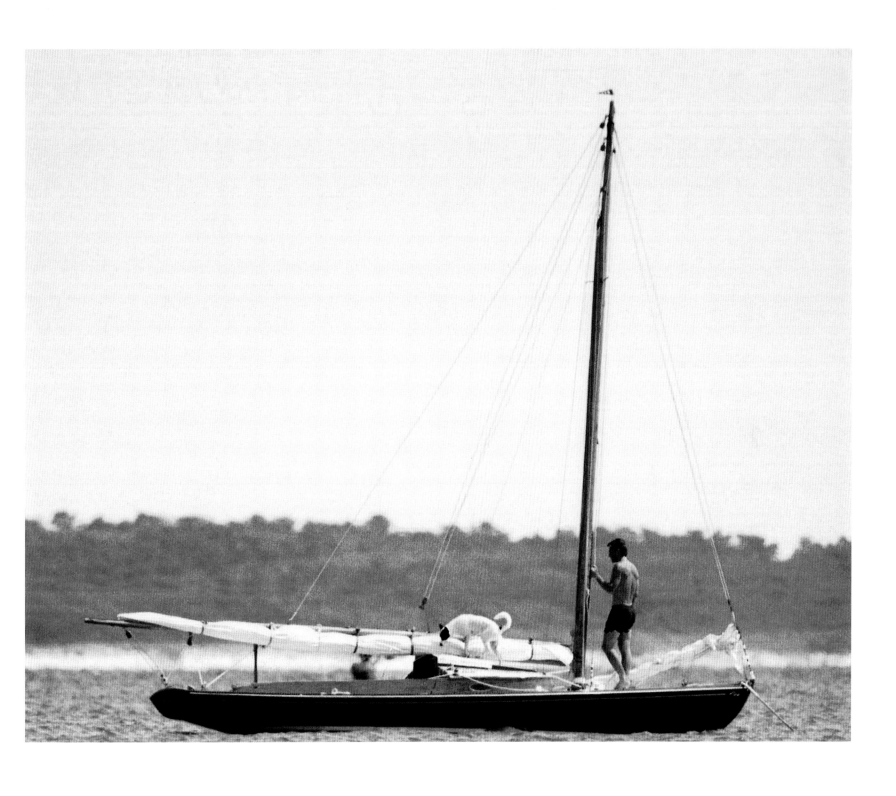

September, 1996 / Hyannis Port, MA / John making the most of the end of summer by spending a few days at the family home on the coast.

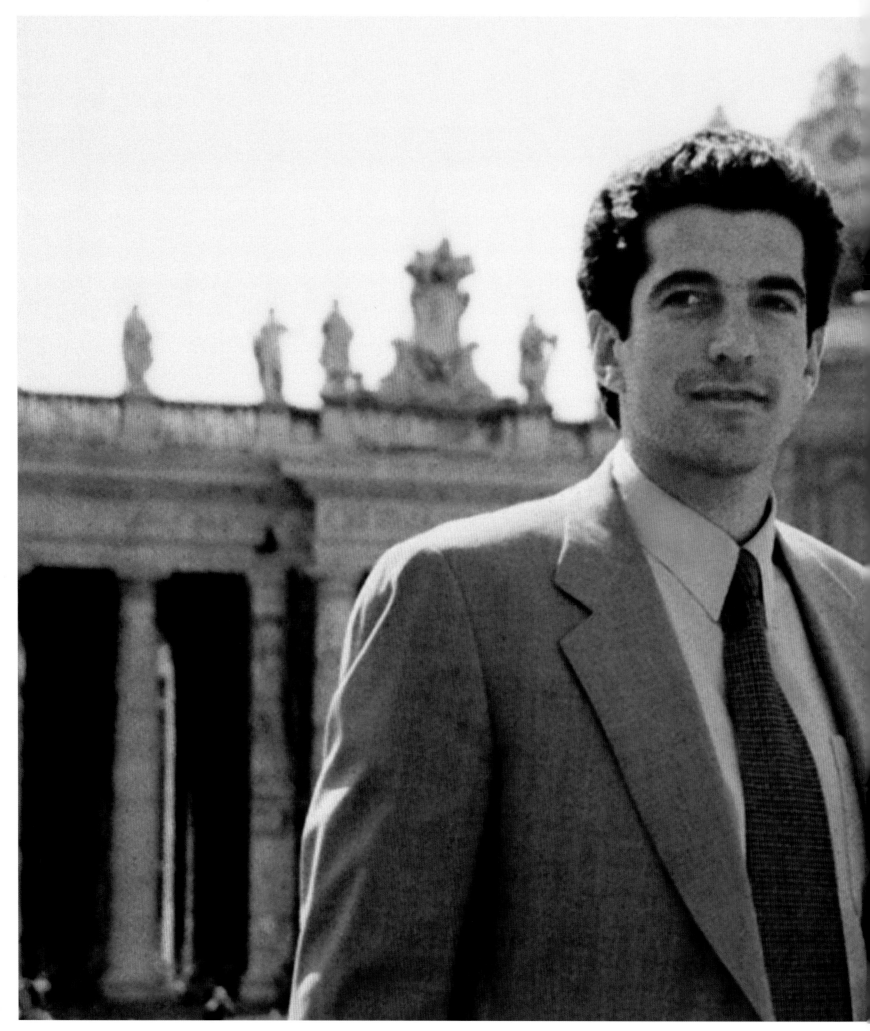

"People keep telling me I can be a great man. I'd rather be a good one." John

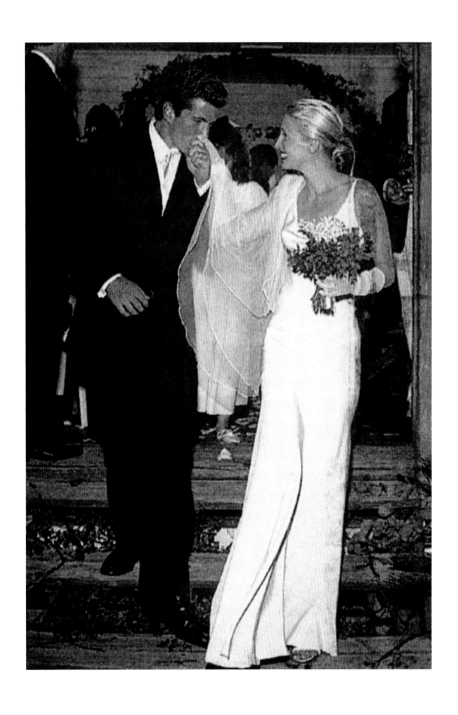

pp. 194-195:
April 20, 1996 / The Vatican, Rome, Italy / John Kennedy Jr. posing in front of Saint Peter's Basilica.

September 21, 1996 / Cumberland Island, Georgia / Wedding of John Kennedy and Carolyn Bessette.

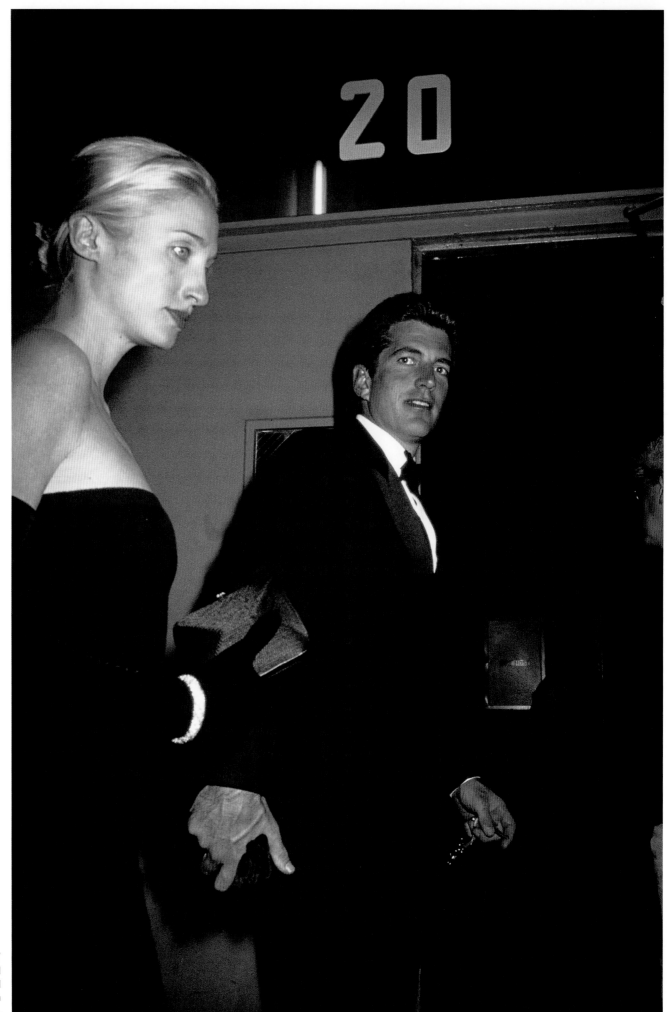

October 5, 1998 / New York, NY /
John and his wife Carolyn head
home after a benefit organized
to finance the restoration
of Grand Central Station.

May 19, 1999 / New York, NY /
John Kennedy Jr. and his wife Carolyn
attend the ceremony for the
Newman's Own/*George* Award, which
awarded 250,000 dollars to the most
generous company of the year. This
money was then donated to the
charitable organization of the
company's choice.

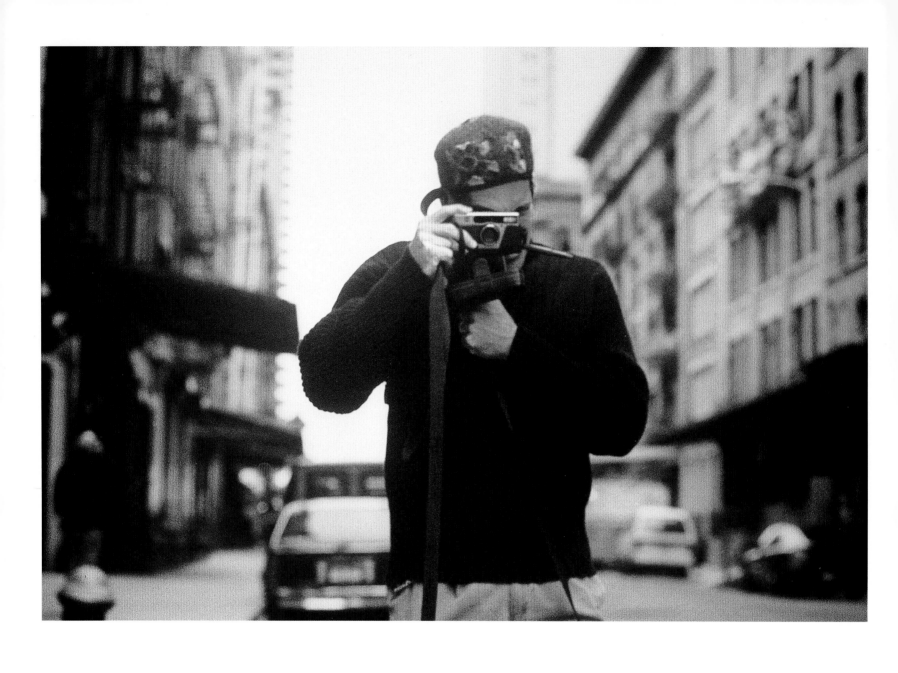

October, 1996 / New York, NY / John was walking his dog, named Friday, in front of his loft building in Tribeca when he noticed a photographer taking a snapshot of him. John whipped out his own camera and photographed the photographer.

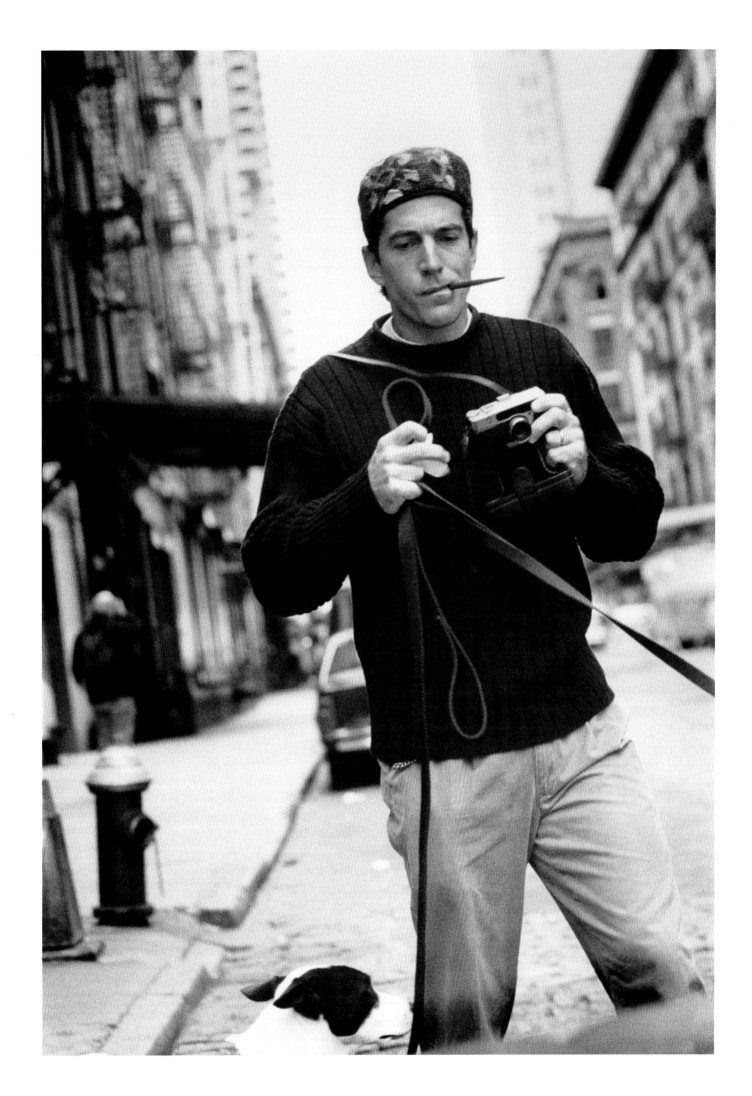

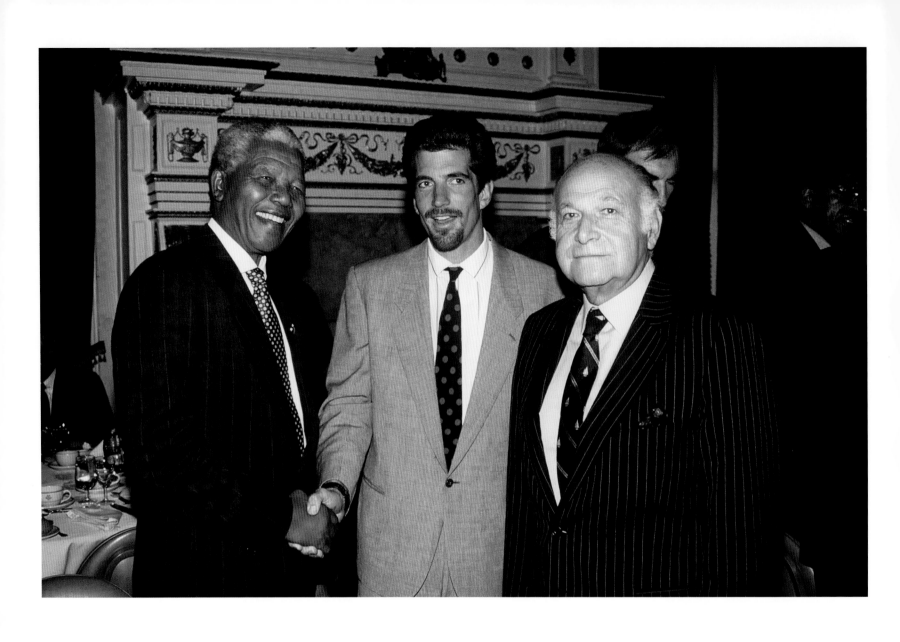

September 28, 1993 / New York, NY / John Kennedy Jr. meets Nelson Mandela during Mandela's visit to New York to speak to the United Nations. To John's right, Maurice Tempelsman, who was Jackie Kennedy's companion from 1975 to 1994, and was very close with John and Caroline.

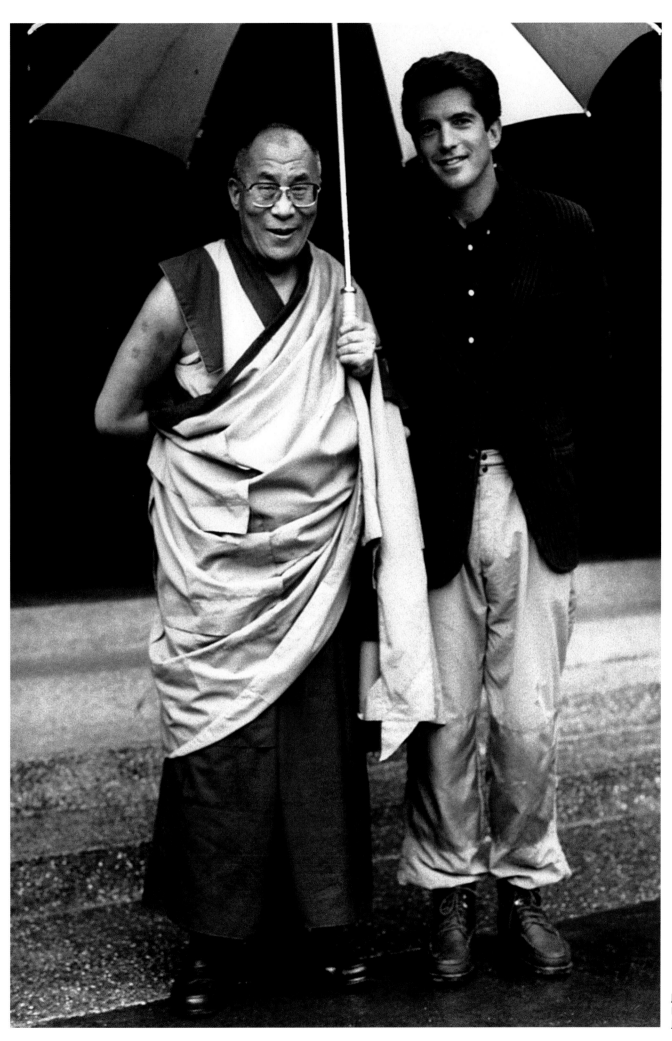

January, 1997 / India /
During a trip to India, John Kennedy
Jr. requested to meet the Dalai Lama.

"Not being a Kennedy, she could recognize both the perils and the positive aspects. One thing she has done is kept the memory and the character of our father very vivid for us."

John, about his mother

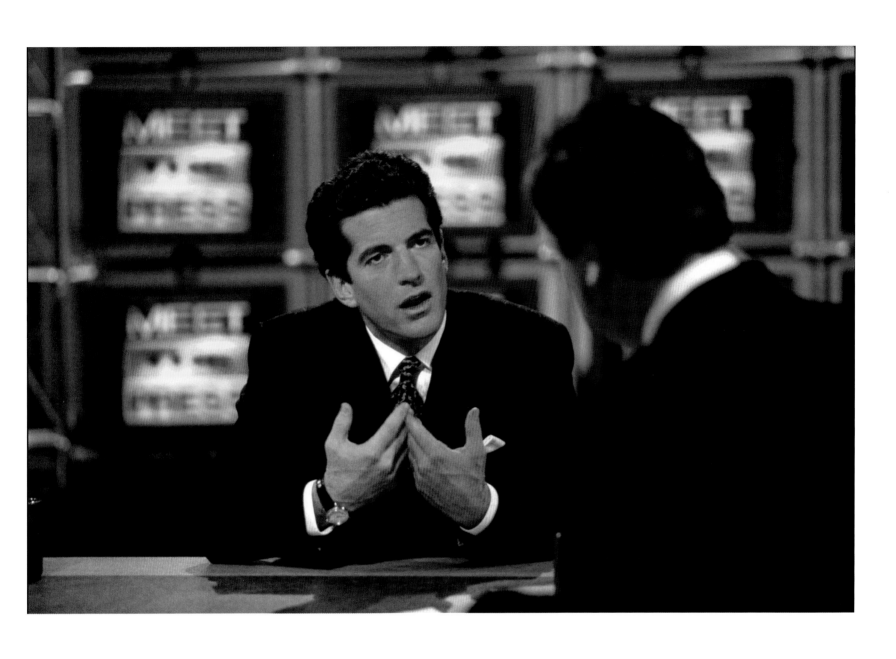

February 14, 1997 / Washington, DC / Tim Russert interviews John Kennedy Jr., then thirty-six years old, for his show *Meet the Press*. The show, during which a notable individual is invited to comment on current events, was one of the oldest and most prestigious television programs in America.

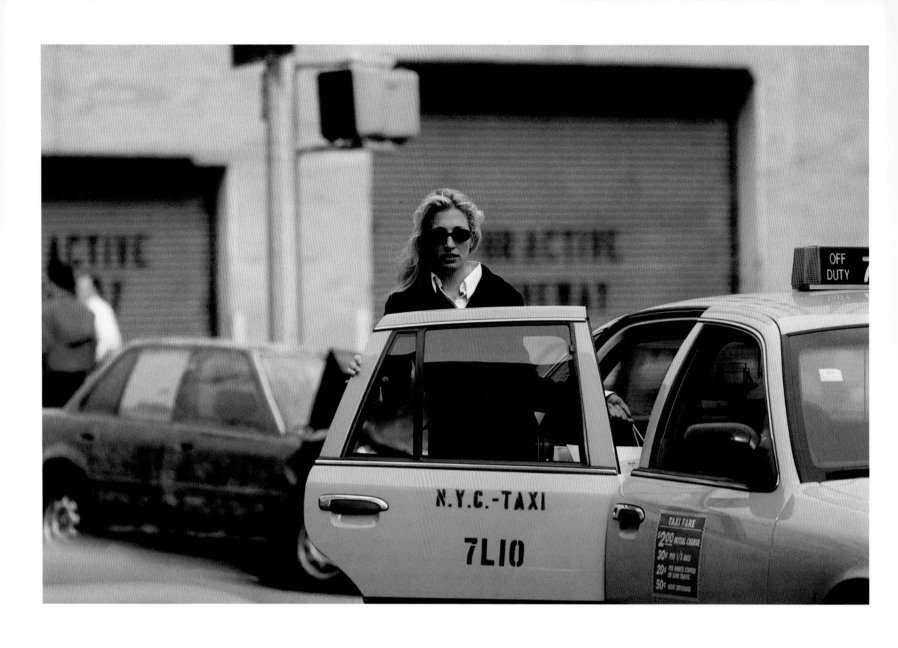

February 27, 1997 / New York, NY / Carolyn exits her loft building in Tribeca and disappears into a taxi.

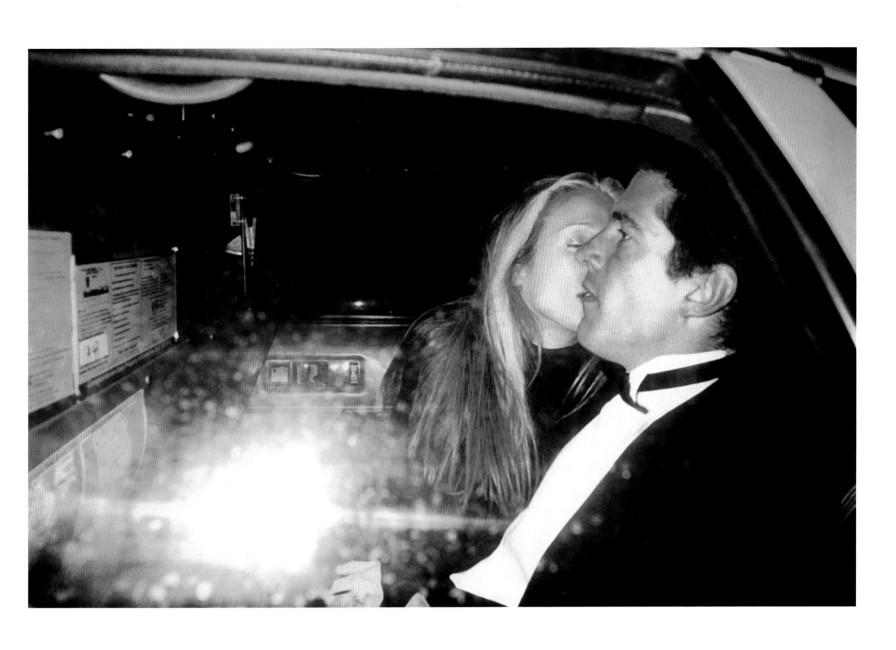

March 11, 1996 / New York, NY / John and Carolyn take a taxi to join some friends for dinner.

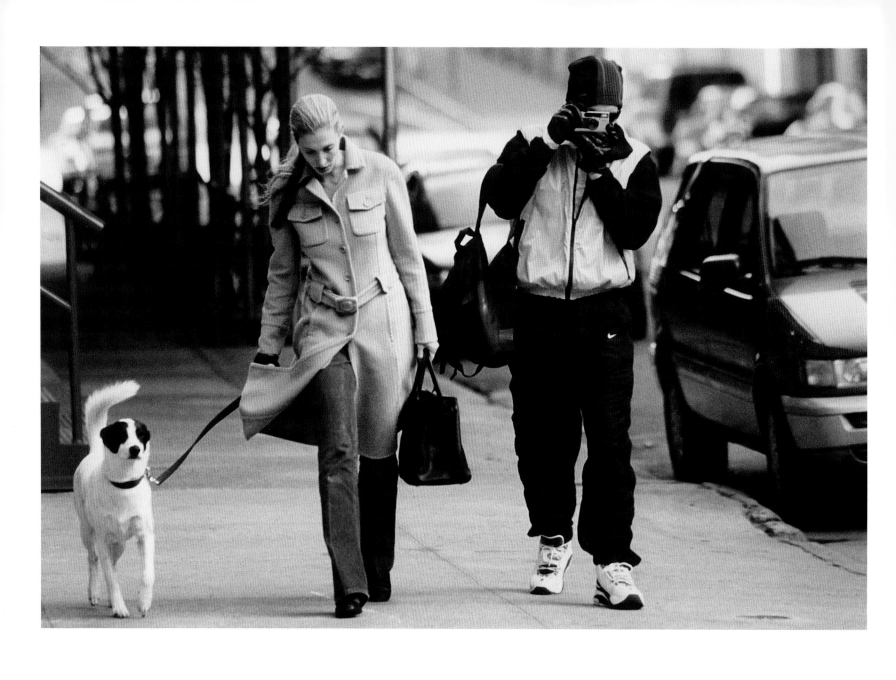

1997 / New York, NY / John and Carolyn walk their dog Friday in Soho. John had gotten in the habit of pulling out his own camera and snapping pictures of photographers whenever he noticed a stranger trying to take a picture of him.

1997 / Big Sky, MT / John having a hard time convincing his dog Friday to get out of the car. John had decided to take a few days off at a ski resort where he and his wife Carolyn traditionally celebrated the New Year.

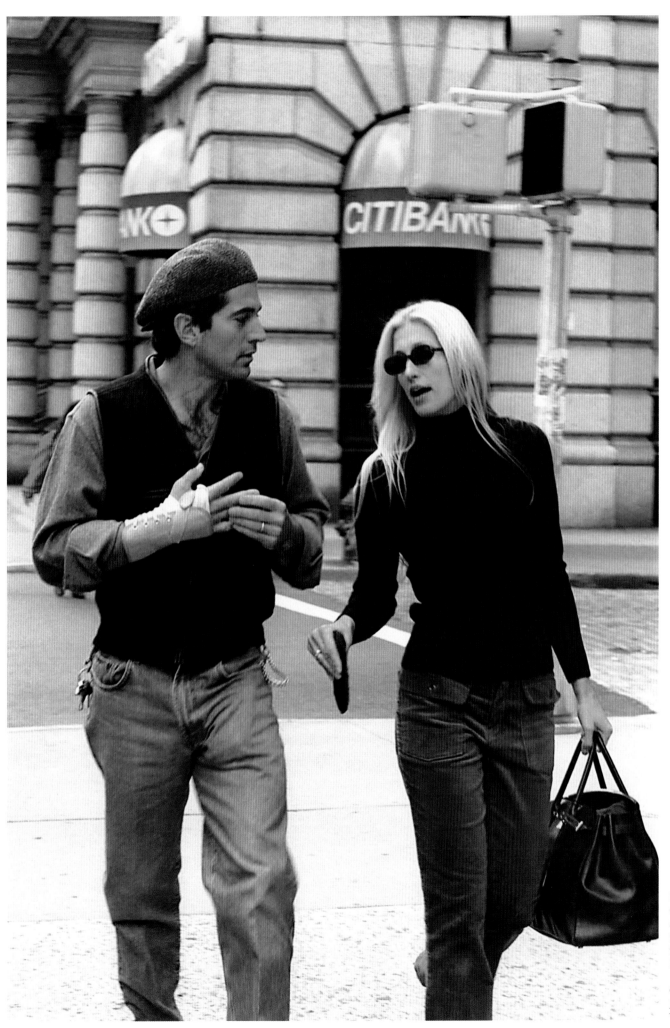

December 20, 1997 / New York, NY / Carolyn and John spend a Saturday afternoon Christmas shopping in Soho. While waiting for Carolyn to come out of a shop, John teaches his dog Friday to shake hands.

October 19, 1997 / New York, NY / John and his wife exiting their New York loft.

"Elegance is best achieved by a woman with a little black dress and the man she loves at her arm."

Yves Saint-Laurent

August 8, 1998 / Bracciano, Italy / John Kennedy Jr. and his wife Carolyn traveled to the shores of Lake Bracciano, near Rome, to attend the wedding of Christiane Amanpour and James Rubin.

212

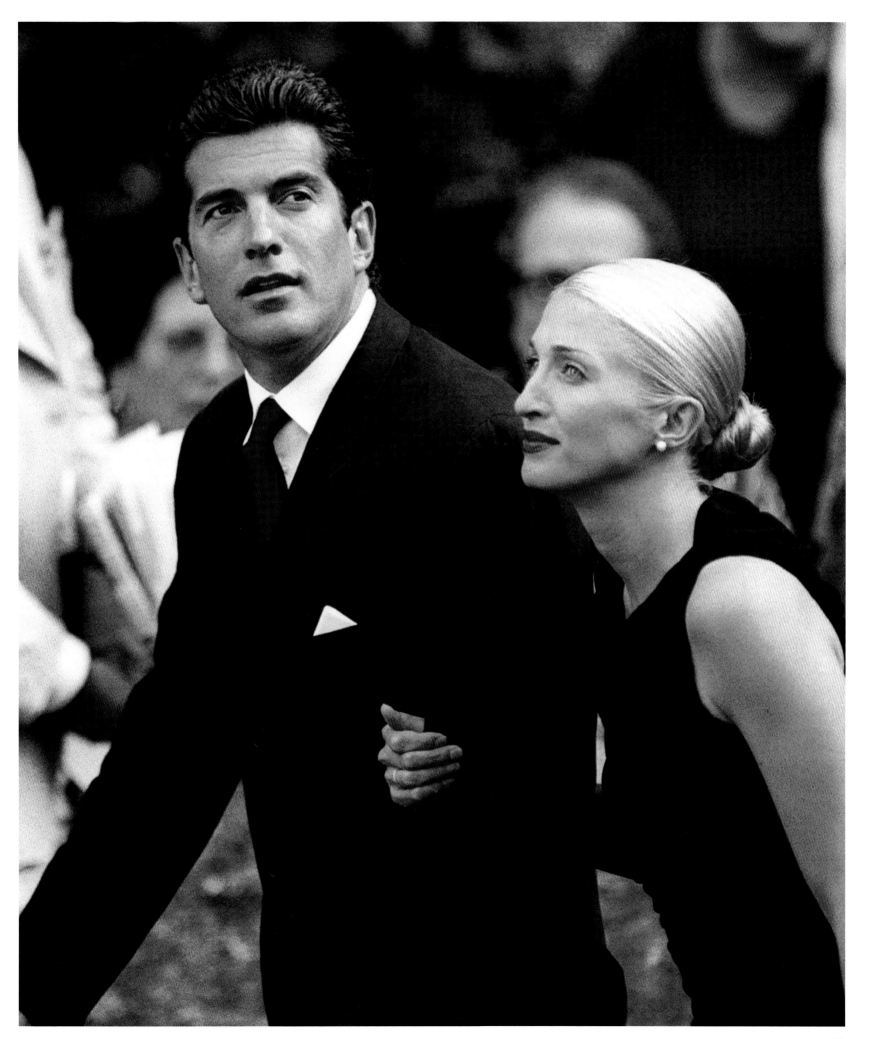

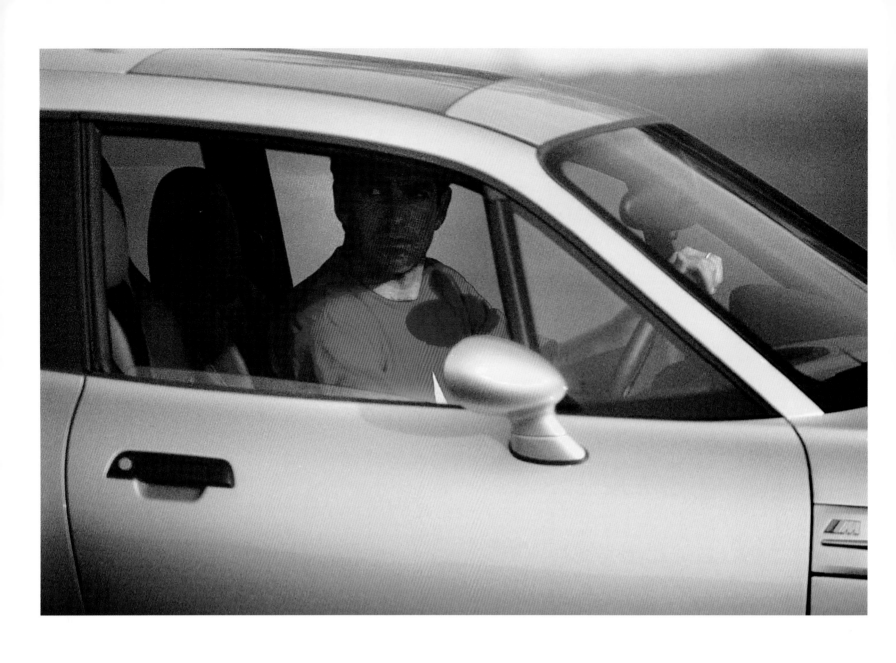

October 13, 1998 / New York / John on his way to the airport to pilot his Cessna.

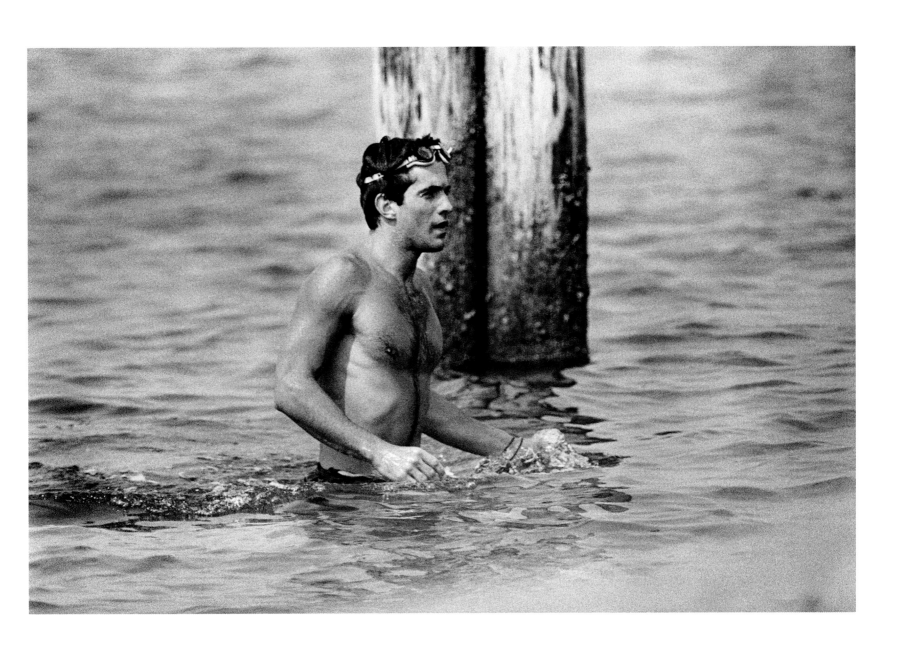

July 18, 1996 / Hyannis Port, MA / John going swimming in Hyannis Harbor.

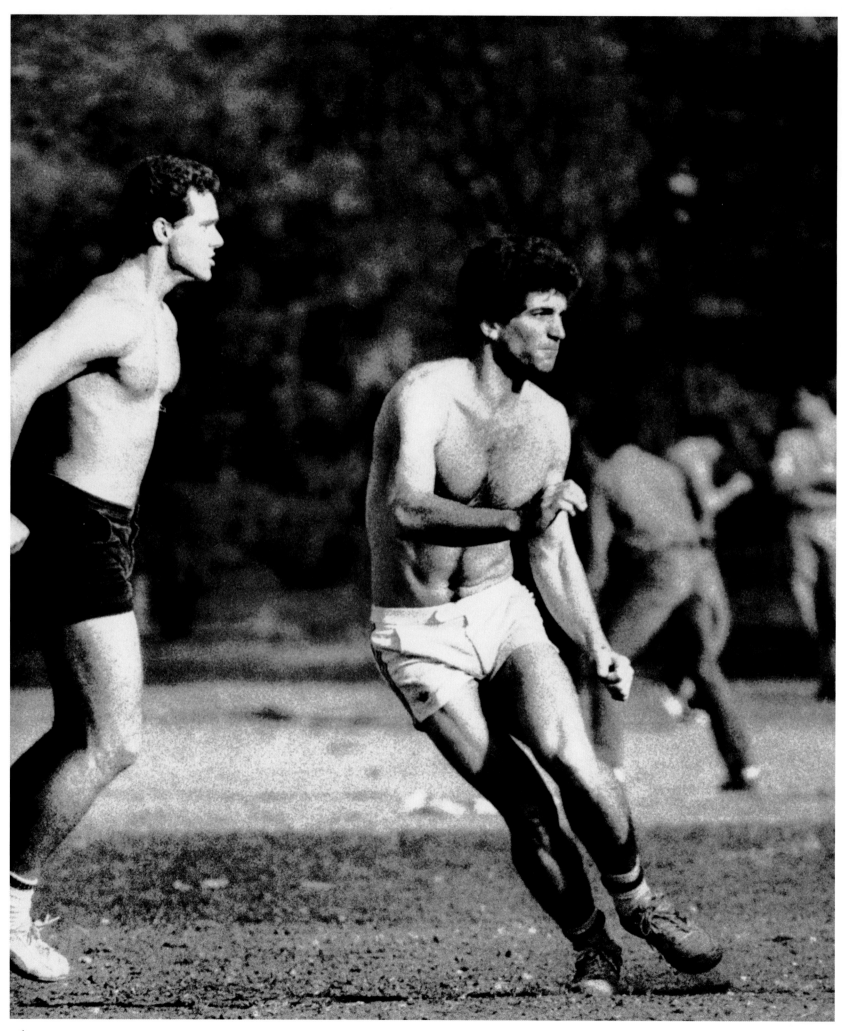

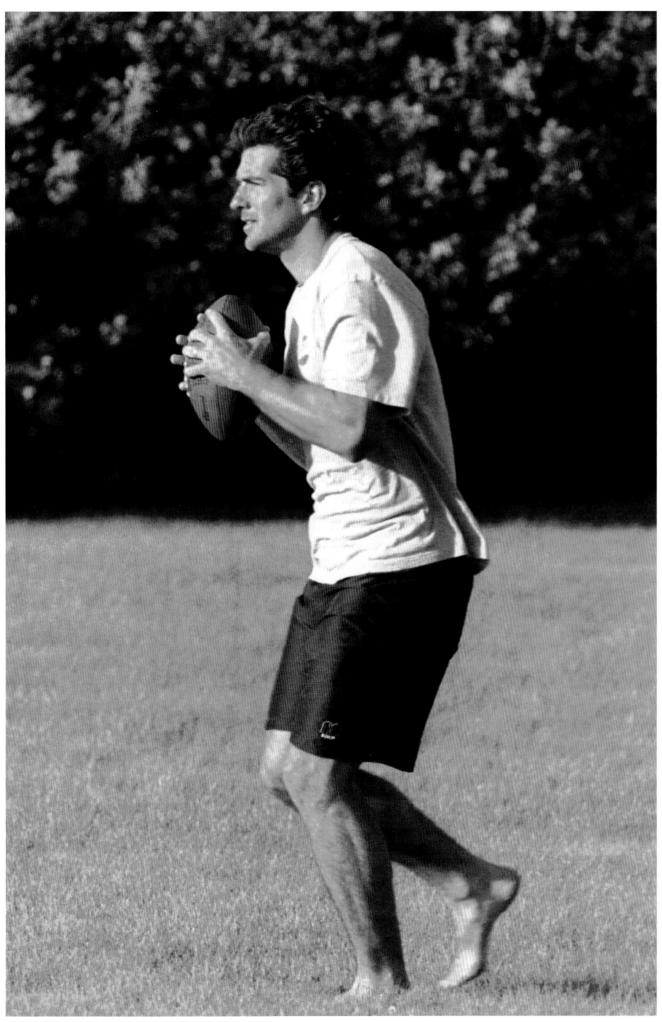

1985 / New York, NY /
John playing football in Central Park.

August, 1997 / Hyannis Port, MA /
John playing football on the lawn
in the family compound.

217

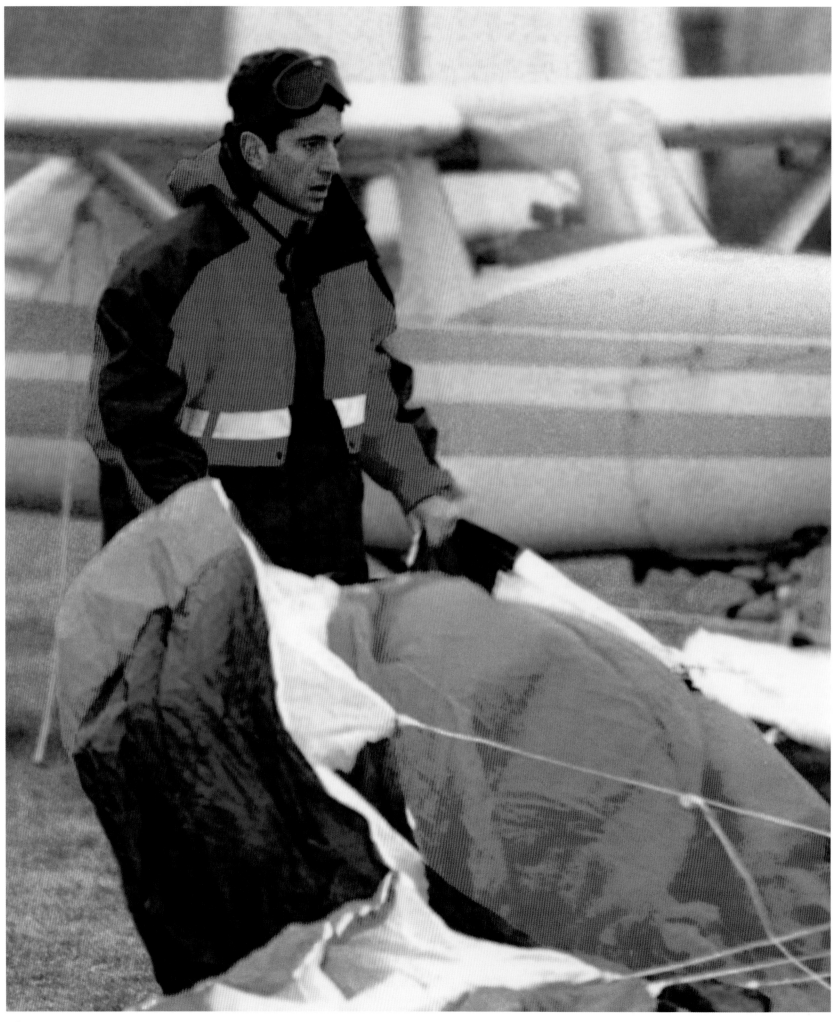

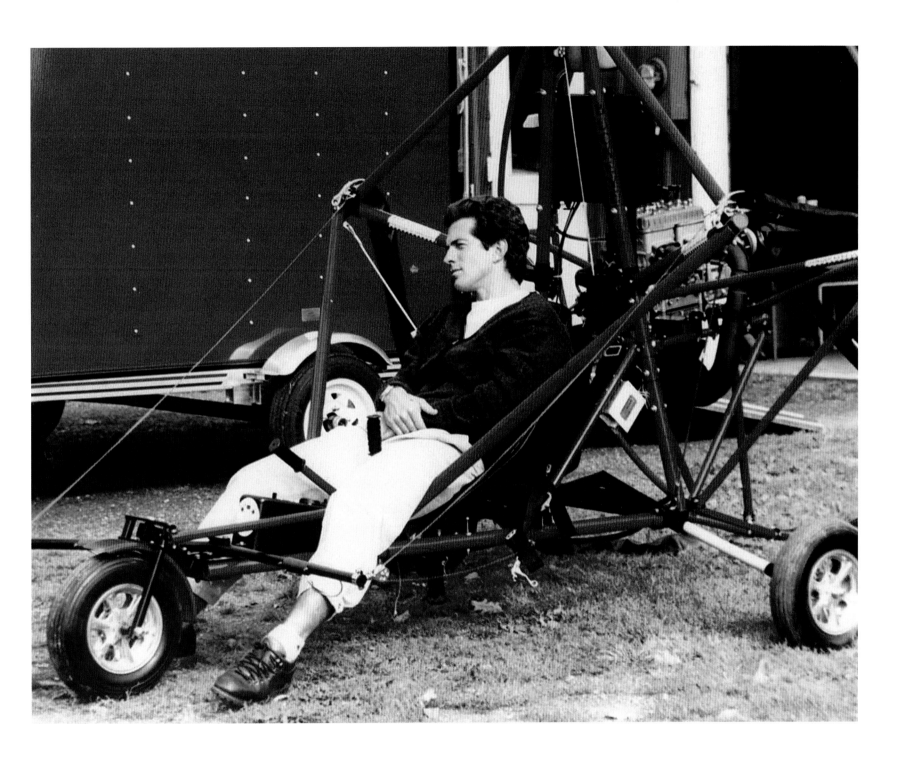

February 1, 1997 / Hyannis Port, MA / John loved high-adrenaline sports. Here, he folds the sail of his paraglider after landing.

1997 / Argos, IN / John settles into the paraglider he personally revamped.

April 13, 1996 / Paris, France / John visits the Louvre.

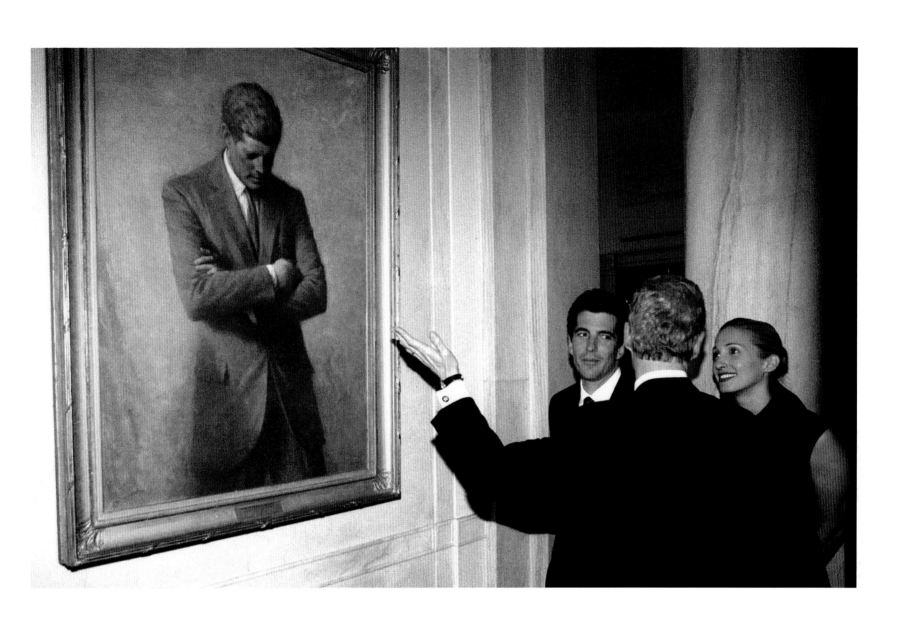

March 5, 1998 / Washington, DC / John Kennedy Jr. and his wife Carolyn are welcomed to the White House by President Clinton, who presented them with the original Aaron Shikler painting that became President Kennedy's official portrait after his death on November 22, 1963.

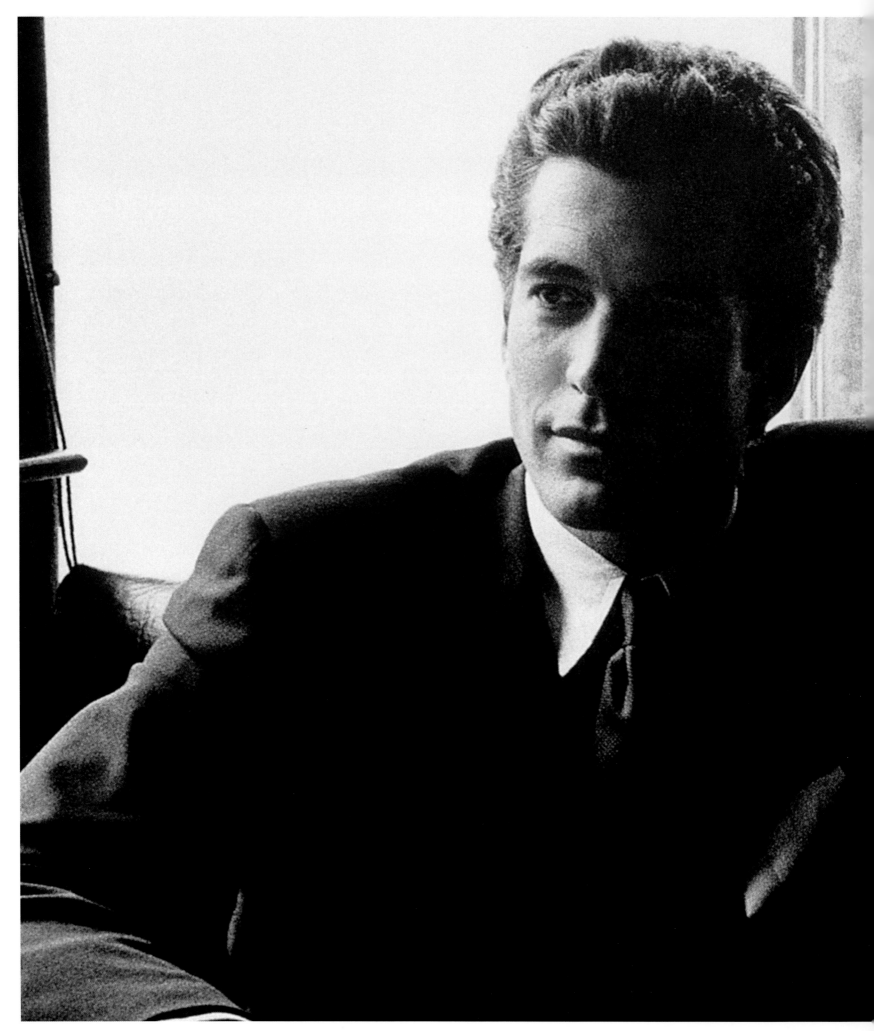

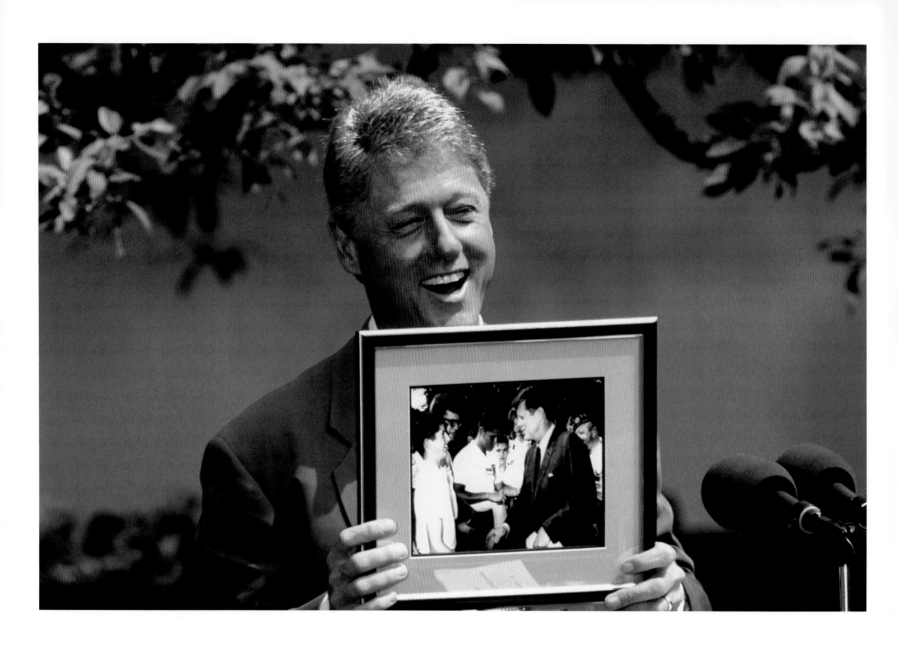

pp. 222-223:
June 30, 1998 / New York, NY / Portrait of John Kennedy Jr., age thirty-seven.

July 1, 1993 / Washington, DC / President Bill Clinton relishes showing the press a photo dated July 24, 1963, showing him shaking hands with President Kennedy. This encounter took place at the White House during the Boys Nation, an introductory political science camp offered to high school students.

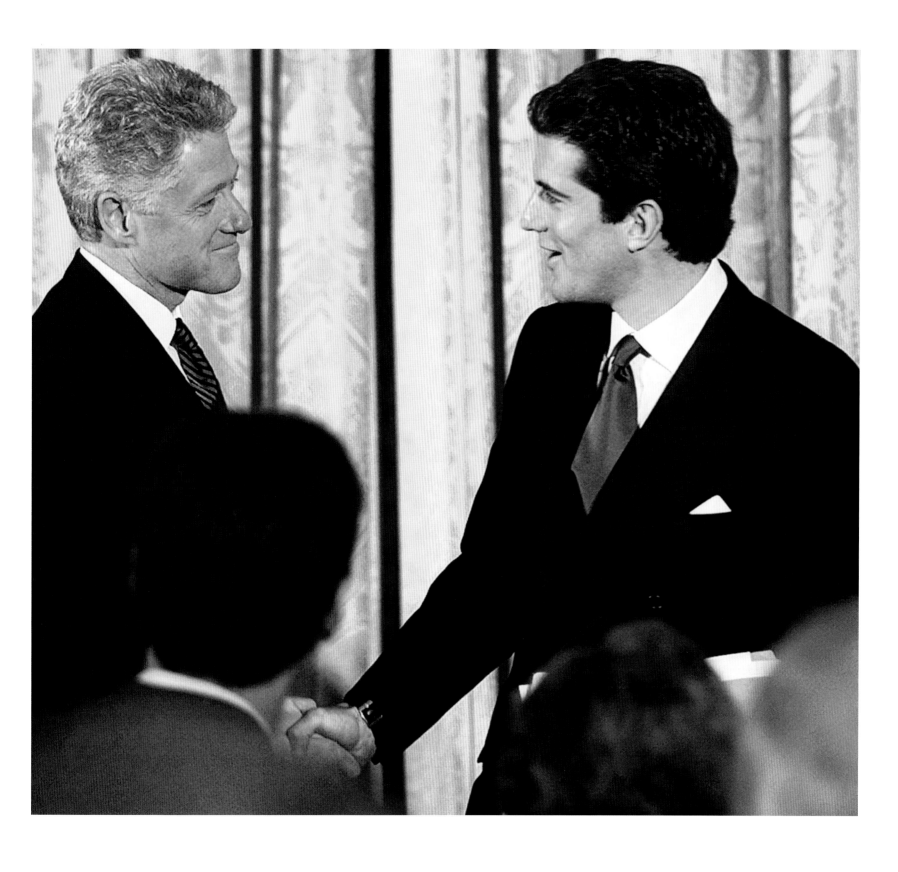

March 5, 1998 / Washington, DC / President Bill Clinton and John Kennedy Jr. attend a White House preview screening of an HBO program entitled *From the Earth to the Moon*.

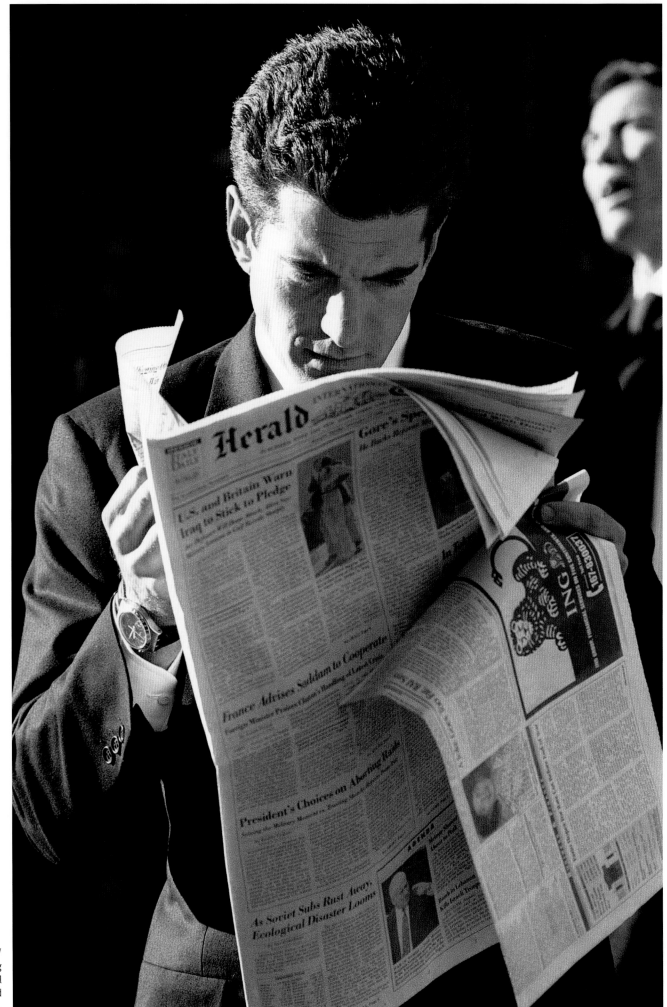

November 18, 1998 / Milan, Italy /
John reads the Herald Tribune during
a trip to Italy to introduce the local
press to his newly launched
George magazine.

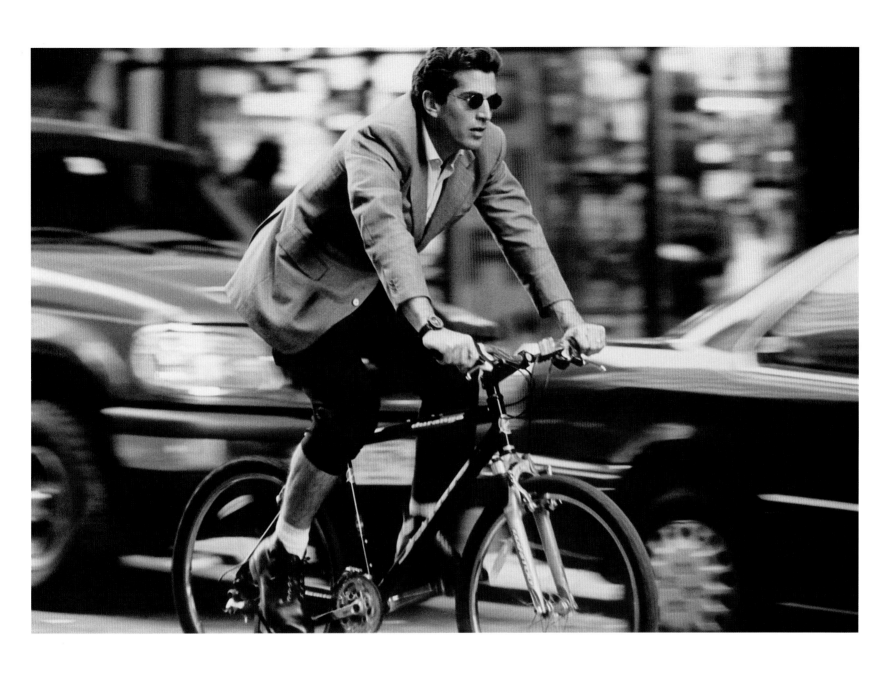

1997 / New York, NY / As was his habit, John takes his bike to get to a meeting at the other end of the city.

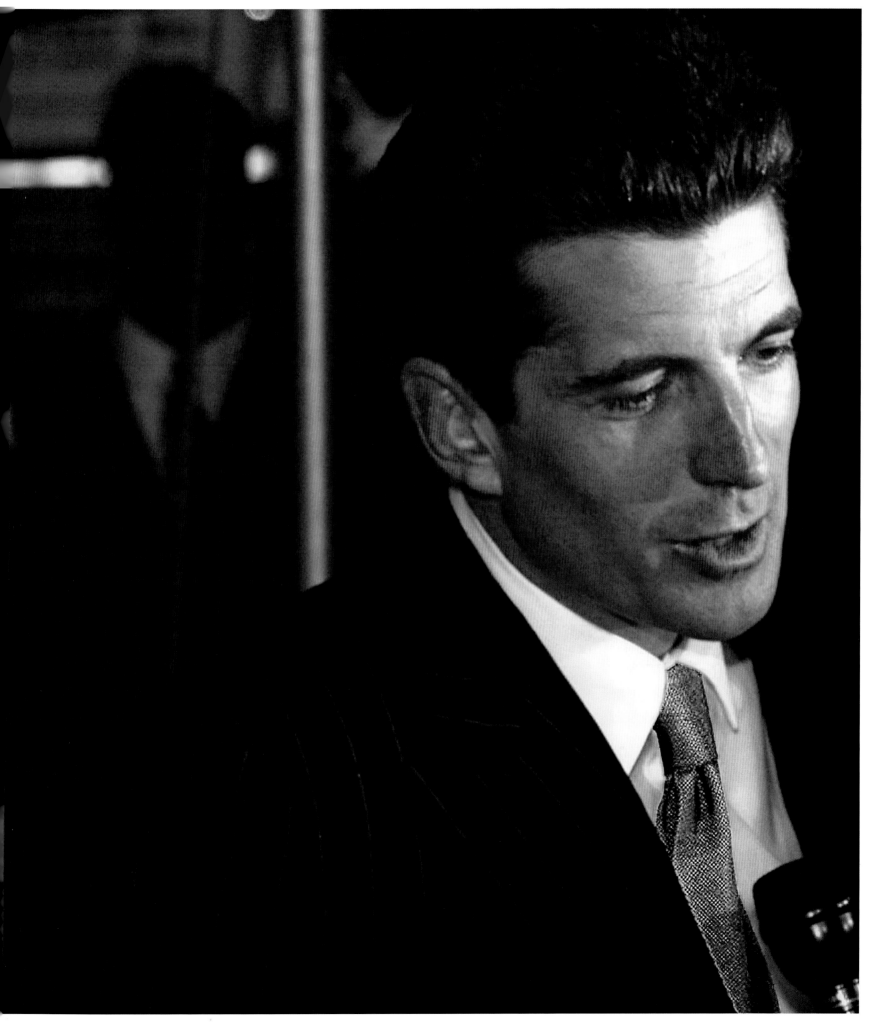

"Somebody up there doesn't like us."

Robert F. Kennedy, 1964, after his brother Senator Edward Kennedy's plane crashed, killing his assistant and pilot

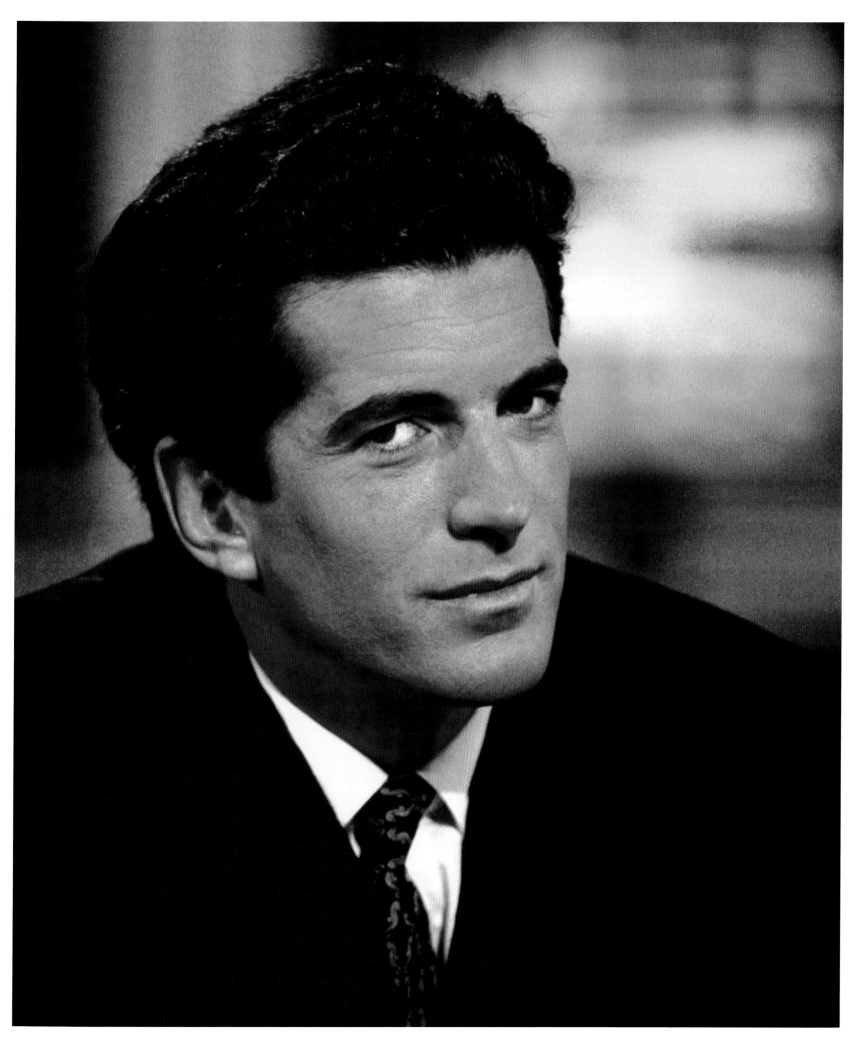

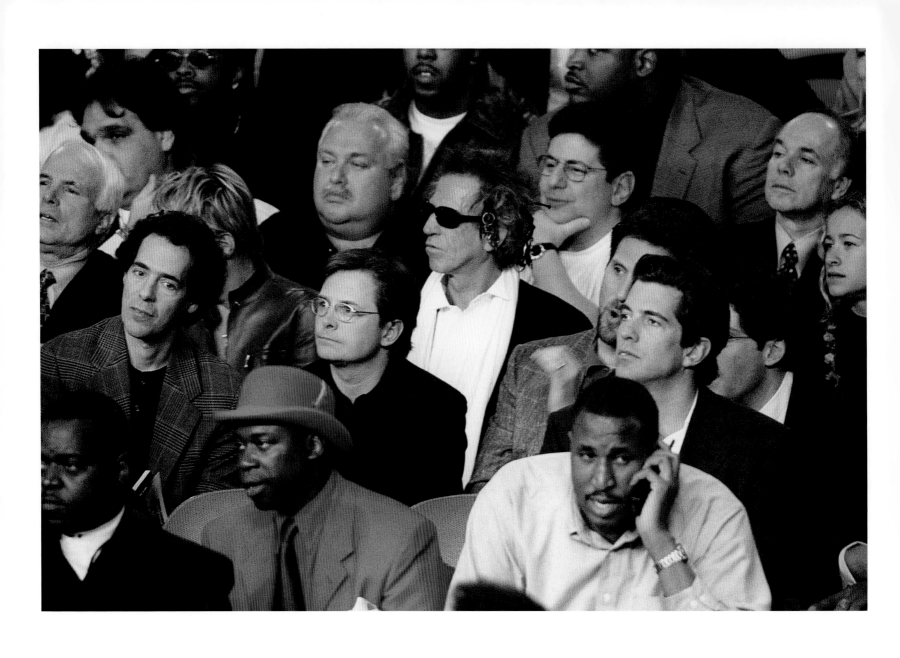

March 13, 1999 / New York, NY / Seated among a crowd of celebrities (including Keith Richards and Michael J. Fox) John Kennedy Jr. watches the World Heavyweight Boxing Championship at Madison Square Garden. That night, Lennox Lewis and Evander Holyfield fought to a draw. Eight months later, Lennox defeated his opponent by decision victory in a Las Vegas rematch.

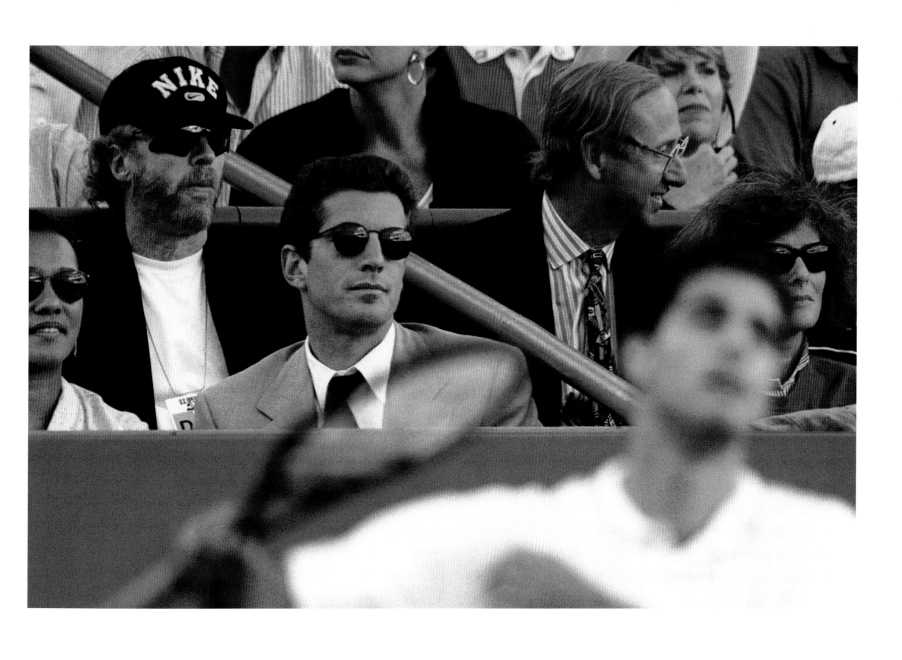

September 10, 1995 / Flushing, NY / John attends the final game of the US Open. That day, Pete Sampras defeated fellow American André Agassi in four sets (6-4, 6-3, 4-6, 7-5). Seated behind John is Philip Knight, ex-CEO and founder of Nike.

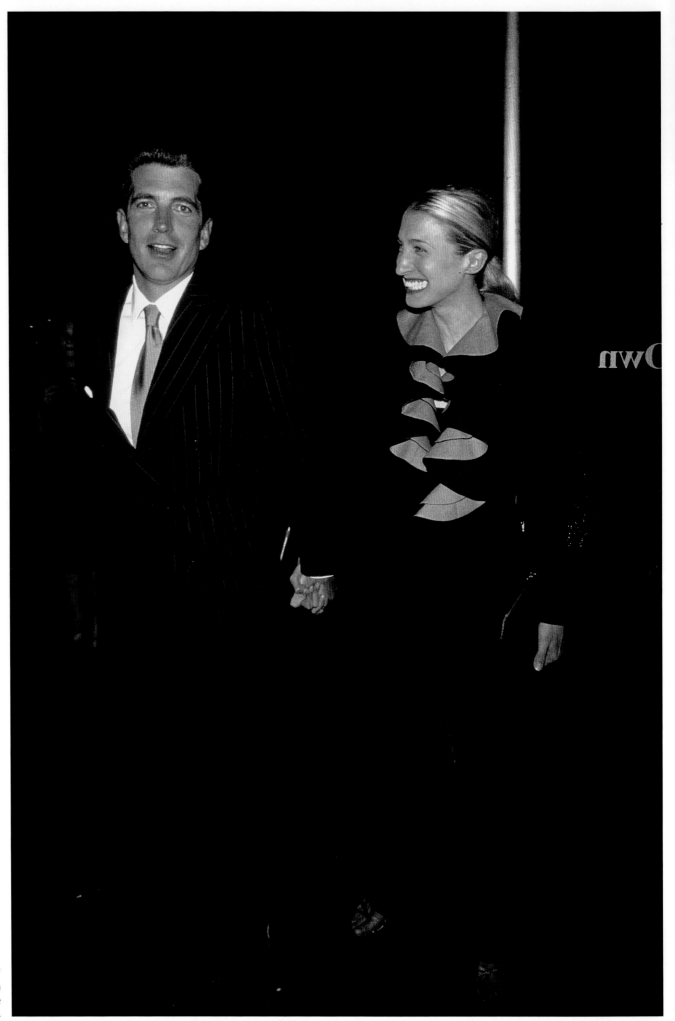

May 19, 1999 / New York, NY /
John Kennedy Jr. and his wife Carolyn
attend the ceremony for the
Newman's Own/*George* Award.

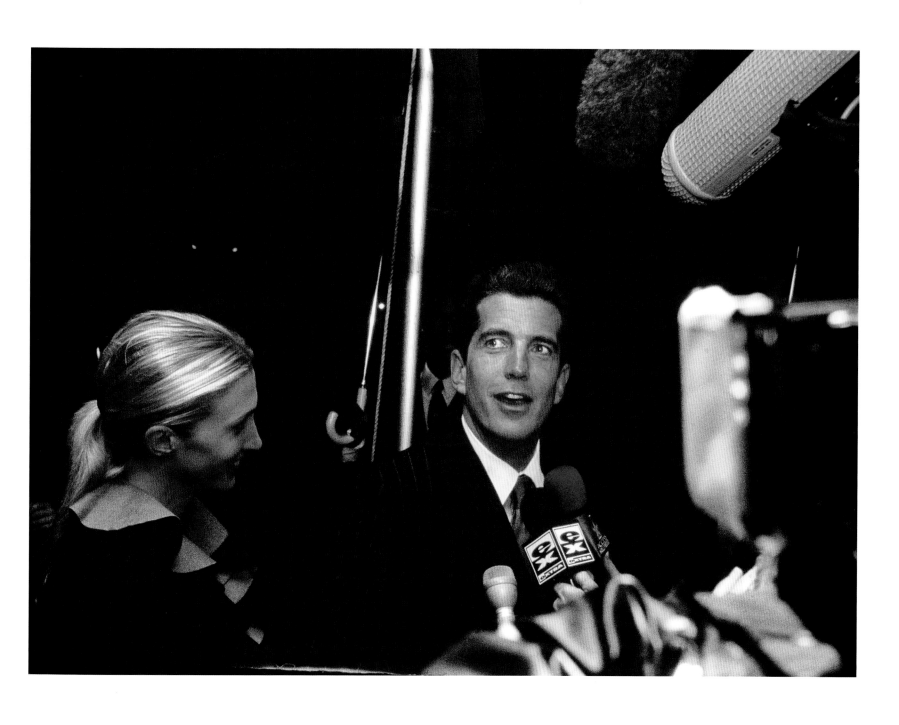

May 19, 1999 / New York, NY / John Kennedy Jr. and his wife Carolyn at the Newman's Own/*George* Award ceremony.

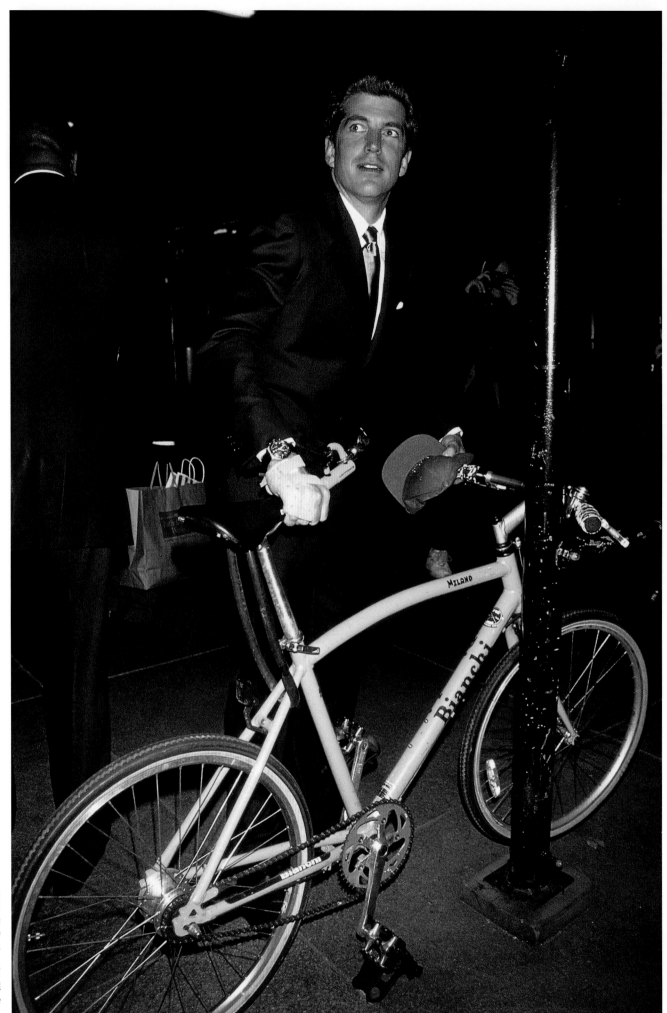

pp. 236-237:
May 19, 1999 / New York, NY /
John Kennedy Jr. and his wife
Carolyn attend the ceremony for the
Newman's Own/*George* Award.

December 18, 1997 / New York, NY /
John rides his bike to a cocktail
party for *George* magazine
at the Alfred Dunhill store.

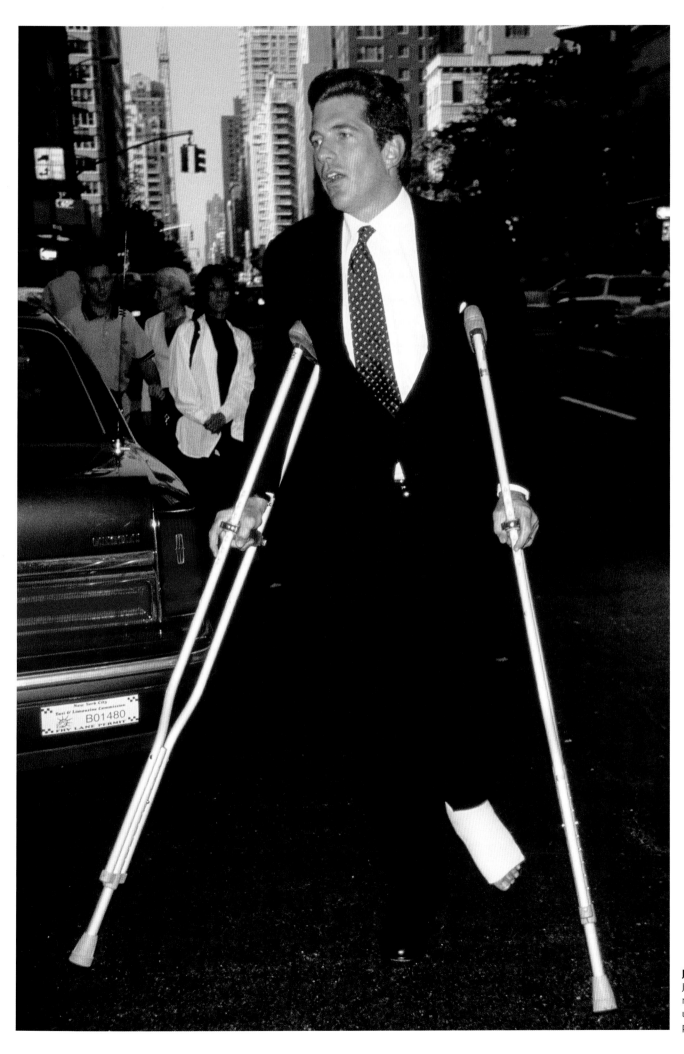

June 10, 1999 / New York, NY /
John goes to a cocktail party for *George*
magazine at Bloomingdale's. He is
using crutches after breaking his ankle
paragliding on Martha's Vineyard.

September, 1998 / Hyannis Port, MA / John checks over his brand new plane.

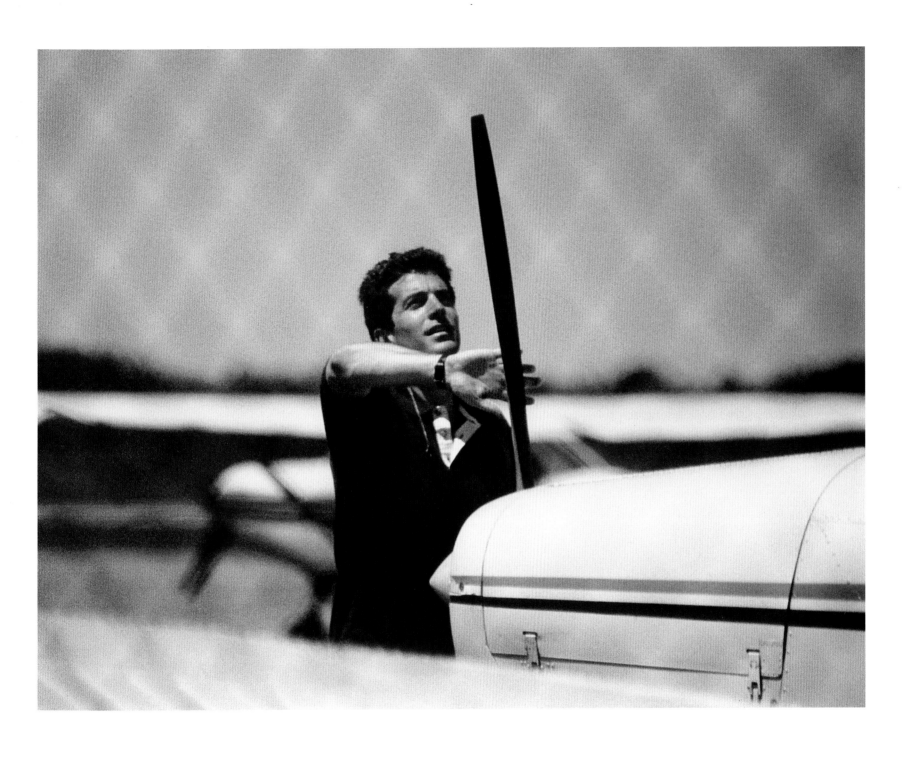

September, 1998 / Hyannis Port, MA / John with his new plane.

July 16, 1999

Martha's Vineyard, Massachusetts: Death of John Kennedy Jr. and Carolyn Bessette

September 12, 1996 / New York, NY / John Kennedy, a few days before his wedding to Carolyn Bessette.

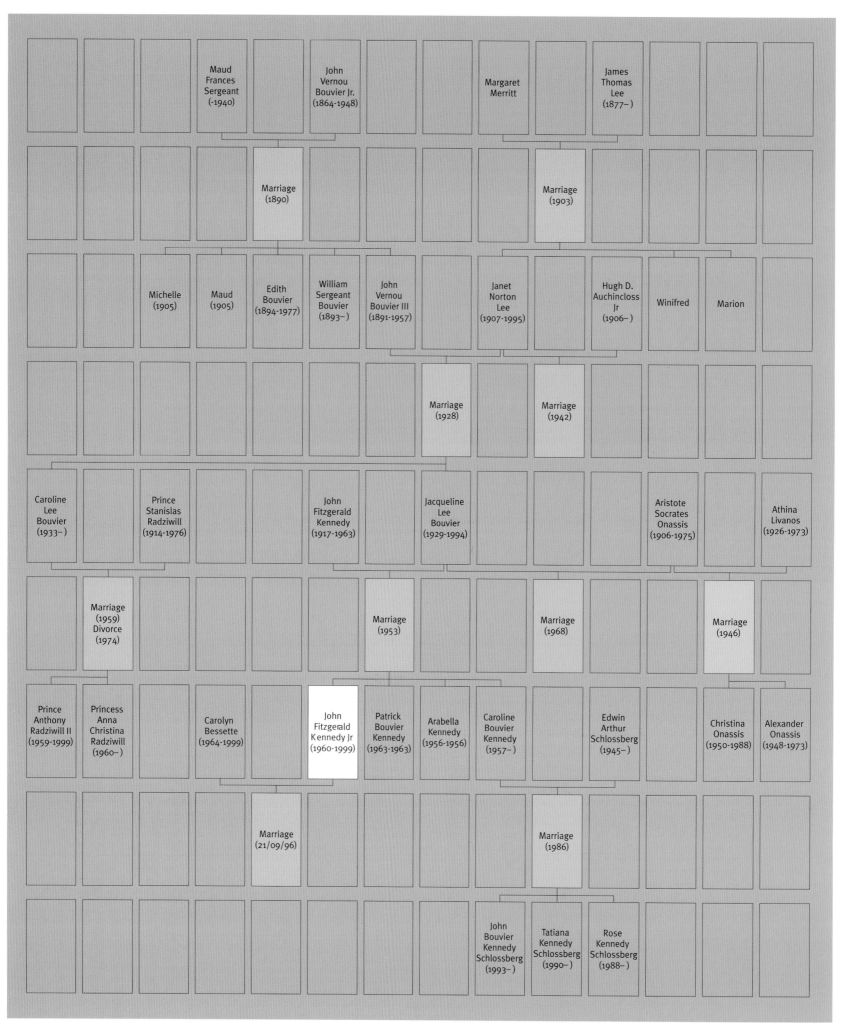

Maud Frances Sergeant (-1940)

John Vernou Bouvier Jr. (1864-1948)

Margaret Merritt

James Thomas Lee (1877–)

Marriage (1890)

Marriage (1903)

Michelle (1905)

Maud (1905)

Edith Bouvier (1894-1977)

William Sergeant Bouvier (1893–)

John Vernou Bouvier III (1891-1957)

Janet Norton Lee (1907-1995)

Hugh D. Auchincloss Jr (1906–)

Winifred

Marion

Marriage (1928)

Marriage (1942)

Caroline Lee Bouvier (1933–)

Prince Stanislas Radziwill (1914-1976)

John Fitzgerald Kennedy (1917-1963)

Jacqueline Lee Bouvier (1929-1994)

Aristote Socrates Onassis (1906-1975)

Athina Livanos (1926-1973)

Marriage (1959) Divorce (1974)

Marriage (1953)

Marriage (1968)

Marriage (1946)

Prince Anthony Radziwill II (1959-1999)

Princess Anna Christina Radziwill (1960–)

Carolyn Bessette (1964-1999)

John Fitzgerald Kennedy Jr (1960-1999)

Patrick Bouvier Kennedy (1963-1963)

Arabella Kennedy (1956-1956)

Caroline Bouvier Kennedy (1957–)

Edwin Arthur Schlossberg (1945–)

Christina Onassis (1950-1988)

Alexander Onassis (1948-1973)

Marriage (21/09/96)

Marriage (1986)

John Bouvier Kennedy Schlossberg (1993–)

Tatiana Kennedy Schlossberg (1990–)

Rose Kennedy Schlossberg (1988–)

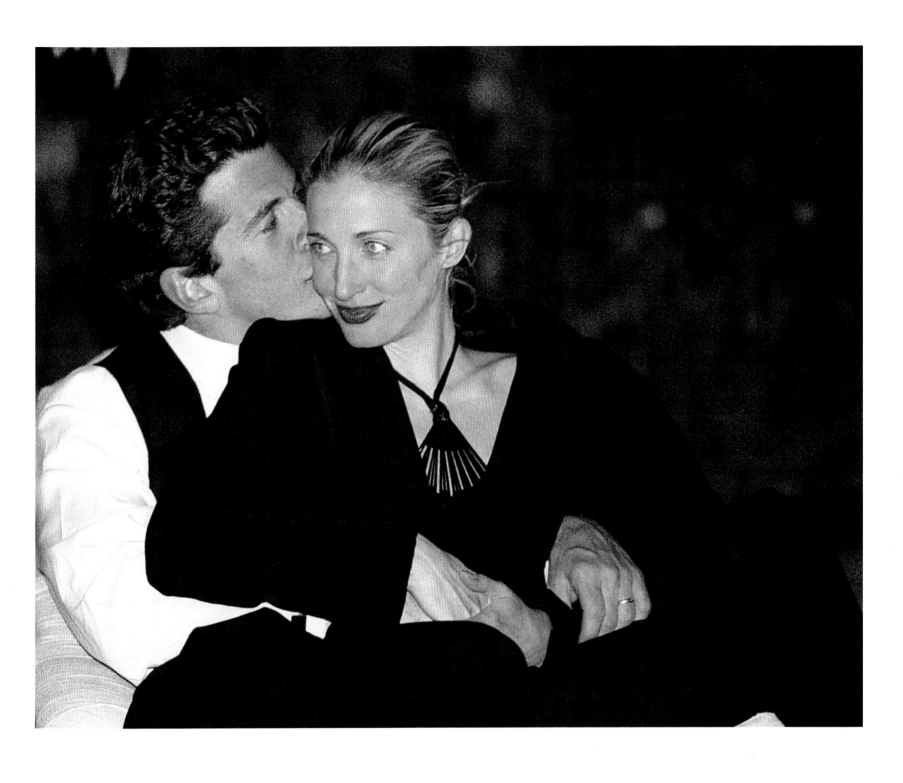

May 1, 1999 / Washington, DC / John Kennedy tenderly kisses his wife Carolyn, during the annual Foreign Correspondents Dinner at the White House.

Aknowledgments

Pierre-Henri Verlhac dedicates this book to his wife Anne.
Zélie, during the making of this third book, you underwent
your third surgery with courage and bravery.

Yann-Brice Dherbier dedicates this book to Maxime Couteau,
who makes him a proud and happy godfather.

Pierre-Henri Verlhac and Yann-Brice Dherbier would like to thank :

... Matt Berman, Jean-Louis Ginibre, and Rose Marie Terenzio,
for listening and for their critical judgment.
Thanks for opening doors for us, for your belief in this project
and for sharing memories with us.

... Daniel and Alain Regard for their work on these photos

... James B. Hill, for his reliability and deep knowledge of the Kennedy archives

... Lara Adler, Jason Crantz, Martine Detier, Ron & Betty Galella, Kris Hook,
Mohamed Lounes, Patrick Mc Mullan, Chrystelle Raignault,
Michèle Riesenmey, Xavier Rousseau, Michael Shulman
and Suzanne Weller
For their efficient help during our research phase.

Credits